TECHTV'S DIGITAL CAMERA AND IMAGING GUIDE

Les Freed with Sumi Das

CONTENTS AT A GLANCE

A Division of Pearson Technology Group, USA
201 W. 103rd Street
Indianapolis, Indiana 46290

TECHTV'S DIGITAL CAMERA AND IMAGING GUIDE

Copyright © 2002 by Que

International Standard Book Number: 0-7897-2639-4

Library of Congress Catalog Card Number: 2001090965

Printed in the United States of America

First Printing: December 2001

04 03 02 01 4 3 2 1

Trademarks

Warning and Disclaimer

TR
267
.F75
2002

ASSOCIATE PUBLISHER
Dean Miller

ACQUISITIONS EDITOR
Angelina Ward

DEVELOPMENT EDITOR
Maureen A. McDaniel

TECHNICAL EDITORS
Brad Braun
Marc Braun

MANAGING EDITOR
Thomas F. Hayes

SENIOR EDITOR
Susan Ross Moore

COPY EDITORS
Candice Hightower
Molly Schaller

INDEXER
Kelly Castell

PROOFREADERS
Mary Ann Abramson
Megan Wade

TEAM COORDINATOR
Sharry Lee Gregory

MEDIA DEVELOPER
Michael Hunter

INTERIOR DESIGNER
Anne Jones

COVER DESIGNER
Planet 10

COVER PHOTOGRAPHER
Shawn Roche

PAGE LAYOUT
Stacey Richwine-DeRome

TECHTV HEAD OF BUSINESS DEVELOPMENT
Dee Dee Atta

TECHTV VICE PRESIDENT/ EDITORIAL DIRECTOR
Jim Louderback

TECHTV EXECUTIVE EDITOR—BOOKS
Regina Lynn Preciado

TECHTV MANAGING EDITOR
Andy Guest

TECHTV MANAGING EDITOR—HELP
Philip Allingham

TECHTV LABS DIRECTOR
Andrew Hawn

TABLE OF CONTENTS

ABOUT THE AUTHORS

Les Freed is a writer and photographer based in Southwest Florida. Les writes on a broad range of technology topics, including digital imaging, computer networking, and the Internet. Les has been a contributing editor at *PC Magazine* since 1994 and a frequent contributor since 1990.

Les' other Que books include *How Networks Work* and *Practical Network Cabling*, both co-authored with longtime collaborator Frank Derfler. Les and Frank shared the 1993 Computer Press Association award for Best How-To Book for *How Networks Work*, still in print in its 5th edition.

Before joining *PC Magazine*, Les was founder and CEO of Crosstalk Communications, developers of the popular Crosstalk data communications program for PCs—back in the days before the Internet made communications software obsolete.

Prior to founding Crosstalk, Les was a Senior Technician and Videotape Editor at CBS News from 1976 to 1981 and a cameraman and News Editor at WTVJ-TV in Miami from 1972 to 1976. He graduated from the University of Miami in 1974 with a B.A. in Electronic Journalism.

Sumi Das, host of TechTV's Fresh Gear, shows viewers each week the best and brightest technology available in the market, covering what's new, what works, as well as offering recommendations on what and what not to buy. She also gives viewers a glimpse into the future by exploring emerging technologies that are still in the research and development phases. Das has been an on-air host since 1998, endearing herself to TechTV viewers as one of the network's leading ladies through her charming, accessible approach to intricate technology subjects.

ABOUT TECHTV

TechTV is the only cable television channel covering technology news, information, and entertainment from a consumer, industry, and market perspective 24 hours a day. From industry news to product reviews, tech stocks to tech support, TechTV's programming keeps the wired world informed and entertained. TechTV is one of the fastest-growing cable networks, currently available in millions of households and distributing content to 70 countries around the world. Check your local television listings for TechTV.

DEDICATION

A heartfelt thanks to my husband Tim, who bought me my first digital camera.

—Sumi Das

ACKNOWLEDGMENTS

Les and Sumi want to thank the following people and companies for their help and support:

Allison Fischman	Karen Thomas
Moira Fischman	Tamara Turse
Dr.Paul Fischman	Chuck Westfall
Aaron Freed	Canon USA
Becky Freed	Cerious Software
Toby Hufham	Digital Domain, Inc.
Andy LaGuardia	FujiFilm USA
Kelly Lesson	Linksys Corporation
Nicole Perez	Minolta Corporation
Mary Resnick	Nikon USA
Will Sanders	Olympus America
Sally Smith	Sony Electronics Corporation
Karen Sohl	Toshiba America Information Systems

Special thanks to Angelina Ward for patience above and beyond the call of duty!

CONTENTS

ABOUT THE PHOTOS IN THIS BOOK

Like all photography books, this book makes extensive use of sample photographs. To keep the retail price reasonable, the book is printed in black and white.

The companion CD-ROM contains the original, high-resolution digital images shown in the book. An image viewer program (for Windows PCs only) is also provided on the CD-ROM.

TELL US WHAT YOU THINK!

As the reader of this book, *you* are our most important critic and commentator. We value your opinion and want to know what we're doing right, what we could do better, what areas you'd like to see us publish in, and any other words of wisdom you're willing to pass our way.

As an Associate Publisher for Que, I welcome your comments. You can fax, e-mail, or write me directly to let me know what you did or didn't like about this book—as well as what we can do to make our books stronger.

Please note that I cannot help you with technical problems related to the topic of this book, and that due to the high volume of mail I receive, I might not be able to reply to every message.

When you write, please be sure to include this book's title and author as well as your name and phone or fax number. I will carefully review your comments and share them with the author and editors who worked on the book.

Fax: 317-581-4666

E-Mail: feedback@quepublishing.com

Mail: Associate Publisher
Que
201 West 103rd Street
Indianapolis, IN 46290 USA

FOREWORD

One of my first assignments at TechTV (then ZDTV) was to produce a television segment illustrating the pros and cons of digital cameras. Little did I know that this would essentially set the tone for my career at the network. Or that I would spend so much time talking about, fiddling around with, and shooting these nifty little gadgets. Of course, there are worse fates. Especially for me, a person whose home is filled with photos. A person always curious about the photographs others choose to have in their rooms, office, and other personal spaces. I find photos as telling as the books people store on their shelves. I love the way they conjure a memory just as a song or smell does. But unlike a melody or fragrance, a photograph preserves the moment with greater accuracy, not allowing emotion or time to cloud the recollection. A photo is the perfect and truthful representation of a moment that might otherwise be forgotten.

My most treasured photos are ones I have carefully transported from my grandmother's home in India. Each time I visit her, I look through the brittle albums that collectively tell the story of her life. They are the best connection I have to a time that I will never know. Occasionally, I come across a photo that I must have—an image where the subjects seem to be looking directly at me, as if knowing that I would come along decades later searching for them.

So, in case you missed it, I hold a certain amount of fondness for photographs and cameras. My 35mm Pentax is dear to me, as is the reassuring sound of a shutter releasing and the familiar smell of photos developing. All the more reason for me to pooh-pooh their new digital counterparts, right? Although I do refuse to throw in my 35mm, you would be hard pressed to find a time when my digital camera isn't close at hand. I've found that digital cameras can knock up the liveliness factor a notch or two at parties (people prefer mugging for digital). They can satisfy every instant gratification-junkie. ("Can I see the picture?") They help you master the technical aspects of photography, because you can be as snap happy as you want to be until your desired effect appears on the camera's small LCD screen. And they can be the conduits for new friendships. ("Can you e-mail me that picture?")

Since the launch of TechTV, the digital camera space is one that the network has always kept on top of simply because of consumer need. Unlike many digital gizmos, digital cameras appeal to people of all levels of technological interest and talents. As I once said on-air, "Just as Latina singing sensation Selena crossed over into the mainstream, so have digital cameras." How do I know this? Because if I had a nickel for every time someone called, e-mailed, voice mailed, or instant messaged me inquiring which digital camera they should purchase for themselves or as a gift for a loved one...well, suffice it to say, I wouldn't have to worry about sales of this book.

You might think that after over three years of covering the digital camera space that I've done and seen it all. I haven't. Advances in cameras are continuous. And the introduction of accessories for these cameras seems equally endless. After all, the questions don't end after you've chosen the best camera for you. How will you print, edit, store, and share your photos? These are a few of the questions that TechTV answers in this book.

To help, a digital camera team consisting of writer Les Freed, myself, and the resident digital camera editorial gurus at TechTV was assembled. Les is a contributing editor at *PC Magazine*. He frequently reviews and writes articles about new entries in the digital camera arena. So you can rest assured that between the lot of us, you're sure to get some sound advice about digital cameras and photography.

By the end of this book we'll have covered six major areas: choosing a camera, choosing a printer, using your camera, working with digital images, sharing digital images, and using online resources. You'll also find Sumi's Snapshot at the close of most chapters. This is our FAQ of sorts for the section. It answers what we imagine will be your most common questions. So having said all that, let's get started.

—Sumi Das

INTRODUCTION

This is the part of the book where I'm supposed to impress you with some marketing statistics telling you how many millions of digital cameras were sold last year. Next, I'm supposed to say that digital photography is the next big thing, so you better get on the stick and buy this book.

But I'm a realist.

Because you're reading this introduction, I'll assume that you fall into one of these three categories:

- You're shopping for a digital camera but don't know what to buy.
- You've recently purchased a digital camera but aren't happy with the results.
- You're an experienced film photographer curious to see what this digital stuff is all about.

If any of these sound familiar, Sumi and I have written this book just for you. Our focus in this book is on choosing and using digital cameras, photo printers, imaging software, and online photo services.

The "choosing" part of the book tells you what to look for in a digital camera, shows you how to buy the one that best suits your needs, and even includes shopping tips to help you get the right price on the right camera. We also provide reviews of today's hottest camera models.

The "using" part of the book tells you a few things you won't find in your camera's instruction manual, like how to actually use your camera. We'll show you how to get the most out of your camera, computer, and printer to produce better pictures than you've ever taken. We explain the techniques you need to know to take good pictures with any camera, but we also include a great deal of digital know-how that you can't get in film-based photography books.

We cover the entire digital imaging spectrum, including cameras, printers, software, online photo printing and sharing services, and essential accessories. The companion CD-ROM provided with the book includes trial versions of our favorite software for editing, organizing, and printing images.

Because this is a photography book, we use plenty of sample photographs to show you how to improve your own pictures. Although the book is printed in black and white, the enclosed CD-ROM includes all the digital images presented in the book, so you can examine them in greater detail than any printing process would allow. We even include a viewer program so you can see the pictures on your Windows PC. (Note to Mac users: We didn't forget about you. There's plenty of Mac-related information here, too.)

Thanks for reading this introduction, and thanks even more for taking this book over to the checkout counter.

Les Freed

PART I

CHOOSING A DIGITAL CAMERA

GOING DIGITAL

There are lots of good reasons to own a digital camera. They're cool, convenient, and fun to use. Best of all, they provide instant gratification for those of us who just can't wait to see how our pictures turned out.

Although they look and operate a lot like film cameras, digital cameras use an entirely different—and entirely electronic—process to create images. There's no film to buy and no waiting for processing. If you just want to view your images on a computer, you don't even need a printer to enjoy digital photography.

But before you take the digital camera plunge, you might want to make sure that you know what to expect from a digital camera so you won't be disappointed later. This chapter covers

- Why digital cameras are different
- How film and digital cameras work
- What you need to get started in digital photography
- A quick tour of a typical digital camera

WHY DIGITAL IS DIFFERENT

Although they look and handle like conventional film cameras, digital cameras are very different from their film cousins, both in the way they work and in the way they're used. The most obvious difference—and the reason that many people purchase a digital camera—is that digital photography is an electronic, rather than chemical, process. Digital images are immediate. You can see them immediately after you take the picture, without taking film to a lab and waiting for prints. Above all, digital cameras are fun. The arrival of inexpensive, high-quality digital cameras has attracted a new class of user—a class in which you might be included—made of people who have little or no interest in conventional photography.

THE COMPETITION: FILM

The silver halide negative film process used in virtually all conventional film photography has been around since the late 19th century. Color film became affordable and popular just after the second World War. You can buy film at any convenience store, and you can get your film developed and printed in an hour just about anywhere in the world. Because the film process is so ubiquitous and the economies of scale are so large, the cost of manufacturing, processing, and printing film images is extremely low.

What's ISO Speed?

If you've ever bought film, you know that film comes in a variety of speeds. Film speed is rated by a number called the *ISO rating*, which tells you how sensitive the film is to light. Common speeds are 100, 200, 400, and 800. Films with higher numbers are more sensitive to light, so they are better for action and low light shots.

Digital cameras don't use film, but they still have ISO speed ratings. Most cameras have several user-selectable speed ratings, so you can choose the setting that works best for your subject matter.

Just like with film, higher ISO settings often produce pictures that look grainy and have less sharpness than slower speeds.

Unfortunately, silver halide film has some disadvantages. As the name implies, the process uses a silver compound to capture light and turn it into a printable image. The price of silver fluctuates with world markets, so when silver prices go up, so does the cost of the film and processing. As anyone who has ever worked in a darkroom or color photo lab can tell you (and I've spent lots of time in both!), the chemicals used to develop film and prints are nasty. The color slide film process, for example, uses formaldehyde and cyanide. As a result, many photo labs must recover and recycle their used chemicals, and many labs treat it like the hazardous waste it is!

There has to be a better way...and there is.

HOW THE DIGITAL IMAGING PROCESS WORKS

Digital cameras don't use film, silver, or chemicals. The entire process of digital photography (excluding the printing process) is electronic.

Digital cameras capture images using an electronic image sensor instead of silver-halide film. Because there's no film, there's no developing process, either. Film cameras store images on film; digital cameras store images on an electronic memory device. Most digital cameras use a small, reusable memory card, which you can read about in Chapter 2, "Which Camera to Buy?"

Digital photography is immediate, inexpensive, environmentally friendly, and very flexible. The latest generation of digital cameras offer excellent image quality, sharpness, and color fidelity. As is the case with all things digital, the next generation of cameras will be better, faster, smaller, and cheaper than the current generation.

But right now, digital cameras are much more expensive than film cameras. For example look at the two cameras—an Olympus 3040 digital camera and a Rollei Prego 90 35mm camera—shown in Figure 1.1. Both have similar features, and both are at the upscale end of the point-and-shoot camera market. Both take excellent pictures, but the Olympus costs $800 and the Rollei costs less than $200.

Less expensive digital cameras are on the market, but you should expect to pay at least $400 for a camera with quality comparable to a 35mm point-and-shoot camera.

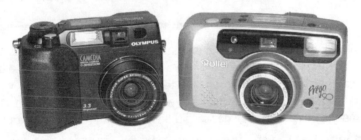

Figure 1.1

Two comparable point-and-shoot cameras, the Olympus 3040 digital (left, about $800) and the Rollei Prego 90 35mm film camera (right, about $200), have prices that differ greatly.

DO YOU NEED A DIGITAL CAMERA?

Despite the tremendous advances in digital cameras, I still don't recommend digital photography for everyone for these reasons: Digital cameras are much more expensive than 35mm film cameras, and the cost of printing digital images is very high compared to film. But there are some compelling reasons to throw caution to the wind and blow that tax refund check on a digital camera. The following are some reasons you may want a digital camera:

- **Immediacy**—You can view digital images immediately, using a small LCD screen on the back of most digital cameras. This makes digital cameras fun at parties and family gatherings.

- **Reassurance**—The immediate playback feature is a lifesaver when you need to be absolutely sure that you got the shot you wanted. This is essential for mission-critical photographic work, such as evidentiary and documentary photography, real estate and insurance claims photos, and event photography. And it's just as important at once-in-a-lifetime events, such as birthday parties, weddings, and graduation ceremonies.

- **No film**—Digital cameras don't use film or processing, so they're cheaper to use than film cameras—unless you want to print your pictures.

- **PC ready**—Digital cameras produce computer-ready digital image files that you can easily incorporate into business presentations, Web pages, and e-mail. You can use a digital camera to produce photos for business applications like flyers or catalogs, or for personal documents like greeting cards and holiday letters.

- **Manipulation**—Good photo editing software turns your PC and printer into a digital darkroom where you can correct and enhance digital images after the fact. You'd need a well-equipped (and smelly) darkroom and years of experience to perform some of the tricks you can do quickly and easily on your computer.

- **Difficult shots**—Digital cameras make taking difficult pictures easy, especially in tricky lighting situations such as nighttime shots and product photography. You can experiment with different settings and exposure options, and see the results right away. With a film camera, you have to wait to get your film processed to see the results; with digital, if you don't like the shot you can do it again until you get what you want.

So far, so good. But here are some reasons why you might *not* want a digital camera:

- **No film**—I know, I listed this as a plus in the previous list. But if you're planning to take a long trip and take lots of pictures with a digital camera, you'll need to bring lots of memory cards or some kind of secondary storage device with you. Either way, you'll wind up spending a lot more money than you would for a dozen rolls of film. Of course, the memory cards and storage device can be erased and re-used over and over.

- **Batteries**—Film cameras use batteries to power the exposure meter, shutter, film advance, and flash. None of these put a heavy load on the batteries, so the batteries last a very long time—often 100–200 rolls of film or more. Digital cameras, however, contain lots of power-hungry electronics, so they eat batteries for breakfast, lunch, and dinner. Rechargeable batteries are a must, and it's a good idea to carry a spare set or two with you if you're heading out for an extended picture-taking session. You'll need to pack a battery charger with your camera gear for vacation trips.

- **Printing**—With a film camera, you can drop your film off at a photo lab and have printed pictures back in an hour or so. Digital cameras require you to print each picture yourself using a photo-quality printer. If you're the type of person who likes to fill up photo albums to share with friends, you might find the digital process tedious and expensive. This will change as new digital printing services become available at many camera and discount stores; see Chapter 12, "Farming Out Your Printing," for more details.

- **Lighting**—Lighting is often more critical for digital cameras than it is for film cameras. This is especially true in harsh outdoor light, in which many digital cameras can't handle the extreme contrast of light and dark.

- **Money**—Digital point-and-shoot cameras are relatively inexpensive, but they still cost three to 10 times as much as comparable film cameras. And although film cameras last for many years, digital cameras become obsolete in two years or so. If you really get into digital photography, be prepared to buy a new camera every couple of years. And as I said earlier, if you like to fill photo albums with prints, be prepared to spend some money on photo paper and ink cartridges for your printer.

- **Learning**—With a film camera, you only need to know how to use the camera to get good pictures—the rest of the process is up to the folks at the photo lab. With a digital camera, you *are* the photo lab. This means that you need to learn how to use image downloading, image editing, and image printing software. On the plus side, you gain greater creative control over your pictures.

GETTING STARTED: WHAT YOU NEED

At the very least, you need a camera (obviously!) and a computer. If you plan to do your own printing, you need a photo-capable color printer.

Although it's possible to use a digital camera without a computer, there's not much point in doing so. You need a way to store, e-mail, and edit your images, and your PC or Macintosh is an essential part of digital photography.

Because you're reading a TechTV book, I'm going to go out on a limb and assume that you know at least a little about computers. If not, there are several introductory computer books, such as *Easy PCs, Sixth Edition*, that can help get you started in computing.

In my day job, I review cameras and computer equipment for *PC Magazine*. As a result, a lot of people ask me for advice on which gizmos and gadgets to buy. The following are the top three questions I get:

- Which camera should I buy?
- Which computer should I buy?
- Which printer should I buy?

The answer to all three questions is the same: Buy the one that's best for your needs. I know that sounds like a lame answer, but the only way you can find the best product for your needs—whether you're shopping for a coat, a car, or a camera—is to do some educated shopping. I'll help with the education part, but the shopping is up to you. Being the nice guy that I am, I even give you some shopping tips in the next chapter.

FILM VERSUS DIGITAL

The number four question I hear all the time is, "Which is better: film or digital?" The answer depends on what you intend to do with your pictures.

If you need images in digital form—for a Web page or product catalog, for example—then a digital camera provides the shortest path to achieve that end.

As an alternative, you could shoot your pictures on film and scan the film on a film scanner (or have it scanned at a photo lab). This process produces the same kind of digital image file that you get from a digital camera, but has the disadvantages of being slower and more complicated. The quality of scanned images depends largely on the quality of the scanner used to convert the negatives or slides into digital form, but even inexpensive film scanners produce excellent results.

Scanners 101

There are two ways to get a digital image from a film picture. You can scan the original negative (or slide) on a film scanner, or you can scan a print on a flatbed scanner (see Figure 1.2).

Film scanners capture more detail and provide more accurate color than flatbed scanners, but you can get a great image from a flatbed scanner.

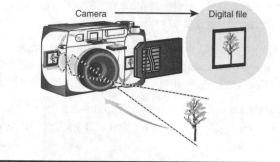

**The Digital Imaging Process
(Elapsed Time: Nearly Instantaneous)**

Camera → Digital file

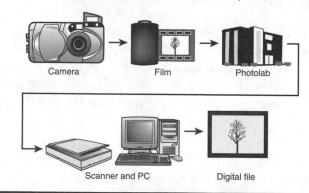

**The Film To Digital Process
(Elapsed Time: At Least 1 Hour)**

Camera → Film → Photolab → Scanner and PC → Digital file

Figure 1.2

You can get a digital image from a film camera, but it takes a lot more steps.

Quality issues aside, digital cameras save time and money. There's no film to buy, and you don't have to wait to get your film processed to see your pictures. Figures 1.3 and 1.4 show the same image taken with the Olympus 3040 and the Rollei Prego 90. The 35mm film from the Rollei was scanned on a Nikon CoolScan 4000 film scanner to produce a digital image file. The image from the Olympus digital camera appears sharper and less grainy than the film image, but the film image has more detail, especially in the shadow areas.

Figure 1.3

This picture was taken with an Olympus C-3040Z digital camera.

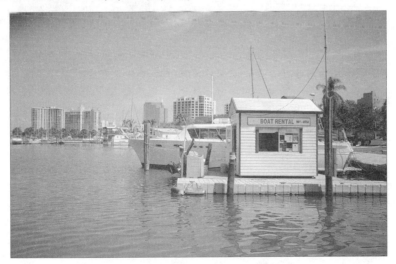

Figure 1.4

This picture was taken with a Rollei Prego 90 film camera and scanned on a high-quality film scanner.

The absence of film and processing time is an advantage to a digital camera, but if your objective is to produce a large number of small prints—family vacation photos, for example—35mm film is hard to beat. In most places, 4×6" prints from 35mm negatives cost around 30 cents.

You can produce very high quality prints from a digital camera on an inexpensive photo-quality printer in your own home, but they cost 40–50 cents each (see Figure 1.5). But even though digital prints are more expensive, you might actually save money because you can print only the good pictures and skip the bad ones.

A Little Printing Math

The 4×6" print is very popular, and accounts for over 90% of photos printed at retail photofinishers. But most computer printers are designed to handle standard 8 $\frac{1}{2}$ by 11" paper.

Many digital imaging programs—like the ones discussed in Chapter 18, "Imaging Software—What Can It Do?"—enable you to print 3 4×6" prints on a sheet of 8 $\frac{1}{2}$ by 11" paper.

Take-out Prints

The surge in popularity of digital photography has attracted the attention of the photofinishing industry. Very few people develop and print their own film at home, but the majority of digital camera owners print their own pictures on their PCs.

But printing at home is slow, tedious, and expensive. Standard 4×6" inkjet prints cost about 40–50 cents each, including paper and ink.

The major photofinishing equipment makers—including photo giants Fuji and Kodak—now make a variety of equipment that allows retail photofinishers to offer digital printing services.

At the retail level, many camera stores now offer walk-up, self-service "photo kiosks" where customers can print images from digital camera memory cards, CD-ROMs, or even a direct USB connection to a camera. Some kiosks even include a film or flatbed scanner so that customers can scan images from old pictures or negatives. These systems typically produce prints on a high-quality dye-sublimation printer that produces better results than most users would get at home with an inkjet printer, but they are expensive to use.

Behind the counter at the photo lab, many lab operators have installed equipment that enables them to make prints from digital images onto silver halide photographic paper. These systems—like FujiFilm's Frontier photofinishing system—enable lab operators to mix conventional film and digital printing jobs on the same production line. Silver halide prints are much less expensive to make than either inkjet or dye-sublimation, and they last longer, too.

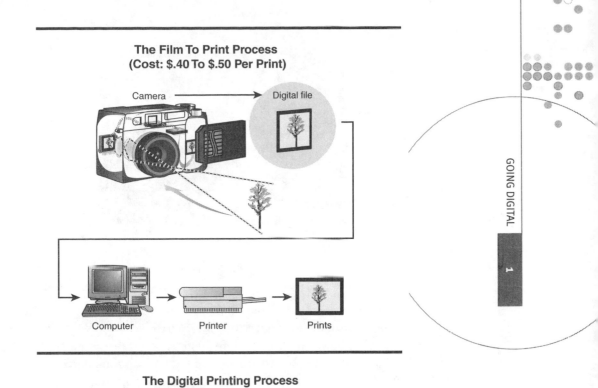

Figure 1.5

It's simpler (and cheaper) to get prints from film, but a digital camera and printer puts you in charge of your own pictures.

A QUICK TOUR OF A DIGITAL CAMERA

Before we launch into the nuts and bolts of cameras, I'd like to take you on a quick tour of a typical digital camera. If you already own a digital camera, you can skip to the next chapter—this information is provided for people who have never used a digital camera before.

I've chosen the Olympus 3040 for this tour because it is a popular camera with all the features you'd expect to find in a camera in this price class. The 3040 is also a well designed camera, with all the controls just where your fingers expect them to be. The use of different shapes and sizes for key controls makes them easy to locate, even in the dark or while you are looking through the optical viewfinder. Figure 1.6 shows the front of the camera.

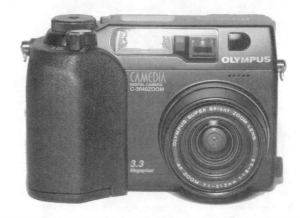

Figure 1.6

The Olympus Camedia 3040 is the top model in Olympus's popular 3000-series camera line.

Let's begin our tour at the top of the camera. Figure 1.6 shows the front view of the camera. The large knob at the top right is the power switch and mode dial. You use this dial to switch the camera between record (picture taking) and playback modes. The silver button in front of the mode dial is the shutter release button. The zoom in/out control is directly in front of the shutter release, so you can operate the zoom and the shutter release with the same finger.

The window on the front of the camera (next to the shutter release) is the flash. This flash is above and to the side of the lens, which helps reduce the "red eye" effect (a problem where people's eyes turn red instead of their normal color, making them look like extras from a cheap horror movie), common to point-and-shoot cameras. The smaller window to the right of the flash is a red light that blinks when the camera's remote control or self-timer functions are active. The clear window directly above the lens is the viewfinder, and the opaque window on the top right corner is an infrared receiver that receives signals from the camera's tiny remote control.

The 3040, like many cameras, can record short movies with sound in addition to still pictures. The five holes just below the infrared receiver are the camera's built-in microphone.

The large round metal and glass object is, of course, the lens. Now let's move around to the back, as shown in Figure 1.7.

The small window on the top of the camera next to the mode dial is an LCD display. The LCD shows several camera settings, and it also shows the number of pictures remaining on the camera's memory card.

The window on the top left side of the camera is the optical viewfinder. Like the viewfinder on P&S film cameras, the image in the viewfinder is an approximation of the final image. Optical viewfinders aren't 100% accurate, especially on cameras with zoom lenses, because the viewfinder doesn't actually look through the camera's lens. It's hard to see,

but there's a small knob on the left side of the camera called a viewfinder diopter adjustment. If you're an aging baby boomer like me, you can use this knob to fine-tune the viewfinder's focus to your eyes.

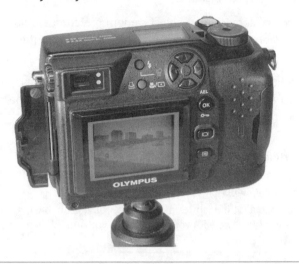

Figure 1.7

The use of different shapes and sizes for key controls makes them easy to locate, even when you're not looking directly at the camera.

The small open door on the left side of the camera hides connectors for external power, a USB connection to a PC, and a video-out connector. The last connector lets you connect the camera to any TV monitor with an external video input so you can view pictures on your TV.

The small screen on the back of the camera is the main LCD display. The display serves three functions. It is used to preview the image when you are taking a picture, to review images after you've taken a picture, and to change camera settings using a menu system built into the camera.

Don't Scratch That Screen!

The LCD screens on digital cameras are made of plastic and are very easy to scratch. They're also very expensive to replace if you do scratch one.

Most camera makers and several third-party camera case makers offer inexpensive custom-fitted cases that protect the camera—and the screen—when you're not using it.

The preview feature is very useful, especially for photos in which framing is critical. When you press the monitor button next to the screen, the actual camera image is shown on the screen. This enables you to see exactly what the camera lens sees, but it drains the batteries very quickly.

As you can see from the picture, you can use the screen to review the pictures you've already taken. You can use the round keypad above and to the right of the screen to move back and forth through your pictures.

The camera's menu system lets you adjust camera preferences and settings. You can navigate through the menu system using the round keypad and the OK button next to the screen.

A door on the right side of the camera provides access to the camera's memory card. A small red light just to the right of the door lets you know when the camera is reading or writing data to or from the card.

You Want Pictures with That Camera?

Digital cameras are pretty expensive. And many buyers discover that the memory card provided with their camera only holds a few pictures.

If you plan to take a lot of pictures at one time, you'll probably need to buy an additional memory card or two with your camera, so you should factor that additional cost into your buying decision.

Finally, there are several smaller buttons on the back of the camera. These are used to adjust the flash, to delete pictures, and put the camera in close-up (macro) mode.

SUMI'S SNAPSHOT

The more you know, the more questions you'll have about digital cameras. Here are a few you're probably asking yourself about now:

How much should I spend?

This is the toughest one to answer, but you need to spend at least $300 to get decent quality pictures. There are several cameras in the sub-$300 price range, but you'll be happier if you spend a little more money to get a higher-quality camera.

How long will my new camera last?

The good news is that the camera itself has very few moving parts to wear out, so it's likely to last a very long time. The bad news is that the digital camera market changes very quickly, so this year's hot model will be next year's old news. If you really get into digital photography, you'll probably get the itch for a new camera every 12–18 months.

How do I store my images?

For the short term, you can store your images on your computer's hard drive. But the digital image files created by your computer are like film negatives—after they're damaged or lost, you can't get them back. Besides, they take up a lot of room on your PC's hard drive. We recommend that you save copies of your images onto recordable CD-R disks. No one knows for sure what we'll be using for computers 10–20 years from now, though, so those CD disks might eventually become obsolete.

WHICH CAMERA TO BUY?

Before you buy a digital camera, you should do your homework and choose the camera that's right for you. Don't just walk into your local national electronics chain store and ask the sales person what to buy, because he or she doesn't know your needs as well as you do.

Digital cameras range in price from around $200 to over $5000. But paying more money for a fancy camera doesn't guarantee that you'll take better pictures. In fact, the more expensive cameras are more complex and take longer to learn to use; many users are better served with a less expensive, simpler camera.

During your quest for the perfect camera, you'll hear lots of technical terms like zoom ratio, CCD type, megapixel count, close focusing distance, and f/stops—much of the same jargon you'd hear when shopping for a film camera. The goal of this chapter is to make you a better, smarter shopper by explaining what those terms mean and why they're important.

Here's a preview of what's covered in this chapter:

- Camera anatomy: the differences between point-and-shoot and SLR cameras
- How to compare cameras
- Mini-reviews of seven popular digital cameras
- How to buy a camera, including shopping tips that save you money

P&S OR SLR?

The first decision you need to make is whether you want a point-and-shoot (P&S) camera or a single lens reflex (SLR) camera. You probably already know what a P&S camera is; it's a relatively small, very automatic camera that you can just point at the subject and shoot. P&S cameras are designed for low cost, simple operation, small size, and light weight. P&S cameras are very popular because they offer a combination of small size and good ease of use at an affordable price.

SLR cameras are larger, heavier, more expensive, and more flexible than P&S cameras. And when I say "more expensive," I mean way more expensive. Digital SLRs start at about $2000 and go up to $5000 and more. As you'll see later in this chapter, that price tag isn't as high as it might seem, especially if you shoot a lot of film and already have a good selection of SLR lenses.

Megapixel Math

Camera makers—and sales people—tend to categorize cameras by the number of picture elements (pixels) they produce. The pixel count has a direct bearing on the quality of the image. In most cases, more pixels means a better picture. Because the number of pixels produced by digital cameras is very large, the term *megapixel* is used as a unit of measurement. One megapixel = 1024 × 1024, or 1,048,576, pixels. Pixels (and how to count them) are explained in detail in Chapter 3, "How Many Pixels Are Enough?"

There's a third class of cameras that aren't exactly SLRs but are too large to call point-and-shoots. These cameras have large zoom lenses, but they don't have through-the-lens viewing like an SLR. Each manufacturer has a different name for this class of camera, but I call them Virtual SLRs because they use a small camcorder-style LCD display instead of an optical or through-the-lens (TTL) viewfinder.

The LCD display allows the viewfinder to display exactly what the camera lens sees. The image in the viewfinder is provided by a tiny color LCD screen that appears much larger than it is, thanks to a magnifier in the viewfinder. These cameras work and feel very much like an SLR, but they're smaller and lighter.

Point-and-Shoot Cameras

The vast majority of film cameras sold today are P&S cameras, as are most consumer digital cameras. Their enormous popularity comes from a carefully blended combination of simplicity, functionality, and even style. P&S cameras are designed to provide the best possible picture quality in a package small enough to carry easily. SLRs might have more features and better picture quality, but those are of little use if the camera is too large or heavy to carry with you.

Because they are designed for the majority of the picture-taking public, P&S cameras must be easy to use. All P&S cameras offer fully automatic operation, so all the user needs to do

is literally point the camera at the subject and shoot the picture. A few P&S cameras allow manual override of some camera settings, and more knowledgeable users can use these settings to take pictures in tricky situations that might fool the camera's automatic operation.

P&S cameras have permanently attached lenses and an optical viewfinder that provides an approximation of the image seen by the lens. The image in the viewfinder isn't exactly the same as the image captured by the lens. This is due to the fact that the viewfinder and the lens each have a slightly different point of view. As you can see from Figure 1.1 in Chapter 1, "Going Digital," the viewfinder is slightly above and to the side of the camera lens. Most P&S viewfinders are designed so that they are most accurate when the subject is 10 or more feet away from the camera, but this poses a problem when shooting close-up pictures.

Another common problem with P&S cameras is that there's no indication in the viewfinder to show you where the camera is focused. This isn't a problem in most cases, but the simple autofocus mechanisms in P&S cameras are often fooled by tricky focus situations where the main subject is off-center in the picture.

Fortunately, virtually all digital P&S cameras enable you to view the image on the camera's LCD screen before you take a picture. This is very handy when framing up and checking focus on group photos and other shots where framing is critical, and it is absolutely essential when taking close-up pictures. Unfortunately, the LCD screen is the most power-hungry part of any camera, and using the screen decreases battery life.

The biggest shortcoming of most P&S cameras is the lens. Because they are designed to be as compact as possible, P&S lens designers must make compromises both in image quality and in lens speed. Although P&S cameras are great for most uses, they aren't very good for shooting subjects that are far away such as birds and wildlife, sporting events, or subjects in low light (like the participants in concerts and weddings).

A Little Thread Makes a Big Difference

Some P&S cameras have screw threads on the front of the lens. The screw threads let you add accessory lenses and filters. Accessory telephoto lenses increase the range of your camera's zoom lens, and wide-angle adapters make it easier to shoot room interiors, group photos, and scenery. Lenses are discussed in detail in Chapter 5, "All About Lenses."

SLR Cameras

Serious photographers—amateur and professional alike—typically prefer SLR cameras. SLR cameras are more complex cameras that provide through-the-lens viewing. They usually feature interchangeable lenses that enable you to choose from a broad array of lenses for special shooting situations. SLRs are larger, heavier, and more expensive than P&S cameras, but they are also much more flexible and—in the proper hands—can produce superior pictures.

The image in an SLR viewfinder is nearly identical to the one that the camera records. Because the image in the viewfinder is seen through the lens, the user can see what is in focus and what isn't. This is useful for manual focusing and for verifying the camera's autofocus operation.

Many photographers prefer to use manual focus for certain situations. Sports photographers, for example, often focus on a particular point—near the goal on basketball court or home plate on a baseball field, for example—so that the camera is ready to shoot when the players reach that point. This enables the photographer to take a picture the instant the players reach the basket or the plate, without having to wait for the camera to autofocus. Manual focus is also useful for scenic, portrait, and close-up photography where the photographer wants to focus on a particular feature, like a distant mountain, the subject's eyes, or the petals of a flower. Most SLRs include a depth of field preview feature, which enables the photographer to determine which objects are in sharp focus for a given exposure setting.

To provide TTL viewing, SLRs use a complex optical path that includes a five-sided glass prism called a pentaprism, a ground-glass viewing screen, a moving mirror, and an eyepiece. The mirror sits in front of the film (or image sensor) and deflects the image from the lens up into the pentaprism, where the image is optically turned and projected onto the viewing screen so that it appears right side up in the eyepiece.

When the user presses the shutter release, the mirror flips up out of the way (momentarily blacking out the viewfinder), the shutter opens, and the image from the lens is projected onto the film in an analog camera, or the sensor array in a digital camera. After the exposure, the shutter closes and the mirror drops back into place. This process takes place in a fraction of a second, and some cameras can repeat the process up to 10 times a second. Obviously, the prism, moving mirror, and viewing screen make SLRs much larger and heavier than P&S cameras.

Digital SLRs

Digital SLR cameras look and work very much like their 35mm counterparts. In fact, the first digital SLRs were built on converted 35mm camera bodies. Like 35mm SLRs, digital SLRs are usually sold without a lens, so you need to add the cost of at least one lens to the price tag. And because one of the major features of SLRs is being able to change the lens, you probably want to buy at least two lenses.

And now the good news: All of the digital SLRs on the market use the same lenses as their 35mm counterparts. (Fuji doesn't make 35mm SLRs, but the Fuji S1 is built on a Nikon film camera body and uses Nikon lenses.) If you're already into 35mm photography and have a good selection of lenses, the price tag of a digital SLR body might not scare you, especially because you can leverage your existing lens investment against it.

35mm Lenses on a Digital SLR

The image sensors in digital SLRs are only 2/3 the size of a 35mm film frame, which actually measures 24×36mm. When you use a lens designed for 35mm cameras on a digital SLR, the effective focal length of any lens is multiplied by a factor of 1.5 or so. This can be a blessing or a curse, depending on what you shoot.

The 1.5X multiplier makes you re-think every lens in your camera bag, and might force you to purchase at least one additional lens. Telephoto lenses become 50% longer with no gain in weight or loss of light transmission. If you shoot sports or wildlife, this is good news. At the other end of the scale, a 20mm ultrawide lens becomes a more sedate 30mm lens on a digital SLR. You'd need a 13mm lens to get that same ultrawide coverage on a digital SLR, but no one makes such a lens. A few companies make 14mm lenses (22mm equivalent), but they are very expensive.

28–105mm zoom lenses are very popular on 35mm SLRs because they provide everything from a moderate wide angle to a short telephoto in one compact, inexpensive package. On a digital SLR, that lens becomes an effective 42 to 157mm—not very wide on the wide end, and longer than most people need for everyday shooting on the long end.

Camera and lens manufacturers have responded by introducing new lenses that are more appropriate for use on digital SLRs. When Nikon announced the D1 in 1999, they introduced a 17–35mm lens at the same time. Canon, Sigma, and several other third-party lens makers now offer similar lenses.

There is one other, less obvious benefit from the multiplier factor. Virtually all lenses—especially inexpensive lenses—have better optical performance at the center of the image than they do at the corners. Digital SLRs use only the center 2/3 of the image—the part with the best sharpness and contrast, and the least optical distortion.

Going Digital and Saving Money, Too

Many professional photographers have already switched at least some of their work to digital SLRs, due to the time and cost savings. If you're an advanced amateur photographer and you shoot more than a few rolls of film a week, you might also find that a digital SLR can pay for itself in a year or two.

Full Frame Sensors

Although the current generation of digital SLRs use an image sensor smaller than a 35mm film frame, future cameras will probably use larger image sensors with higher pixel counts. Several manufacturers have already given sneak previews of their next-generation cameras, which use a full-sized (24×36mm) image sensor—the same size as a 35mm film frame.

Want to check my math (and see how I justified the cost of a digital SLR to my wife)? I do nature photography, mostly birds and wild animals. As you might expect, I'm lucky to get 1 or 2 good shots out of a roll of film. Like most nature photographers, I shoot Fuji and Kodak's top-of-the-line slide film, which costs about $7.50 a roll for 36 exposures. My local lab charges $6 per roll for processing. In other words, it costs me 37.5 cents every time I press the shutter release on my film camera.

A typical digital SLR costs $2500. That's only 185 rolls of processed slide film. Since I switched to shooting mostly digital, I don't have to deal with storing hundreds of boxes of processed slides. Instead, I save my good digital shots onto a CD-R disk and simply delete the bad ones.

POINTS OF COMPARISON

With so many models to choose from, buying a camera can be more complicated than buying a car. Here are the main things to look for when comparing cameras:

- **Size and weight**—This might seem obvious, but a bigger camera isn't necessarily a better camera. Consider how you plan to use the camera, and make sure you don't buy one that's too big or too heavy to carry with you.

- **Resolution**—The more pixels a camera produces, the better the pictures will be. A 3.3-megapixel camera produces a sharper, clearer picture than a 1.3-megapixel camera. If you'll be printing your images, you want as many pixels as you can get. If you're buying a camera primarily for Web or e-mail use, a 1-megapixel camera is all you need.

- **Focal length**—The length of the camera's lens determines how the lens sees the world. Shorter focal lengths provide a wider angle of view than longer ones. In the 35mm world, a 50mm lens is considered the "normal" angle of view; it's about a 1:1 representation of what the eye sees. Smaller film (and digital) formats require smaller lenses. Because the image sensors in most digital cameras are smaller than a 35mm film frame, camera makers usually specify focal lengths in their 35mm equivalents, not in the actual focal length.

- **Zoom range**—This term (sometimes called *optical zoom range*) defines the range of coverage of a zoom lens. A 2X lens is twice as long at the long end as it is on the short end of its range. The longer range makes distant objects appear closer. Most P&S cameras have 2X or 3X lenses. Beware of a feature called *digital zoom*, which electronically magnifies the captured image to give the effect of a larger lens. Digital zoom significantly reduces image quality and is a gimmick feature that manufacturers include because it's cheap to implement and sounds high-tech.

- **Lens aperture**—Also called f-stop, this number rates the lens' ability to pass light. A lens with a higher f-stop rating passes less light than one with a low number, so the lower the number, the better. A lens with a low number is said to be faster than one with a high number; this is because lower f-stops allow you to use higher shutter speeds. See Chapter 5 for more detailed information.

- **Flash mode and range**—Manufacturers often fudge the numbers when rating the flash range of their cameras. Most cameras provide decent flash coverage out to about 8 to 10 feet; after that, they fall off fast. If you take a lot of group pictures, you want to make sure that the flash can cover everyone, including the people at the edge of the picture. The best way to test this is to take a few test pictures in the camera store. Many cameras include a feature called daylight fill flash. This is an important feature to have, and I'd recommend against buying any camera that doesn't have it.

- **External flash connector**—If you take a lot of flash pictures, you might want to add an external flash unit at some point. Many cameras do not include a connector for an external flash, so check before you buy. External flash units are more powerful than built-in flashes. They give you more control over lighting and they reduce the drain on your camera's batteries.

- **Viewfinder**—The viewfinders on P&S cameras range from excellent to awful. The only way to tell one from the other is to look through the viewfinder with your own eyes. Better cameras have an adjustable diopter setting, which lets you adjust the focus in the viewfinder to suit your eyes. This is especially important if you wear glasses or contact lenses.

- **LCD display**—The LCD display is very important, so make sure you get one that you can see in all kinds of lighting. None of them are visible in full daylight, but the screen should appear very bright and full of contrast under indoor lighting conditions. Some screens include an anti-reflective coating that makes them easier to see in bright light. If the surface of the screen appears dull, then it has this coating; if it's shiny, it doesn't.

 The size and quality of LCD displays vary widely from tiny 1.5-inch screens with 110,000 pixels up to 2-inch screens with 200,000 pixels. Larger screens are easier to see, and the higher the screen's pixel count, the sharper the image displayed on the screen.

 A few cameras include a tilt/swivel feature that lets you move the screen independently of the camera body. This is very useful for over-the-head or low-angle shots, because it lets you see what you're shooting even when you can't see the optical viewfinder.

- **Battery type**—Digital cameras eat batteries, especially if you use the LCD screen often. Inexpensive cameras (and even some expensive ones!) come with a set of AA alkaline batteries that last only an hour or so. If the camera you're considering uses AA batteries, buy at least two sets of batteries and a charger, and factor that cost into your buying decision. Increasingly, manufacturers are moving towards Lithium Ion rechargeable batteries, which provide better service life and lower weight. These batteries and a charger are included with the camera, although you'll likely want to buy a spare battery.

- **Included memory**—Most camera manufacturers include a memory card with the camera. Check to see how many pictures the provided memory card holds at the camera's highest resolution setting. Chances are good that you'll need to buy an additional memory card or two to meet your needs.

- **Connection**—Virtually all cameras come with a USB cable to connect the camera to your computer. Avoid cameras with older, slower serial connections. A few high-end cameras use a Firewire (also called IEEE 1934 or iLink) connection. Firewire is much faster than USB, but you need a Firewire port on your PC to use it. If you don't have one, you need to purchase a Firewire card (about $80) for your computer.

- **Driver software**—Most camera makers provide a USB storage class driver with their cameras. This driver makes the memory card in the camera appear to the computer as an additional disk drive, which makes it easy to copy files from the camera to the PC.

- **Video output**—Some cameras provide a video output option that lets you view pictures on any TV with a video input. This is a great feature, because it lets you see your pictures on something larger than the camera's tiny LCD screen. If you travel overseas, make sure the camera supports both the NTSC (North America) and PAL/SECAM (Europe/Mideast) video standards.

A QUICK TOUR OF THREE P&S CAMERAS

Hundreds of different models of digital P&S cameras are available on the market, and I can't possibly list them all here. Fortunately, those hundreds of cameras fall into three broad categories: entry level, compact, and high end. The following sections cover one representative from each class of camera and give you a quick review so you can get an idea what to expect from each. We've also included the "street price"—the price you can actually expect to pay, which is usually much lower than the manufacturer's list price.

Entry Level: Olympus Brio D-100 ($300 Street Price)

This little camera is nearly small enough to be classified as a compact, but its low price, lack of a zoom lens, and 1.3-megapixel image sensor place it firmly in the entry level end category (see Figure 2.1). The Brio's non-zoom lens covers an area equivalent to a 35mm wide-angle lens on a 35mm film camera. This is a good compromise focal length, because it is wide enough for group photos and scenic shots. It's not long enough for portraits, however; if you move close enough to fill the frame for a typical head-and-shoulders portrait, the wide angle lens distorts facial features in a fairly unflattering way and the flash is so close that it overpowers the subject.

Within its limits, the Brio's lens is sharp and full of contrast. One of my favorite features of Olympus's 35mm P&S cameras is their innovative lens cover that provides excellent protection for the camera but is quick to open and can't get lost. The Brio's cover works the same way and doubles as the power on/off switch for the camera.

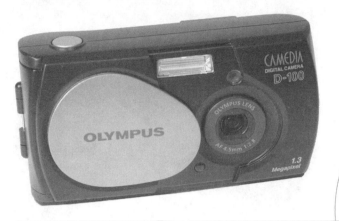

Figure 2.1

The Brio D-100 is small, light, and easy to use. At $300, it's a great starter camera.

The Brio starts up quickly and is ready to take a picture as soon as you slide open the lens cover. The built-in flash is very good and covers large rooms better than some $1000 cameras I've tested. The rear-mounted LCD screen is sharp and clear, but is difficult to see in bright light—a common problem with all LCD screens. The Brio uses two AA-sized batteries, but the camera doesn't include rechargeable batteries or a charger, which cost an additional $40 or so.

This is a nice, compact camera that is great for casual family photos and vacation pictures, but some users won't like the Brio's OK-but-not-great picture quality and lack of a zoom lens. If you want to get started in digital photography without spending a lot of money, this is a good place to start; if you move up to a higher-end camera, you can keep this as a second camera or give it to your kids.

High End: Nikon 990/995 ($800–$900 Street Price)

Nikon's 900 series cameras keep getting better and better. The original 900 and 950 models had some design quirks that made them hard to use, but the newer model 990 and 995 are much improved.

The 900 cameras employ a unique split-body design. The lens, flash, and viewfinder are on the left side of the camera, while the battery compartment, LCD display, and controls are on the right. The controls are grouped around a comfortable rubber grip that makes the camera easy to hold and operate, even with one hand (see Figure 2.2).

The two halves of the camera are joined by a sturdy swivel mechanism that allows the lens unit to rotate 270 degrees. This design lets you hold the camera above your head or low to the ground while keeping the LCD screen visible. You can even turn the lens around to face the rear of the camera for self-portraits. It sounds weird but works very well. This swivel mechanism is also great for tripod-less self-timer shots, as the lens can be adjusted (if you have a steady spot to place the camera) to provide some of the functionality of a tripod.

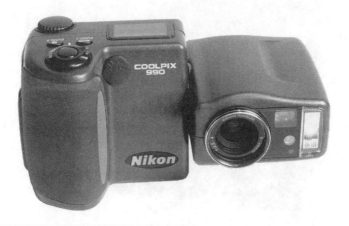

Figure 2.2

Nikon's CoolPix 990 features a unique swiveling lens that makes low-angle and over-the-head shots easy.

Picture quality is excellent, thanks to a very good 3X zoom lens and a 3.34-megapixel image sensor. The older model 990 uses AA batteries, but the newer model 995 includes a Lithium Ion battery and charger as standard equipment.

Pocket Compact: Canon Digital Elph S-300 ($550 Street Price)

If cool counts, then this is your camera. Canon's Elph film camera was one of the first cameras on the market to use the Advanced Photo System (APS) film format. Although APS has been slow to take off in the US, the Elph has found a devoted cult following thanks to its small size, cool stainless steel finish, and great picture quality.

The Digital Elph S-300 offers the same features as the APS Elph: small size, very good picture quality, and a fit and finish that feels like it was cut from a solid block of steel (see Figure 2.3).

Figure 2.3

Canon brings its Elph product line into the digital world with the S-300, a tiny 2.1 megapixel camera with a 3X zoom lens.

Despite the small size, the S-300 has an excellent lens and a powerful flash. It comes with a LiOn battery pack and a clever, lightweight battery charger. My only gripe about the Elph is that for $550, you don't get a protective carrying case, and the stainless steel finish is easy to scratch.

Bargain Shopping

The digital camera market is very competitive, and manufacturers are continually adding new models and upgrading old ones. If you don't have to have the latest and greatest model, you can often save a hundred dollars or so by buying a model that's about to be discontinued. Watch for price cuts in popular models—it's a sure sign that the model is about to replaced with a new one. Unfortunately, cutting the price on an already-popular model usually drives demand through the roof (you do remember supply and demand from your high school economics course, right?), so these models often sell out quickly.

A QUICK TOUR OF TWO SLR CAMERAS

Currently, there are about a half-dozen digital SLR models on the market, but only a few (Canon's EOS D30, Fuji's Finepix S1, and Olympus's Camedia E10) are designed for and marketed to amateur photographers. The Canon and Fuji cameras primarily appeal to advanced amateur and professional photographers who already have a set of lenses. Canon's D30 works with any EOS system lenses, and Fuji's FinePix S1 works with most Nikon lenses. If you don't have any lenses but want an SLR camera, The Olympus E10 might be what you need.

Fuji FinePix S1 Pro ($2500 Street Price)

Unlike their counterparts at Nikon and Canon, Fuji's engineers didn't have an existing 35mm camera to use as a starting point for their digital SLR. Instead of starting from scratch, Fuji started with a Nikon N60 35mm SLR camera. Fuji buys N60 cameras from Nikon, removes the film transport and other unnecessary parts, and adds Fuji's own digital camera electronics. The resulting Fuji S1 is a startlingly good digital camera, despite a few design quirks that result from marrying Fuji's digital innards to Nikon's camera (see Figure 2.4).

When The S1 first came out, Fuji advertised it as being a 6-megapixel camera, even though the image sensor has only 3.5 million pixels. Fuji's pixels are arranged differently than conventional CCD sensors, and the S1's internal software can create a 2, 3, or 6-megapixel file using the data collected from the image sensor. After using this camera for about six months, I can say that the truth lies somewhere in the middle. In the 6-megapixel mode, the S1 produces pictures that have more detail than 3-megapixel cameras, but they're not as good as pictures from a true 6-megapixel camera.

I love this camera, but I wish that Fuji's engineers had started with a higher-performance Nikon body. The S1's autofocus system isn't nearly as good as later model Nikon bodies, and the N60/S1 doesn't work with Nikon's latest line of professional lenses.

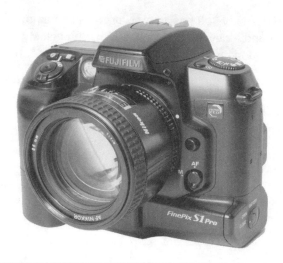

Figure 2.4

Fuji's FinePix S1 Pro is built on a modified Nikon N60 film camera, so the S1 works with most Nikon lenses.

On the other hand, starting with a higher-end body would have increased the cost significantly, and the S1's autofocus is good enough for most studio and non-sports work. The S1's picture quality is stunning, with very accurate color and outstanding detail. The S1's 2-inch, 200,000 pixel LCD display is one of the best I've seen on any camera.

If you're a Nikon user looking to move to digital, the S1 is an excellent choice. Fuji includes an AC adapter and a 1Gb IBM Microdrive in the box; all you need to add is your favorite Nikon lenses and a set of AA batteries.

Olympus Camedia E10 ($1700 Street Price)

The E10 is a unique design that borrows some design and engineering cues from Olympus's all-in-one 35mm SLR cameras. The E10 is a true SLR, but it does not have interchangeable lenses like most SLR cameras. The E10's lens provides 4X zoom, equivalent to a 35–140mm lens on a 35mm camera. Because the lens is permanently attached to the camera, dust can't get inside and settle on the image sensor.

Another interesting E10 feature is that the mirror doesn't move, making the E10 quieter than conventional SLR cameras. The E10's mirror is semi-transparent, and a small portion of the light from the lens is diverted to the viewfinder. One big plus of this design is that it allows conventional SLR through-the-lens viewing, as well as live image preview on the camera's swiveling 1.8-inch LCD display—something that other digital SLRs can't do (see Figure 2.5).

Although it looks a bit odd, the E10 handles just like a conventional 35mm camera. The controls are well thought out and easy to locate, and the swiveling LCD screen is bright and clear. Image quality is excellent, thanks to an Olympus-designed 4-megapixel image

sensor. Like the Fuji S1, the E10 has slots for both SmartMedia and Compact Flash memory cards. The E10 is powered by four AA batteries, but Olympus doesn't include rechargeable batteries or a charger with the camera.

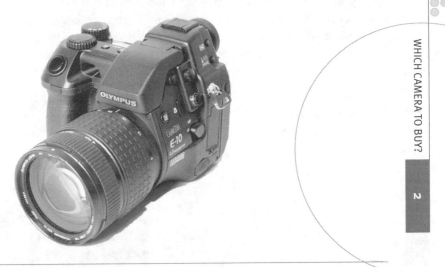

Figure 2.5

The E10 is a unique camera that uses a semi-transparent mirror that eliminates much of the noise of conventional SLR cameras. The 4X zoom is permanently attached, which keeps dust out of the camera.

VIRTUAL SLRS

If you need a camera with a long lens but don't want to spend the big bucks for a digital SLR and an expensive telephoto lens, a virtual SLR might be just what you need. The two cameras in this section feature 10X zoom lenses that are just the ticket for closing in on birds, wildlife, and sporting events.

As I mentioned earlier, it's very difficult to design an optical viewfinder that accurately tracks a zoom lens. Virtual SLRs get around that problem by dispensing with the optical viewfinder in favor of a tiny color LCD screen inside the viewfinder. When you look in the viewfinder, you see a live preview of the camera image, very much like shooting with a video camcorder. An added advantage of this approach is that you can tell if your picture is too light, too dark, or out of focus before you press the shutter release.

These two cameras—the Canon Pro90 IS and the Olympus C700Z—have a number of features in common. Both sport large 10X zoom lenses that are roughly equivalent to a 37–370mm lens on a 35mm camera. Let me put that into perspective: Canon's 35–350mm lens for their 35mm SLR cameras costs $1700 and weighs over three pounds. These cameras cost less than that lens alone, and weigh one-third as much.

Canon PRO90 IS ($1100 Street Price)

The *IS* in this camera's name stands for *Image Stabilization*, a Canon-patented technology that virtually eliminates the blur caused by camera movement. The end result of IS technology is that it lets you take telephoto pictures without a tripod. Before IS technology, photographers used a rule of thumb to decide when to use a tripod. If the shutter speed was less than the lens' focal length, then you needed a tripod or your pictures would be blurry because you can't hold the camera steady enough without some sort of support.

With IS technology, you can take sharp pictures at speeds about 10 times slower. This means that you can take the PRO90IS to the zoo, get those great shots of that hippo that's always on the far side of the pond, and come home with sharp, clear pictures (see Figure 2.6).

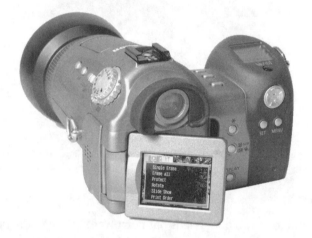

Figure 2.6

Canon's PRO90IS combines a 10X zoom lens with Canon's patented Image Stabilization technology.

Apart from the lens and IS technology, the PRO90IS looks and works much like Canon's G1 P&S camera. Although the PRO90IS uses a 3-megapixel image sensor, the lens (apparently borrowed from a Canon Camcorder) isn't quite large enough to cover the entire image sensor. As a result, the PRO90IS produces images with 2.7 million pixels. The PRO90IS is simple to operate and has an excellent built-in flash. If you need more power than the built-in flash provides, a hot shoe mount on top of the camera accepts any Canon flash unit.

Canon ships the PRO90IS with one LiOn battery and a fast charger. The battery is the same one used by many Canon camcorders and by the D30 digital SLR, so it's widely available.

Virtually Popular

Virtual SLRs are coming on strong. Manufacturers like them because they provide users with SLR convenience without the complicated and expensive mirror and prism used in conventional SLRs. Consumers like them because they're small and light, and they look and work like something they already know how to use—a camcorder.

Olympus C-700Z ($700 Street Price)

Like Canon's Pro90IS, the Olympus C-700 features a 10X zoom lens in a package only slightly larger than a standard P&S with a 3X zoom (see Figure 2.7). Although the C-700 is considerably smaller and lighter than the Canon PRO90IS, the C-700 doesn't have image stabilization. This means that you might need to use a tripod to get sharp pictures at the longer focal lengths.

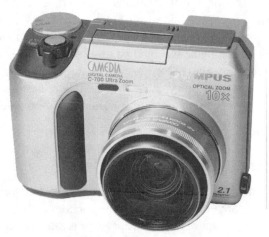

Figure 2.7

The Olympus C-700Z packs a 10X zoom lens into a camera that's not much bigger than a standard P&S camera.

The C-700Z uses a 2.1-megapixel image sensor. Like all Olympus cameras, it handles very well, and the big zoom lens produces very good pictures. The control layout is similar to Olympus's excellent 3040 (featured in Chapter 1), and the pop-up flash unit works very well.

The C-700Z runs on 4 AA batteries, and you need to buy your own rechargeable batteries and charger. If you want a big zoom at a low price, the C-700Z is a good choice—if you can live with the less-than-state-of-the-art 2.1 megapixel resolution.

HOW TO BUY A CAMERA

So far, I've talked incessantly about the cameras and their capabilities, but sooner or later you'll actually want to plunk down your cash and buy a camera. There are basically four ways to buy a camera: from your local camera store (most likely part of a national chain), from a big electronics retailer (the same ones that sell everything from PCs to dishwashers), from a mail-order specialist, or on the Web.

I'll start by stating that you can have a pleasant buying experience at any of these outlets. You can also enter a living, burning hell where you and your money are eternally parted. The difference between heaven and hell is in being a smart shopper.

Your Local Camera Store

There was a time, long ago, when every major town and big city had one or more professional camera stores. These stores stocked everything from low-end P&S cameras up to multi-thousand dollar pro cameras. The service was usually great, especially if you were a regular customer.

Competitive pressure and the arrival of national chain stores put many of these stores out of business, but a few survive. Their prices aren't always the best, but the sales people are very knowledgeable (but often opinionated) and willing to spend time to make a sale (because most of them work on commission). If you have such a store in your town, I'd recommend that you start your shopping there. Don't expect the pro store to meet a price you saw in last Sunday's Best Buy ad, because they can't. They don't buy in the volume that the national electronics chains do, but they shouldn't be too much higher than the chain stores, either.

My personal experience has been that it pays to establish a relationship with your local camera store. Local camera stores usually have liberal return policies, so you can bring something back after a few days if you decide that you really don't like what you bought.

Many of the mom and pop local camera stores have been acquired by one of the national camera store chains. Many—but not all—of these stores still offer a high level of service but with prices that are competitive with discount stores. Most of the national chain stores (Wolf Camera and Ritz Camera, to name two) also operate online stores. This works in your favor because Wolf and Ritz can't charge different prices at their online and brick-and-mortar stores. If they hope to be successful on the Web, their prices have to be competitive. This usually translates to lower prices in their retail stores.

Where's the Gray Market?

Spend any time shopping for a camera, and you're bound to hear the term *gray market*. Although the name conjures up images of unmarked crates being unloaded from a tramp steamer under cover of darkness, it's not quite that bad.

Gray market goods are merchandise imported into the United States by someone other than the manufacturer or its designated importer. Large camera stores often dispatch a buyer to Tokyo or Hong Kong, looking for bargains on large lots of a particular item. The camera store acts as its own importer, arranging for shipment to the United States and payment of all U.S. import duties. The store can offer these products at a lower price than normally imported merchandise.

Gray market goods are usually identical to regular merchandise, with one major and important exception: the warranty. Most U.S. camera distributors are wholly-owned subsidiaries of their overseas manufacturers. The U.S. distributor has exclusive rights to import, sell, and service that manufacturer's products in the United States. Gray market goods are usually not covered by the U.S. importer's warranty. If a gray market item fails during the warranty period, you might have to send it overseas to get it repaired.

Some camera importers take a very hard line on gray market goods. U.S. service facilities often refuse to repair any gray market merchandise, even if the owner is willing to pay for the repairs. Reputable dealers always identify gray market merchandise as such, giving buyers a way to save a few dollars if they're willing to forego the U.S. warranty. Disreputable dealers sell gray market goods without alerting the buyer.

National Electronics Chains

I live in a very small town, but it's big enough to have three national electronics chain stores. These stores offer excellent prices but often have very limited selection and high employee turnover. If you can find a knowledgeable salesperson or if you walk in the door knowing exactly what you want, these stores are great places to shop.

On the other hand, I've heard salespeople in both stores give bad buying advice about the products they're selling. They're not out to get you; they simply aren't intimately familiar with the products. There's usually one person in each department who is a product wizard that knows all and tells all. Your job is to find that person when you go into the store.

Mail Order and the Web

Up until a few years ago, I would never recommend that anyone buy any photographic equipment via mail order. Today, I cautiously recommend a few mail order stores to knowledgeable buyers—but most of those knowledgeable buyers already know which stores are okay and which to avoid.

If you want to learn who's hot and who's not in Web and mail order retailing, I recommend that you stop by www.photo.net, and check the ongoing discussion of Web and mail-order retailers.

Many Web camera retailers are operated by large mail-order camera stores. These outlets often have the lowest possible prices, and you can save a ton of money if you know what you're buying. At the very least, buying online or through mail order might save you from paying your local sales tax. But remember that part of that savings in sales tax is eaten up by shipping costs that you don't have to pay when you buy in person.

Most mail order and Web merchants are honest and up-front, but you should know about the potential pitfalls:

- **Add-ons**—You see a camera advertised at a great price. When you call to inquire, you're told that the camera is out of stock. But wait, some are available as part of a package for $200 more. The package contains a tripod, a camera bag, an external flash, and a lens cleaning kit. When you get the camera, you discover that the tripod, bag, and flash are all very low-quality items, worth maybe $40, tops. The cleaning kit is a $.75 package of lens tissue.

 In another variation on this theme, some stores remove items that are normally included with the camera (batteries, charger, flash memory) and then quote the price for the camera alone. If you want the other items (which are rightfully supposed to come with the camera in the first place), you have to pay extra.

- **Bait and switch**—The merchant advertises a product at a great price, but they don't actually have any in stock. When you inquire about the advertised item, the salesperson steers you to a different, usually higher-priced, item.

- **Substituted merchandise**—This is one of the most common complaints I hear about mail order. Let's say you order a Canon EOS camera with a 28–105mm lens. When you receive the camera and lens, you discover that the camera is okay, but the lens isn't a Canon lens and is a third-party brand that costs half as much—a difference of $200 in this case. Mail-order ads usually skirt this fine line by advertising something like "28–105mm lens for Canon EOS." What you wanted was a "Canon 28–105mm lens for EOS." Moving the word "Canon" makes all the difference.

- **Gray market**—Many mail-order companies sell gray-market merchandise (see the previous Caution sidebar) without letting the customer know. They use terms like "USA Warranty" to lead you to believe that the camera is covered by the manufacturer's U.S. warranty. What they really mean is that the camera store—and not the manufacturer—provides the warranty. If your camera breaks during the warranty period, you must return it to the store, where it will be repaired (or not!) by the store's repair technicians, not the factory trained technicians at the manufacturer's repair facility.

- **Outrageous shipping charges**—I've seen mail-order stores that charge a minimum of $20 and often more for shipping a 2 pound package from New York to Miami. And that's for UPS Ground service.

- **Used/Returned goods**—Mail-order firms are regulated by federal law and postal regulations, so they must accept returns for up to 30 days after the sale for any reason. This can work for or against you. If you aren't satisfied with your purchase, you can return it for a full refund, but some mail-order stores are notoriously slow at issuing refunds. The bad news: Returned merchandise is often repackaged and sold as new, even though someone else might have had the merchandise for 30 days.

The bottom line boils down to a few simple rules:

- **Know what you're buying**—You should know what the manufacturer packs in the box with the particular camera you're buying. Check the manufacturer's Web site if you're in doubt.

- **Know the prices**—A few phone calls or a few minutes of searching the Web should turn up a range of prices for the item you want. If a particular retailer's price is way too high, cross them off the list.

- **Know your dealer**—Check with the Better Business Bureau or other consumer protection.

- **Any deal that sounds too good to be true, is**—If you see a camera advertised for an incredibly low price, there's probably a reason.

Shopping in New York City

I live in Florida, but I spend a lot of time in New York City, along with millions of tourists from all over the world. When you walk down any main drag in New York, you pass dozens of small electronic and camera stores that sell everything from film to SLR systems.

I don't doubt that some of these stores are run by fine, upstanding merchants who are out to make an honest living—but I haven't found one yet. These stores often sell obsolete, out-dated, or gray market merchandise at inflated prices. The situation has gotten so bad that the New York City Department of Consumer Affairs has established a special Electronics Enforcement Squad to deal with the problem.

According to New York's Commissioner of Consumer Affairs, "Year after year we receive more complaints about electronics stores than almost any other category. That does not include the number of people we suspect never have the chance to complain because they have already returned to their home state or country before they realize they were ripped off." For more information on shopping in New York City, see the Department of Consumer Affairs Web site at `www.ci.nyc.ny.us/html/dca/html/elecstores.html`.

If you're in New York and want to shop for camera stuff, do what the city's professional photographers do: Hop in a cab and have the driver take you to B&H Photo on 9th Avenue and 33rd Street, just a couple of blocks west of Macy's. Like Macy's, B&H is an enormous, one-of-a-kind store. It's one of the largest, best-stocked, and most reputable dealers in the country. B&H is closed Friday afternoon and Saturday, but it's open on Sunday. Eat before you go; you'll be there a while.

SUMI'S SNAPSHOT

Hopefully, this chapter has helped you sort out which class of camera you prefer. You're now armed with enough information to go out and do some preliminary shopping. Here are a few more questions you're likely to have at this point:

How can I tell if the camera I'm looking at is the latest model?

The best way we know is to check the manufacturer's Web site. All of the digital camera makers provide detailed product info on their sites, although they generally don't offer any pricing information. See the list of camera manufacturers in Chapter 23, "Digital Imaging Resources on the Web," for more info.

How do I know what is a fair price for a particular model?

Shop around. Get prices from several retailers on the same model. Prices vary from one retailer to another, but the camera business is very competitive, so there shouldn't be a huge difference from one retailer to another. If one merchant offers a spectacular price on a particular product, make sure they're offering a new-in-the-box item and not a returned or refurbished product. I usually tell people to use the Web to comparison shop, even if you don't plan on buying online. Going to several brick and mortar stores is time consuming, but looking up prices on several different Web sites can be done quickly. Prices from Web outlets and brick and mortar stores vary widely.

Where can I get more information on a particular mail-order or Web retailer?

Check the camera store discussion at www.photo.net, or check with the Better Business Bureau. Be aware, though, that one often hears good stories about bad retailers and bad stories about good ones. Use your judgment.

How can I protect myself when buying mail order?

Use a credit card. All major credit card companies act as buyer's advocates in cases of fraud. Never pay with a check or money order if you can help it, as you have little recourse if you aren't satisfied.

HOW MANY PIXELS ARE ENOUGH?

The first thing people want to know about a digital camera is "how many pixels does it have?" Although this is not a bad question to ask, it's not the only factor to consider when choosing a camera. Cameras with higher pixel counts generally create higher quality pictures, but they also create larger files that aren't appropriate for some uses.

For example, if you're purchasing a camera to use primarily for sending snapshots via e-mail or the Web, you have to resize your images to a smaller size to reduce upload and download times. You don't need a 3-megapixel camera if you'll always resize the images down to a megapixel or less.

To help you decide how many pixels you need (and how much money you need to spend to get those pixels), the following topics are covered in this chapter:

- Are more pixels always better?
- How film and digital cameras work
- Where do pixels come from?
- How image sensors work
- What's coming down the road

COUNTING PIXELS

If you plan to print most of the picture you take with your digital camera, you want as many pixels as you can get. This is especially true if you'll be printing your images on a high-quality photo printer. The larger the print, the more pixels you need to get an acceptable picture. Table 3.1 shows how many pixels you need for several popular print sizes.

TABLE 3.1—Approximate Number of Pixels Needed to Produce a High-Quality Print at Different Paper Sizes	
Megapixels	**Maximumm Print Size**
1.3	4×6''
2.0	5×7''
3.3	8×10''
5.0	11×14''

Let Me Count the Pixels...

Many people—including camera manufacturers—often incorrectly use the term *resolution* to refer to the *pixel count*, or the number of pixels produced by a camera. Resolution refers to the camera's ability to capture small details. Pixel count is simply the number of pixels produced by the camera's image sensor. Although the two terms are related, they're not the same.

IS MORE ALWAYS BETTER?

The short answer is yes. All things being equal, a camera with more pixels produces better pictures than a camera with fewer pixels. The pixel count determines the overall size and quality of the images created by a digital camera. In general, the more pixels, the more detail a picture contains. Pictures with more details appear sharper than pictures with less detail.

Pass the Dots, Please

Printer technology is improving almost as fast as camera technology. As discussed in Chapter 9, "Inkjet Printers," inkjet printers (the most popular type of printer for printing digital camera images) print images using tiny dots of ink. The more dots the printer can produce, the clearer the image appears.

Just a few years ago, 600 dot per inch (DPI) printers were the norm. Today, there are several inexpensive printers on the market that can print more than 2,000 DPI. These new printers take better advantage of the increased pixel counts and higher detail of newer digital cameras.

In a film camera, picture quality is a factor of the size of the film, the sharpness of the lens, and the resolving power of the film. In a digital camera, resolution is determined by the

number of pixels in the image sensor, the sharpness of the lens, and the camera's ability to convert raw pixels into an electronic image. In the film world, the easiest way to get more detail is to use a larger piece of film. In the digital world, you get more detail by creating more pixels—up to a point, as you'll see in a moment.

Pixel count has become the main yardstick used to measure and compare cameras. Digital cameras produce images with millions of pixels, so the term *megapixel* is used as shorthand for "a million pixels."

To understand what pixels are and why they're important, it helps to understand how conventional film cameras work.

HOW FILM WORKS

Photographic negative film contains millions of tiny, light-sensitive silver halide crystals on the surface of the film. Each individual picture on a roll of film is recorded on a unique area on the film called a frame. As you take pictures and wind the film, the most recently exposed frame moves out of the area behind the camera's lens, and another, unexposed frame moves into place, until you get to the end of the roll of film.

When the film is developed, the crystals that were exposed to light remain on the film; those that weren't exposed to light are removed in the developing process. (The process works just the opposite for slide film, which produces a positive image instead of a negative.) As a result, dark areas on the film have more crystals; lighter areas have fewer.

WHERE DO PIXELS COME FROM?

Digital images on your computer screen are composed of a series of colored squares called pixels. Each pixel is described by three or four numbers that define each pixel's color and brightness. In the RGB color space system most commonly used for consumer digital imaging, each picture has a red, green, and blue value, and each value ranges from zero (dark) to 255 (bright). Red, green, and blue light combine to make white, so a pixel with an RGB value of 255,255,255 displays as 100% white. Similarly, a pixel with a value of 0,0,0 displays as black, and a pixel with a value of 0,255,0 displays as bright green. There are other color space systems besides RGB. For example, the cyan, magenta, yellow, black (CMYK) system is often used for images that are to be printed via conventional four-color offset printing presses, which use cyan, magenta, yellow, and black inks.

What's a JPEG, Anyway?

Digital images are stored in electronic files, and the most common of these is the Joint Photographic Experts Group, or JPEG, format. JPEG files can be stored with varying degrees of electronic compression, which make the files smaller and faster to work with. Information about file formats and compression is presented in more detail in Chapter 20, "Outsourcing Your Printing."

Digital cameras are basically small computers that convert live images into digital files. They record images by electronically detecting light (photons) striking the face of an electronic image sensor. The face of the image sensor contains millions of light-sensitive transistors called *phototransistors* or *photosites*. Each photosite represents one pixel, and the terms are often used interchangeably when discussing image sensors. When light strikes one of the photosites, it causes a change in the electrical charge flowing through the transistor. The stronger the light, the stronger the change.

The camera builds an image from the array of pixels by electronically scanning the contents of each pixel. Image sensors are monochrome; that is, they see light as black or white. To make a black-and-white sensor see color, each photosite on the sensor is covered with a layer of color filters called a *color filter array*, or CFA. Most cameras use red, green, and blue (called GRGB) CFAs, although some use a cyan, yellow, green, and magenta (CYGM) array. For clarity, I'll illustrate the more common GRGB arrangement, but the process is the same for CYGM sensors.

The dye layers effectively make each photosite sensitive to only a single color, depending on the color of the dye. The dye is applied in a pattern (called a *Bayer pattern*) such that each row has either alternating red and green or blue and green pixels. If you do the math, you'll see that in a GRGB sensor, there are twice as many green pixels are there are red or blue. That's because green provides much of the perceived detail in the picture, while red and blue contribute relatively little detail information. By using twice as many green pixels, camera designers can squeeze the most detail out of the image sensor.

When you take a picture, a chip inside the camera called an image processor reads the data collected by the image sensor. The processor mathematically combines the data from each pixel with the data from its neighboring pixels to produce an RGB value for each pixel. The RGB data is collected and saved as an image file on the cameras' storage media.

SENSOR SIZE

The image sensors used in most digital cameras were originally developed for use in camcorders, so they are very small. Sensors are measured on the diagonal. The Charge Coupled Device (CCD) image sensors used in most digital cameras measure 1/1.8'', or .555", or 13.7mm (see Figure 3.1). For comparison, a 24×36mm (35mm) film frame measures 1.70" or 43.2mm on the diagonal (see Figure 3.2).

Smaller image sensors have some distinct advantages, but they pose a number of design problems, as well. Smaller sensors enable manufacturers to sell the same sensor to both video and still camera makers, reducing costs through economies of scale. They also require smaller lenses, which reduces the size and weight of cameras. But the pixels on a small sensor are very close together, which in turn requires that the lenses used with small-sensor cameras be of very high quality. In fact, a big part of the cost of a 3-megapixel P&S camera is in the lens.

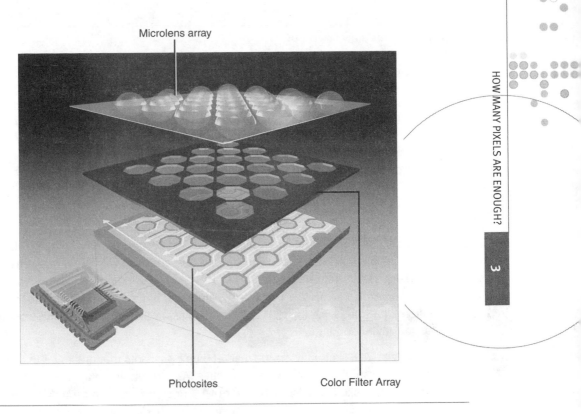

Microlens array

Photosites Color Filter Array

Figure 3.1

A CCD image sensor contains three main parts (top to bottom): the microlens, the Color Filter Array, and the photosites. (Diagram courtesy of Fujifilm USA)

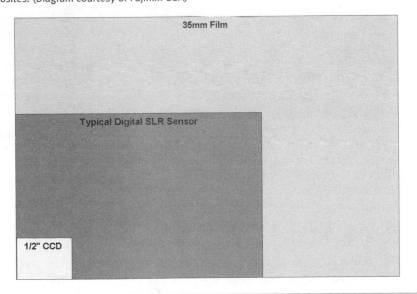

35mm Film

Typical Digital SLR Sensor

1/2" CCD

Figure 3.2

The CCD and CMOS image sensors used in most digital cameras are much smaller than a 35mm film frame.

Where'd My Pixels Go?

When comparing camera specs, you'll often see numbers for "number of sensor pixels" and "effective pixels." The latter number is the actual number of pixels produced by the camera, and it is always lower than the first number. So where did those pixels go?

Some of the pixels at the edge of the sensor have an opaque black dye that blocks light from hitting those pixels. This is done so that the camera has a reference point for the darkest part of the image.

Some cameras lose some effective pixels because the camera's lens can't cover the entire sensor area. Canon's PRO90IS, for example, uses a 3.3-megapixel sensor, but the lens—borrowed from one of Canon's DV camcorders—is too small to cover the entire sensor. As a result, the camera only uses the central part of the sensor, giving an effective pixel count of 2.6 megapixels.

The individual pixels on a small sensor have less surface area than the pixels on a larger sensor. As a result, they capture fewer photons, which makes them less sensitive to light than large image sensors. Many CCD sensors employ a grid of tiny lenses—one per pixel—called a *microlens array*. The microlenses are larger at the top (outside) than they are at the bottom (the side facing the CCD chip), so they act as light magnifiers and work to increase the sensitivity of the CCD.

Most digital SLRs currently on the market employ sensors that are larger than 1/2" but still significantly smaller than a 35mm negative. As a result, the effective focal length of SLR lenses is multiplied, usually by a factor of 1.5 or so, when used on a digital SLR. The next generation of digital SLRs will likely use full-frame 24×36mm sensors, providing better light sensitivity and eliminating the multiplication factor.

Aspect Ratio

Because many CCD image sensors were originally designed for use in video cameras, they have the same 4:3 horizontal-to-vertical size ratio (called the *aspect ratio*) as a television screen. Unfortunately, 35mm film has a 3:2 aspect ratio, which is proportionally much wider than a TV screen. Some digital cameras allow you to shoot in either 4:3 or 3:2 mode. The 3:2 mode is very convenient for producing prints on 4×6" paper, because the entire image fits perfectly.

5×7" and 8×10" are also very popular print sizes, even though neither of them match the 3:2 aspect ratio of a 35mm negative. And they don't match a 4:3 sensor, either—although a 5×7" print is a very close match. Keep this in mind when you're shooting an important photo—a group picture at a wedding or other event, for example—that may wind up as an 8×10" print.

WHAT'S COMING NEXT?

It's a safe bet that next year's cameras will have more pixels and more features at lower prices than this year's crop. The image sensor is one of the most expensive components in a digital camera. As with all semiconductor devices, they are cheaper to make in large quantities, so prices should come down as digital cameras become more popular.

So far, I've only mentioned CCD image sensors, but there's another type of sensor that's coming on strong. Complimentary Metal-Oxide Semiconductor (CMOS) image sensors are making a comeback. If the term CMOS sounds familiar, it's because you've heard it before. Much of the circuitry used to build PCs and other computer devices is made with CMOS technology. CMOS image sensors are very inexpensive to produce compared to CCD sensors. Early CMOS sensors suffered from poor light sensitivity, high noise levels, and awful image quality. They were typically used in low-cost, low-resolution applications like Web cameras, security cameras, and even toy cameras.

Advances in CMOS technology have led to the development of much higher quality CMOS image sensors. Canon's D30 digital SLR, for example, uses a CMOS image sensor that produces very high quality images with very low noise. CMOS sensors have some other advantages besides their low cost. CMOS sensors are made using the same process as microprocessors, RAM memory, and Digital Signal Processor (DSP) chips, so CMOS image sensors can contain additional circuitry directly on the sensor chip. This reduces the parts count, which decreases costs and increases reliability. CMOS sensors also use less power than their CCD counterparts, resulting in longer battery life.

At some point in the future, we'll reach a point where camera and printer technology reaches an equilibrium—a point where more pixels doesn't add more quality. Experts' opinions differ on where that point is. A high-quality 35mm film frame contains the equivalent of about 12–18 million pixels. But the vast majority of prints produced by commercial photo labs are 4×6". Even a 1-megapixel camera can produce an acceptable 4×6" print, and a 3-megapixel camera produces a 4×6" print that is nearly indistinguishable from film.

SUMI'S SNAPSHOT

I want to buy a digital camera, but I'm afraid that by the time I learn how to use it, it will be replaced with a better model.

Welcome to the world of digital photography, where equipment obsolescence is a fact of life. Just remember, a good camera still takes good pictures, even after a newer, better model comes on the market.

I want to get into digital imaging, but I don't want to buy a digital camera just yet. Can I use my film camera to make digital images?

Yes, you can. You can purchase a film scanner or have your images commercially scanned. Scanner prices range from about $400 to $2000, and they can produce stunning digital images from 35mm negative or slide film. If you'd rather not spend that much money, many photofinishers can scan your images for you; they deliver your scanned images on a CD-ROM.

Should I buy a 3-megapixel camera now or wait for the next generation of 4 or 5-megapixel cameras?

This is always a tough question to answer, because no one knows where the mexapixel race will stop. Many industry experts think that 3 megapixels are more than enough for most non-commercial applications.

STORAGE AND CONNECTION OPTIONS

Although it's not the most glamorous part of the camera, the storage medium plays an important role in the camera's operation. Each time you take a picture, the camera stores the image data onto some sort of removable memory card. When you're finished shooting (or when the memory card fills up), you need to transfer the images from the memory card into your computer. There are two ways to accomplish this; you can download the images from your camera to your PC using a cable, or you can remove the memory card and place it in an external card reader attached to your computer.

This chapter guides you through the storage and connection options used by most digital cameras, including

- The difference between SmartMedia and CompactFlash
- Sony's up-and-coming Memory Stick media
- Serial, USB, and Firewire connection options
- Using an external card reader

STORAGE MEDIA

Most digital cameras use one of three major—and incompatible—types of storage media: CompactFlash, SmartMedia, and Memory Stick (see Figure 4.1). All three types utilize a technology called *flash memory*, a special type of memory chip that can store data indefinitely without external power. When your camera writes data onto a flash memory device, the data is stored in the flash memory where it can be retrieved at a later time. Flash memory can be erased and re-used hundreds of thousands of times. It's fast, convenient, and reliable.

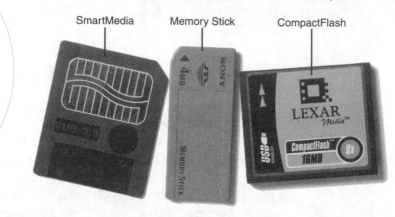

SmartMedia Memory Stick CompactFlash

Figure 4.1

These are the three major types of storage media used in digital cameras.

Most cameras use flash memory for storage, but there are alternatives. Sony's popular Mavica line of cameras stores its images on 3 1/2" floppy disks. When you fill up a disk, you simply pop it out and replace it with another. Transferring pictures to your PC is a simple matter of copying the files from the disk to your hard drive. Floppy disks only hold a small amount of data, so floppy disk storage only works for low-resolution pictures. A few Sony cameras use a small 3" CD-R drive; these cameras hold about 160 pictures on a disk that can be played back in most any computer with a CD-ROM drive.

With a few exceptions, most cameras take only one type of storage media. When you buy a camera, you commit yourself to a particular type of storage. Although all three storage media accomplish the same task, there are some subtle but important differences between the three types.

CompactFlash

CompactFlash (CF) cards are small, durable memory cards that contain some flash memory and a controller chip. The controller chip manages the memory in the card, making it appear to the host computer (or camera) as a removable disk drive (see Figure 4.2).

Figure 4.2

CompactFlash (CF) memory cards are small and durable. They're available in a large variety of sizes from 8Mb to 1Gb.

The original CompactFlash design was created in 1994, and an industry association was created to promote the use of CF cards in 1995. CF cards are small, measuring 1.4"×1.7". There are two types of CF cards. Type I cards are 3.3mm (.13") thick, and are the more common of the two. Type II cards are 5.5mm (.19") thick, and are becoming more common. CF cards are available in capacities up to 512Mb.

CF cards have small guide slots on two sides of the card. These slots ensure that the card can only be inserted one way. The front edge of the card has a tiny 50-pin connector that is modeled after the very reliable connector used in laptop PC Card (formerly called PCM-CIA) expansion cards. The resemblance to PC Cards is more than passing, the electrical signals used by a CF card are identical to those used by a PC Card. This allows the use of CF cards in a PC Card slot with only a simple, inexpensive adapter.

CF cards are rugged and reliable. I've dropped them, left them in my pants through the wash, and generally abused them for years without a failure.

SmartMedia

SmartMedia cards are another type of flash memory commonly used in digital cameras. SmartMedia cards are slightly larger than CF cards, but are much thinner. One side of the card contains a gold plated contact area, divided into 22 sections (see Figure 4.3). The card connects to the host device through this area.

SmartMedia cards are built on a single piece of silicon, so they don't require a circuit board, which is why they are thinner than CF cards. But SmartMedia cards don't contain any controller electronics, so the camera or PC must manage the SmartMedia card as a memory device, not a disk. From the user's point of view, there's very little difference.

Until recently, SmartMedia cards were only available in sizes up to 64Mb, but 128Mb cards are now available. Some older cameras won't work with the new, high-capacity cards, due to the fact that the controller circuits in the camera were designed before 128Mb cards were available.

ID 32MB

Figure 4.3

SmartMedia cards are slightly larger than CF cards, but are much thinner. SmartMedia cards are available in capacities up to 128Mb.

Watch Your Volts!

Early SmartMedia cards required 5 volts of power to operate, but newer cards use 3.3 volts. The two types aren't interchangeable, so it's important to purchase the right type for your camera. You can use a 3.3V card in a 5V camera, but not the other way around.

SmartMedia cards have a "write protect" feature that is activated by placing a silver sticker on the card near the connectors. When the sticker is in place, the data on the card is protected from accidental erasure.

There have been some issues regarding compatibility of SmartMedia cards when used in multiple devices. Because the card doesn't contain its own controller electronics, it is up to the device manufacturer to format the memory for use in their particular device. For example, I've experienced cases where a SmartMedia card that had been used in a particular MP3 player would no longer work in one of my digital cameras. The camera refused to recognize the card, but the card worked perfectly in the MP3 player. I finally managed to salvage the card and return it to camera duty by formatting the card in an external card reader attached to my PC.

Newer SmartMedia cards contain a unique serial number that can be used to identify the owner of a particular card. These cards are called SmartMedia ID cards. There's no real application for the serial number feature in the U.S. market as yet. The ID concept was designed to provide a way to manage electronic rights for downloaded music. I've only seen one device—Fuji's FinePix 40i combination camera/MP3 Player—that required the use of an ID card. The ID number might come in handy at some future time when you'll be able to drop off your memory cards at the camera store for printing (more about this in Chapter 20, "Outsourcing Your Printing").

Memory Stick

Memory Stick is Sony's entry into the flash memory race. I could be mean and say that this is the memory format brought to you by the same people that invented the Betamax VCR, but I have friends at Sony, and I'd like to keep them. Besides, Sony (having learned a thing or two with Betamax) has licensed several other companies to build Memory Stick devices. Sony makes a wide variety of still and video cameras, audio players, laptop computers, and PDAs that use Memory Stick. The big attraction (apart from its small size) is that you can use any Memory Stick card in any compatible device with no hassles (see Figure 4.4).

Figure 4.4

Memory Stick cards are currently used only in Sony products, but Sony has licensed a number of other companies to use the technology.

The Memory Stick looks like a purple stick of chewing gum, only a bit shorter. And chewing gum generally doesn't have a set of gold contacts at one end like the Memory Stick does.

Sony doesn't make the memory chips inside the Memory Stick; they buy them from a third-party supplier. This has the unfortunate effect of making Memory Stick somewhat more expensive than other flash storage media. Memory Sticks are available in sizes up to 128Mb.

Movies on a (Memory) Stick?

An enhanced version of Memory Stick called MagicGate, includes a copyright protection mechanism similar to SmartMedia's ID feature. Remember that Sony owns one of the world's largest record companies, so rights management is a big issue with them.

Memory Stick features a useful write protect switch that makes it easy to protect data. A clever notch cut at one end of the stick makes it impossible to put in upside-down.

The Memory Stick architecture can be used for devices other than memory. Sony has hinted that future Memory Stick devices might include a Global Positioning Satellite (GPS) receiver, a Bluetooth wireless network card, and even a tiny Memory Stick camera that could plug into a PDA to store pictures or video (on another Memory Stick, of course.)

IBM Microdrive

When I first heard (via e-mail) that IBM had created a tiny hard drive that fit inside a CF Type II card, I figured it was just another e-mail hoax. When I saw the Microdrive at a trade show a few weeks later, I was amazed.

The Microdrive is a tiny, moving platter hard drive, just like the one in your laptop or desktop PC, only much smaller (see Figure 4.5). The original Microdrive had a capacity of 170Mb, but 340Mb and 1GB versions followed each successive year.

Figure 4.5

The IBM Microdrive is a miniature hard drive that fits into a CF Type II slot.

The Microdrive offers storage capacity not available in any flash memory product, and it has a much lower cost per megabyte than flash memory.

Although the Microdrive provides excellent value for the money, it's not for everyone. All hard drives have moving parts, and those parts eventually wear out. Hard drives are also susceptible to damage from shock. I've dropped my Microdrive (on the carpet, thankfully) a couple of times with no ill effects, but if it had been a concrete floor instead of carpet, the drive likely would have been damaged. Microdrives aren't as fast as flash memory cards. The drive takes a few seconds to spin up to speed when you turn on the camera, and this might add a few seconds to your camera's start-up time. Negatives aside, the Microdrive is an excellent value and provides enough storage for long trips.

When It Works, It's Wonderful...

The Microdrive has some compatibility issues, especially with older cameras. Even if your camera has a Type II CF socket, there's no guarantee that it works with all Microdrives. Check with the camera maker (or IBM's Web site) to make sure your camera is compatible. Some cameras work with the newer 1Gb Microdrive but not with the earlier 170 and 340Mb drives.

CONNECTING YOUR CAMERA TO YOUR PC

After you've taken some pictures with your camera, you need to transfer those pictures to your PC so that you can erase the memory card and take some more pictures. You also need to transfer the images to your PC so that you can view, print, or e-mail them.

All PCs (and Macs) provide connections—often called ports—to connect external devices like cameras. There are three major types of ports in use today; serial, USB, and FireWire (also called IEEE 1394 or iLink.) The difference between these three types of ports is in the speed at which they transfer data. Faster speed translates into faster picture transfer times. Serial ports are the slowest, USB is in the middle, and FireWire is the fastest.

The type of port you need depends largely on the type of computer you have. Virtually all PCs and Macs made in the past few years have USB ports. Newer Macs and a few PCs (notably those from Sony) have FireWire ports.

Serial Connections

Older PCs and Macs used serial ports to provide a relatively slow connection to the outside world. Serial ports were originally designed to connect modems and other slow communication devices, so they didn't need to be very fast. The fastest speed available on a serial port is 115,200 bits per second.

Macs and PCs use different connectors for their serial ports. PCs use a DB-9 connector, while Macs use a Mini-DIN connector. Unless you have an older camera, you needn't worry with either type, because very few cameras use a serial connection anymore.

USB Connections

Virtually all cameras on the market today use a Universal Serial Bus, or USB connection. USB ports operate at 12 million bits per second, more than 100 times the speed of a serial port. USB connections use a bus architecture, meaning that you can connect up to 128 devices to a single USB connection using an adapter called a USB hub.

USB is a big improvement over a standard serial connection, but it can still be slow when you're trying to move large amounts of data from a camera to a PC.

No USB? No Problem!

If your PC is so old that it doesn't have a USB port, it's probably too slow and has too small a hard drive to do any meaningful work with digital images, anyway.

FireWire Connections

FireWire is the newest and fastest way to connect a digital camera or digital video camera to a PC. FireWire operates at speeds up to 400 million bits per second. Like USB, FireWire uses a bus architecture that allows connection of up to 63 devices to a single port.

FireWire is an Apple Trademark, and FireWire ports are also called IEEE 1394 ports (the generic name) and iLink (Sony's trademark). All FireWire ports are electrically compatible, although there are two different types of connectors for FireWire ports.

The larger 6-pin connector is the more common of the two, and is usually found on computers and other AC powered devices. 6-pin FireWire connectors can supply a limited

amount of power to external devices. The smaller 4-pin connector is most often found on cameras and other battery-powered devices.

FireWire is standard issue on all DV (Digital Video) camcorders. Only a few high-end still cameras (like Nikon's D1 series) use a FireWire connection, but other makers will move to FireWire over time.

EXTERNAL CARD READERS

If you use your camera frequently, you might want to consider buying an external card reader for your PC. Card readers are small devices that look and work like miniature disk drives. You connect the card reader to your PC or Mac using a USB or FireWire connection. When you insert a memory card into the reader, the contents of the memory card appear as an additional disk drive on your PC. This allows you to move files from the card the same way you'd move files from a floppy disk or CD.

Because card readers draw power from the host PC, they work independently of your camera. This means that you can download files from one memory card while you take pictures with another. It also saves battery power, because your camera doesn't have to be powered on while you're downloading images using the card reader.

There is a wide variety of card readers on the market. You need to choose one based on the type of media you use and the type of connection you want. Several companies offer dual-mode card readers that can accept both SmartMedia and CompactFlash cards (see Figure 4.6).

Figure 4.6

This USB card reader, made by Microtech International, has slots for CompactFlash (top) and SmartMedia cards. You can use both slots at once.

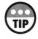

Hope for the USB-Less

Although parallel printer ports weren't mentioned earlier, there are some card readers that connect to the PC via a parallel connection. These are usually very slow and should only be used as a last resort if your PC doesn't have a USB connection.

If you have a notebook PC with one or more PC Card slots, you might want to consider a PC Card adapter. These small, inexpensive adapters install in a PC Card slot and accept a CompactFlash, SmartMedia, or Memory Stick card (see Figure 4.7). They're much more convenient than external card readers, because they are very small and there's no cable to connect. CompactFlash PC Card adapters are very inexpensive—often less than $20—because all the controller circuitry is built into the CF card itself. SmartMedia and Memory Stick adapters are more expensive at around $50 to $100.

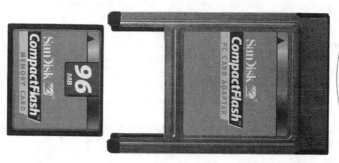

Figure 4.7

This PC Card adapter accepts a Type I or II CF card and inserts into any notebook PC Card slot.

SUMI'S SNAPSHOT

I'd like to use FireWire, but my computer didn't come with a FireWire port. Can I add one?

Yes. It's fairly easy to add a FireWire port, as long as your PC has an open expansion slot. Several companies offer FireWire PCI cards that install into an expansion slot in your PC. These cards range from about $80 to $120 and provide two or three FireWire connectors. They're a great addition if you use a FireWire card reader and a DV camera.

What about adding a USB port?

Frankly, if your computer is so old that it doesn't have a USB port (all Pentium MMX and later PCs typically do), then it's probably too slow and has too small a hard drive for any serious digital photography work.

If I buy a camera that uses SmartMedia cards, can I use those cards in a friend's CompactFlash camera?

No, the two cards are physically and electrically incompatible.

What happens to my images after they're copied to my hard drive?

After you copy the images from your memory card to the PC, you can erase and re-use the memory card. The images remain on your PC until you delete them—or until your PC fails. Most PCs now come with a CD recorder, and you should make a backup copy of your important pictures to protect against a computer crash.

CHAPTER 5

ALL ABOUT LENSES

The lens is one of the most important—yet often over-looked—parts of any camera. Advanced amateur and professional photographers often have six or more lenses in their bags. Choosing the right lens for the shot is an important part of the creative process.

Digital camera users don't usually have the luxury of interchangeable lenses. Most digital cameras come with a permanently attached zoom lens that can be adjusted to suit a variety of shooting conditions.

This chapter explains

- How to choose the correct focal length for your picture
- How the lens aperture setting affects the pic-ture's focus
- How Image Stabilization works
- When to use a macro lens
- How to spot common lens faults

LENS BASICS

A lens is the camera's eye. Like the human eye, a camera lens frames and focuses the subject. And like the human eye, a camera lens contains a diaphragm that adjusts the amount of light that passes through the lens.

When you look at the specification sheet for almost any camera (or removable lens), you see two numbers—the focal length and the maximum aperture, or f-stop—that describe the lens. The focal length describes how the lens sees the world, and the maximum aperture measures the lens' efficiency.

The focal length of a lens determines the camera's angle of view. Because most cameras have zoom lenses, you usually see the focal length expressed as a range of numbers, like 28–105mm. Shorter focal lengths provide a wider angle of view, and longer focal lengths provide a narrower field of view. Figure 5.1 shows the same scene photographed with several different lenses.

As you can see, there's a huge difference in the angle of view in the example pictures. In the widest shot, you can barely tell that there's a boat at the dock; in the closest shot, you can read the lettering on the sides and back of the boat.

What's "Normal?"

A *normal* lens is one that provides a field of view similar to that of the human eye. Of course, we see with two eyes, which provides a 3-dimensional view of the world, and a camera only sees with a single lens, producing a 2-dimensional image. There's a lot of debate over exactly what a "normal" lens is, but the consensus of opinion is that it's a lens with a focal length slightly larger than the diagonal measurement of the film plane.

The diagonal of a 35mm film frame is about 43mm; a normal lens on a 35mm camera is around 50mm. Different digital cameras use different-sized image sensors, so the focal length of a normal lens on a digital camera depends on the sensor size. To avoid confusion, most digital camera manufacturers state their lens focal lengths in their 35mm equivalent. There are two good reasons for this. First, many people are familiar with 35mm cameras, so they're also familiar with 35mm focal lengths. Second, the use of 35mm equivalent focal lengths makes it easy to compare lenses on cameras with different-sized image sensors.

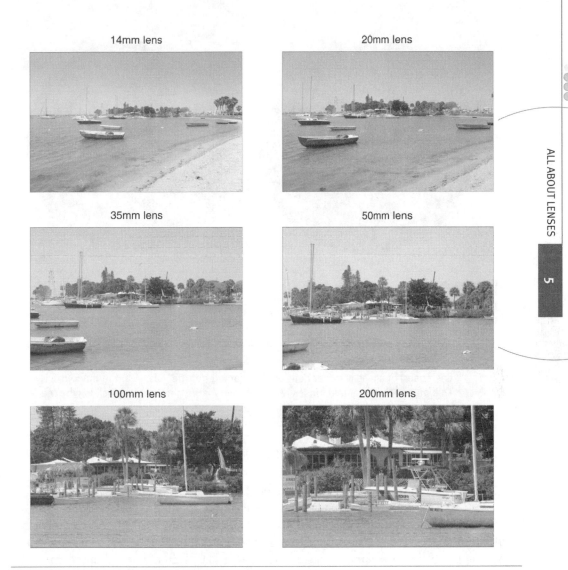

14mm lens

20mm lens

35mm lens

50mm lens

100mm lens

200mm lens

Figure 5.1

The same scene photographed with 14mm, 20mm, 35mm, 50mm, 100mm, and 200mm lenses on a Canon D30 digital SLR. All six pictures were taken from the same position without moving the tripod.

F-Stops

The maximum aperture of the lens is usually expressed as a formula like $f/2.8$. The aperture is also called the f-stop, and it measures the ratio of the lens' focal length to it's diameter (see Figure 5.2). A lower f-stop allows more light to pass through the lens. A lens with a wider aperture is said to be "faster" than one with a smaller aperture because the larger aperture allows more light to pass through the lens. This in turn enables the photographer to use a higher shutter speed to obtain the correct exposure for a given scene.

Figure 5.2

The picture on the left shows a 50mm lens set to the widest aperture, in this case, $f/1.8$. On the right, the same lens is set to $f/11$.

Speed Costs

The speed of a lens is dependent on the diameter of the glass used to make the lens. This means that very fast lenses tend to be very large and heavy, which is why the lenses on most digital cameras have a maximum aperture of $f/2.8$ or so. Anything faster adds too much weight, size, and cost to the camera.

Most lenses contain a diaphragm that enables the user to adjust the amount of light passing through the lens. The adjustment is necessary to obtain the proper exposure over a wide range of light conditions and shutter speeds. (Exposure is covered in depth in Chapter 7, "Exposure Basics.") This adjustment is called the aperture adjustment or f-stop adjustment. As you adjust the diaphragm to make a smaller opening, you are also reducing the amount of light that passes through the lens. F-stops are calibrated as a series of numbers. The standard f-stop numbers are 1.4, 2, 2.8, 4, 8, 11 ,16 ,and 22, although many cameras enable you to select a number in between the standard stops. Each standard f-stop passes half the amount of light as the previous f-stop, so a lens set for $f/2.0$ passes twice as much light as the same lens set for $f/2.8$. This confuses many users, because a higher f-stop number represents a smaller lens aperture, which in turn passes less light.

Depth of Field

As we just saw, smaller f-stops (higher f-stop numbers) pass less light than lower numbers. But something else happens as the size of the aperture decreases; the depth of field (also called depth of focus) increases. *Depth of field* describes the area of view that is in sharp focus. Larger openings produce less depth of field, and smaller openings increase depth of field.

The photos in Figure 5.3 show how depth of field changes with different f-stop settings.

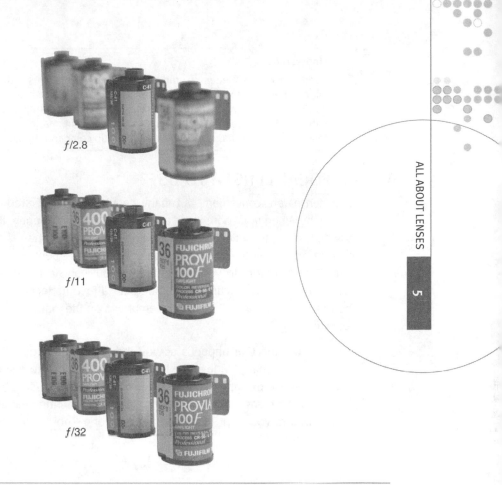

Figure 5.3

These three pictures were taken with the same lens, set at $f/2.8$, $f/11$, and $f/32$.

Most (but not all) digital cameras allow you to manually select an aperture setting. This gives you creative control by enabling you to decide what is and isn't in sharp focus. Many SLR cameras (including most digital SLRs) have a feature called Depth of Field Preview that lets you see the effect of different aperture settings in the viewfinder.

ZOOM LENSES

The vast majority of cameras—both film and digital—on the market today include zoom lenses. A *zoom lens* is one that can adjust to cover a range of focal lengths. Zoom lenses are very convenient, because they allow the photographer to adjust the framing and field of view of a photograph by simply adjusting the lens zoom. You could accomplish much the same effect with a single focal length lens by moving the camera closer or further away from the subject, but a zoom is faster and easier. As you'll see later, different focal lengths give different perspectives on the subject.

Understanding "X"

Zoom lenses are often measured by their zoom ratio. A lens with a range of 50 to 150mm has a 3X zoom ratio; one with a 35–350mm range has a 10X ratio. Don't confuse zoom range with the magnification ratio, which is something else entirely. The magnification ratio tells you how large (or small) a lens is in relation to a normal lens. A 200mm lens, for example, has a 4X magnification ratio compared to a normal 50mm lens.

WHICH FOCAL LENGTH TO USE?

Zoom lenses are convenient, but many people don't understand how to use them most effectively. When you zoom in on a subject, two things happen. First, longer focal lengths provide less depth of field (at the same aperture setting) than short focal lengths. As you zoom in on a subject, focusing becomes more critical because a smaller area is in sharp focus. This can work to your advantage if you want to isolate an object that is placed against a busy or distracting background. It's a favorite technique of fashion and portrait photographers, because it places the emphasis on the main subject and leaves everything else blurry.

The second thing that happens as you increase a lens' focal length is a phenomenon called foreshortening. Wide-angle lenses used very close to a subject tend to accentuate items (noses, for example!) in the center of the picture, making them appear larger than they are. Longer lenses tend to "flatten" the view, rendering near and far objects more realistically. Unless you want to accentuate someone's nose, you should never use a wide-angle lens for portraits.

the only refs for this sample are book and web refs...want this or change to tip?

sd

Add-On Lenses

Some cameras let you use external, add-on lenses to extend the zoom range or to increase the wide-angle coverage of the lens. These add-on lenses are covered in Chapter 6, "Essential Accessories."

Longer focal lengths make for attractive portraits, and they let you get in closer to distant subjects like zoo animals, players at sporting events, and distant scenery. But many users aren't aware that longer lenses magnify not only the subject, but vibration, too. In most cases, you can use most P&S cameras handheld in bright light with no ill effects. But if your subject is in the shade or it's getting late in the day, you need to use a tripod to hold the camera steady and prevent blurring caused by camera shake. If a tripod isn't available (ie: you left it in the car because you knew you wouldn't need it), you can always steady your camera by leaning against a building or tree.

Hold Still!

Some cameras—like Canon's PRO90 IS—have a feature called *Image Stabilization* that reduces the effects of camera shake. Canon's image stabilizer technology uses motion sensors and two tiny motors inside the lens. When the sensors detect camera movement, they instruct the motors to move a glass element inside the lens in the opposite direction. This cancels out the movement and results in sharper pictures, even with very long zoom lenses.

Other brands of cameras use electronic image stabilization, which is done in the camera's electronics and isn't as effective as Canon's patented system.

CLOSE FOCUSING (MACRO) LENSES

Many cameras have a close focusing feature—often called a macro focusing feature—that enables you to get very close to a subject. Technically, a macro lens is one that can produce a life-sized image on the film (or image sensor), but camera makers have stretched the term to include any camera that focuses closer than 1 foot or so.

Most digital cameras have a macro feature, but some are much more effective than others. Some cameras can only focus close when they are zoomed to their widest setting. This reduces the effectiveness of the macro feature because the shorter focal length provides the least amount of magnification.

Some cameras can't use their flashes in macro mode because the flash is designed to illuminate objects more than a few feet away from the camera. This is especially true for cameras with pop-up flash heads.

Macro focusing lenses are great for getting very close to small subjects like bugs and flowers. They're also great for taking pictures of small items like jewelry, which is especially helpful if you plan to use your camera to create a home inventory for insurance purposes.

COMMON LENS FAULTS

Lenses are complex, precision-made optical instruments. Precision costs money, so some lens designers take shortcuts to reduce the cost and size of lenses, especially on P&S cameras. Here are some common lens faults to watch for when testing out a new camera:

- **Vignetting**— A *vignette* is a small portrait, usually placed in a frame with rounded corners. Vignetting in a lens happens when the image is darker in the corners than in the center of the picture.

- **Chromatic Aberration**—This is a fancy name for a prism-like effect that is especially noticeable at the corners of the picture. It's most visible when there's a sharply-defined object like a tree limb or roofline at the edge of the picture. The aberration shows as a sharply colored (usually purple) line or blur in an area where there is no color.

- **Barrel and Pincushion Distortion**—Barrel distortion happens when a vertical object appears thicker in the middle than at the ends—just like a barrel. Pincushion distortion is the opposite effect; objects seem to be pinched towards the center.

SUMI'S SNAPSHOT

Why do I sometimes see one or more colored spots in my pictures?

You're seeing the result of a problem called *lens flare*. Flare happens when the light passing through the lens reflects off one or more of the glass elements inside the lens. Flare is most likely to happen when the camera is pointed toward the sun or a bright light.

What is the purpose of a lens hood?

A lens hood—also called a lens shade—keeps stray light from entering the camera lens. Stray light can reduce contrast and cause lens flare. If your camera came with a lens hood or if one is available as an accessory, use it.

I always keep a UV filter on my 35mm camera lens. Do I need one on my digital camera?

UV filters block ultraviolet light, which can cause a bluish cast on film, especially at high altitudes. Most digital cameras aren't sensitive to UV light, so there's no need for a UV filter. But a UV filter won't hurt anything, and the filter does protect the camera's lens from dust and scratches.

CHAPTER 6

ESSENTIAL ACCESSORIES

Okay, so you've decided on the perfect digital camera. But even the perfect camera can use some help now and then. In this chapter, you're introduced to some essential camera accessories.

Unless you're a consummate gadget freak or a serious photographer, you probably don't need all of the accessories featured in this chapter. But the accessories discussed in this chapter can help you take better pictures.

Read on to take a close look at

- Accessory lenses that add telephoto and wide-angle capabilities
- Filters for tricky lighting conditions
- Batteries and chargers that let you shoot longer
- Flash accessories to cover difficult lighting situations
- Camera supports that help you hold the camera level and steady

ADD-ON LENSES

Lens designers face a tough set of compromises with point and shoot cameras. Lenses for these cameras must be small and relatively inexpensive to build. At the same time, they must provide sharp, clear pictures under a wide variety of shooting conditions.

Most P&S cameras come with a 3X zoom lens, usually equivalent to a 35–105mm lens on a 35mm film camera. This range of focal lengths provides decent coverage at the wide end, good enough for family group shots and scenic travel pictures. At the long end of the zoom, these lenses provide the perfect focal length for informal portraits, and they enable users to zoom in on small or distant subjects like kids' sporting events or animals at the zoo.

But many users find that their P&S cameras can't get wide enough or zoom in far enough for certain shooting situations. For example, real estate agents and interior designers often need to take pictures that show the size and layout of a room, but the lenses on most P&S cameras don't zoom out wide enough to cover an entire room. At the other extreme, a 3X zoom lens doesn't zoom in far enough to get close up pictures at sporting events or at the zoo.

Many camera makers and third-party lens manufacturers offer accessory lenses (called converters or adapters) that attach to the camera's built in lens. Wide-angle adapter lenses like the one shown in Figure 6.1 allow the camera to see a wider field of view, making them ideal for sweeping scenic pictures and interior pictures of small rooms.

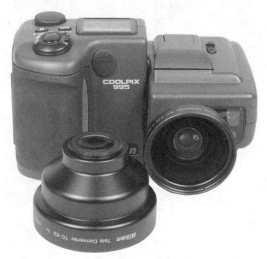

Figure 6.1

This Nikon 995 has wide-angle (shown on camera) and telephoto adapter lenses.

Without the wide-angle adapter, the Nikon 990's lens is equivalent to a 38mm lens on a 35mm camera. The wide-angle adapter changes the field of view to be equivalent to a 24mm lens. Although 14mm might not sound like much of a difference, it provides a much wider view, as the pictures in Figure 6.2 show.

Figure 6.2

Nikon's wide-angle adapter radically widens the camera's field of view, as shown in these two pictures taken from the same spot.

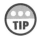

Is the House Falling?

Extreme wide-angle lenses make close things look large and distant things look small. This can cause distortion when you're shooting room interiors, building exteriors, and other large objects. Try to keep the camera as level as possible to avoid making rooms look like the walls lean in at the top!

At the other extreme, telephoto adapters increase the lens' effective focal length. This narrows the field of view and provides a closer view of distant objects. Telephoto converters are usually measured by their magnification factor; a 2X adapter doubles the lens focal length; a 3X adapter triples it. The two pictures in Figure 6.3 were taken with and without a 2X telephoto adapter.

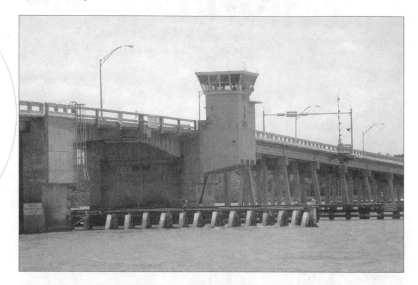

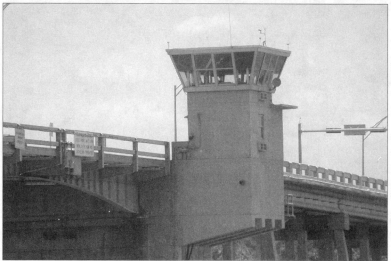

Figure 6.3

These two pictures show how a 2X telephoto adapter works. The picture on the left was taken with a Nikon 995 at full zoom, and the picture on the right was taken with the 2X adapter.

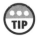

Steady As She Goes, Matey!

Long lenses magnify your subject, but they also magnify camera movement and reduce the amount of light passing through the lens, which results in slower shutter speed. When using longer lenses in anything other than full daylight, you'll probably need a tripod to hold the camera steady.

FILTERS

Optical filters are glass elements that attach to the front of your camera's lens. Filters change the light that passes through them. There are dozens of different types of filters on the market, but only a few types are appropriate for use with digital cameras, so this section focuses on those.

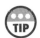

Fitting Filters

To use filters, you need a camera with a threaded front lens element. If you haven't bought a digital camera yet, you might want to keep this fact in mind.

Ultraviolet Filters

Ultraviolet (UV) filters are very popular with 35mm film camera users. UV filters are nearly clear, with a very slight yellowish tint that blocks ultraviolet light. Many 35mm camera users keep a UV filter on their lenses at all times to provide additional protection for the front of the lens.

Apart from their "glass lens cap" duties, UV filters are very helpful when shooting outdoor pictures, especially on sunny days or at high altitudes because UV rays—present in all sunlight—can affect the color balance of film pictures, often seen as an excessive amount of blue. Digital cameras aren't as affected by UV rays as film, so UV filters aren't as useful in digital photography as they are in the film world.

Polarizing Filters

If you've ever owned a pair of polarized sunglasses, you know how they reduce glare and reflections and provide a clearer view of the world on bright days. Polarizing filters work the same way for cameras, making them one of my favorite digital camera accessories.

There are two types of polarizing filters. Linear polarizers are commonly used in sunglass lenses, computer monitor anti-glare screens, and as filters for older, non-autofocus cameras. Circular polarizers are a newer type of polarizer designed to work with autofocus cameras. Figure 6.4 shows a typical polarizing filter mounted on a digital camera.

Like all filters, polarizers have a threaded ring that screws into the front of your lens. A second ring allows the polarizer to rotate 360 degrees without unscrewing the lens from your camera. This allows you to adjust the polarizer for the best effect. As you rotate the polarizer, reflections and glare are reduced or disappear completely. Figure 6.5 shows how a polarizing filter can remove reflections from water.

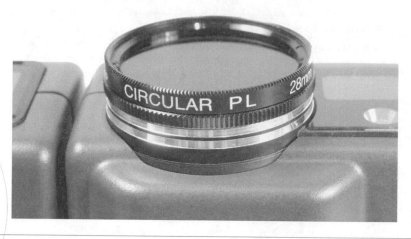

Figure 6.4

A circular polarizer is mounted on this Nikon 995 camera. The "28mm" marking on the filter refers to the diameter of the filter, not the focal length of the lens.

Figure 6.5

Polarizing filters remove glare and reflections, as shown in these two pictures of a fish pond, taken with (right) and without (left) a polarizer. Polarizers also darken blue skies and increase contrast, as you can see in these two pictures of a parasailer. The picture on the right was taken with a polarizer.

In the picture on the left, the bright sky causes reflections on the water that obscure the fish underneath. With the polarizer attached, the reflections are drastically reduced, revealing the fish beneath the surface.

Polarizers tend to increase the contrast between light and dark objects and are often used to make white clouds stand out against a blue sky. The only downside to polarizer filters is that they reduce the amount of light passing through them. This results in reduced shutter speeds, reduced depth of field, or both, so they are typically only used outdoors in bright light.

Too Many Filters Can Spoil the Picture!

Be careful when using more than one filter at a time. If you stack several filters on top of one another, you might introduce unwanted reflections into the lens. Also, be careful when using multiple filters with wide-angle lenses; sometimes the edge of the filter holder blocks the corners of the picture, a problem called *vignetting*.

You can't see the effect of the polarizer through the camera viewfinder unless you're using an SLR camera. If you're using a polarizer filter with a point and shoot camera, you need to turn on the camera's preview feature and adjust the polarizer while viewing the preview image on the camera's LCD screen.

Neutral Density Filters

Neutral density, or *ND*, filters reduce the light passing through them, but they don't affect the image in any other way. The most useful type of ND filter Is called a *graduated ND filter*. This filter is tinted a dark gray at one end, and the tint gradually fades to clear at the other end. Graduated ND filters are most often used to block light from a very bright object—usually the sky—so that it doesn't overwhelm the picture.

Graduated ND filters are available in screw-in mounts like those used for UV and polarizing filters. Screw-in graduated ND filters come in a rotating mount like a polarizer, so you can rotate the filter to best fit your subject. Unfortunately, this arrangement doesn't let you adjust the vertical position of the filter, so these filters force you to place the light-to-dark transition point in the middle of the picture.

The clever folks at Cokin Filters have come up with a better solution. The Cokin Creative Filter system uses square filters that fit into a rotating mount attached to your lens. Cokin's mount lets you slide the filter up and down so that you can adjust the transition point to suit your picture, not the other way around (see Figure 6.6).

Graduated ND filters are a favorite tool of scenic and travel photographers. A properly placed ND filter can tame a bright sky and allow the photographer to emphasize the foreground subject. Figure 6.7 shows how I used a graduated ND filter to photograph a bridge on a gray, cloudy day.

Figure 6.6

Cokin's Creative Filter System holds up to three filters in a rotating mount. This picture shows a graduated neutral density filter in its holder.

Figure 6.7

The picture on the left is washed out and flat looking because of the bright sky. A graduated neutral density filter darkened the sky, allowing the bridge and the water to stand out.

One more word about the Cokin filter system: Cokin makes over 160 different filters for their system, including a variety of special effects, polarizer, and ND filters. One big plus of the Cokin system is that you can use the same set of filters for several different cameras or lenses, even if the lenses have different diameters.

Cokin filters have a very devoted following. One Cokin user thinks so much of their products that he created a Web site devoted to Cokin filters (http://www.geocities.com/cokinfiltersystem/). It's actually more informative than Cokin's own site (www.cokin.fr).

BATTERIES AND CHARGERS

Digital cameras are jam-packed full of electronics. As you might expect, those electronics require a lot of power. The image sensor, LCD display screen, and flash circuits are the main power-eaters in a camera. You can't take pictures without the image sensor, but judicious use of the flash and LCD screen can greatly prolong battery life.

Most cameras take only one specific type of battery. The vast majority of cameras on the market today use AA-size batteries. A smaller but growing number of cameras use some sort of proprietary rechargeable battery; these are usually unique to each camera maker.

If your camera came with a battery pack and charger, it's most likely a Lithium-Ion (LiOn) battery. These are the newest and most efficient batteries on the market. Unfortunately, they're also the most expensive. LiOn batteries have several advantages over conventional rechargeable batteries. They're exceptionally light, so they don't add much weight to the camera. They charge quickly, so you don't have to wait all night for your battery to recharge. Unlike some other types of rechargeable batteries, LiOn batteries can be recharged at any time, even if the battery isn't completely dead.

If your camera uses AA batteries, you need to purchase at least one set of batteries and a charger. There are two major types of AA batteries: single use and rechargeable. Single-use batteries are used once and discarded; rechargeable batteries can be recharged and used over and over.

Single-Use Batteries

The two most common types of single-use batteries are alkaline and lithium.

Know Your Battery Jargon

Single-use lithium batteries are not the same thing as rechargeable lithium-ion (LiOn), which is a completely different type of battery.

Alkaline batteries are great for flashlights, but they don't last very long in digital cameras. Despite this fact, many camera manufacturers include a set of alkaline batteries in the box with the camera as a "starter" set. A fresh set of high-quality AA alkaline batteries will let you take maybe 4 or 5 pictures before they drop dead.

Don't Smoke That Camera!

Not all cameras can use all types of AA batteries. In particular, lithium batteries can damage equipment that isn't specifically designed to use them.

Lithium batteries last as much as 20 times longer than alkaline batteries, but they are much more expensive. Lithium batteries are very light and have a very long shelf life. They work very well in electronic flash units, and they even work well in digital cameras. They'd be the perfect battery if they weren't so terribly expensive. Because of their long shelf life, they're a good choice for items that you use sporadically.

Rechargeable Batteries

Nickel cadmium (NiCd) and nickel metal hydride (NiMh) are two similar, but subtly different, rechargeable battery technologies. The older NiCd batteries have less power capacity than NiMh batteries. More importantly, some NiCd batteries exhibit a phenomenon called the memory effect. If you partially discharge a NiCd battery—say down to 50% power—and then recharge it, the battery "remembers" the last discharge cycle and only discharges to 50% the next time you use it. You can prevent this problem by always running the batteries until they are completely dead, but this is inconvenient.

If LiOn Batteries Are So Great, Why Don't They Come in AA?

You can't buy LiOn AA batteries because LiOn batteries operate at a higher voltage than conventional batteries. A single LiOn cell produces 3.4 volts; conventional AA batteries produce 1.25 to 1.5 volts.

NiMh batteries provide nearly twice the power of NiCd batteries, and they don't suffer from the memory effect problem. This makes them better suited for use in digital cameras and other devices that require large amounts of power. Although they were expensive when they first arrived on the market, the price of NiMh batteries has dropped dramatically in the past two years. NiMh batteries are the best choice for most digital camera users.

If you already have a NiCd charger, don't try to save money by using your old charger for NiMh batteries! Although they have similar names and are based on similar technologies, the two batteries use completely different chargers. Figure 6.8 shows two inexpensive chargers that accept both NiCd and NiMh batteries.

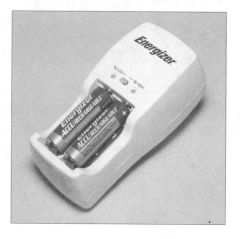

Figure 6.8

Two combination NiCd/NiMh chargers. The smaller unit on the left charges 4 batteries overnight. The larger unit on the right charges 8 batteries in 2 1/2 hours.

All NiMh batteries are not created equal. Manufacturers rate the power capacity of their batteries in milliamp hours, abbreviated *mAh*. This rating describes how long the battery can put out a specific amount of power. AA NiMh batteries typically run anywhere from 1100 to 1800 mAh. The capacity rating is usually marked on the battery, as shown in Figure 6.9.

Figure 6.9

These two AA NiMh batteries—both from the same manufacturer—have very different capacity ratings. The upper battery is only 1200 mAh; the lower one provides 1600 mAh, or 33% more power.

NIMh batteries don't last forever. They can be charged and discharged a finite number of times, usually somewhere between 500 and 800 times. If you buy more than one set of batteries, make sure you use the batteries as a set, and don't mix batteries from one set with batteries from another. Use a piece of colored tape or a permanent marker to identify the batteries in each set so you don't mix them up.

Power Struggle

NiCd and NiMh batteries share an annoying trait called self-discharge. NiCd and NiMh batteries lose 1% (NiCd) to 3% (NiMh) of their charge per week, even if they are just sitting in your camera bag.

Moral of the story: If you buy an extra set or two of rechargeables, make sure they're charged before you use them. If they've been sitting around, they'll let you down just when you need them most!

OFF-CAMERA FLASH UNITS

Virtually all point and shoot cameras include a built-in electronic flash. Like everything else in a compact camera, the built-in flash represents a design compromise among cost, size, and power consumption. As a result, the flash unit in most cameras is perfectly adequate for typical point and shoot applications like close-ups of the kids or small group photos. But when you need to cover a large area or light a subject more than about 12 feet away, most built-in flash units literally fall short.

External flash units like the one shown in Figure 6.10 solve many of these problems. These units are several times more powerful than built-in flash units, and they provide a wider beam of light, which makes them a good choice for use with wide-angle lenses.

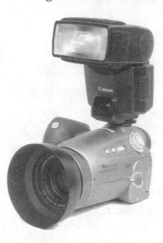

Figure 6.10

This Canon external flash unit is mounted on a Canon PRO90IS camera.

As you can see from the picture, this particular flash unit attaches directly to the camera with no external cables or adapters. The mechanical and electrical connection between the camera and the flash is accomplished by a connector called a *hot shoe* (see Figure 6.11).

Figure 6.11

This is the hot shoe mount on the Canon PRO90IS. The five round silver spots are electrical connectors that let the camera and the flash communicate with one another.

Unfortunately, many compact digital cameras are too small to have a hot shoe, so you can't attach a flash directly to the camera. Some cameras—like the Nikon 990 shown in Figure 6.12—don't have a hot shoe, but they do have a connector that enables you to connect an external flash. Of course, after you've connected the flash, you need someplace to put the flash. Nikon and several other vendors sell flash mounting bracket kits that contain a mounting bracket and a cable with a hot shoe. This lets you use a standard hot shoe flash, and it provides a sturdy mounting place for the flash unit. Figure 6.12 shows the Nikon 990 with the Nikon mounting bracket and a Nikon SB-28 flash unit.

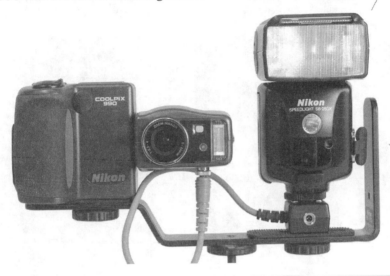

Figure 6.12

Nikon's SK-E900 flash bracket kit includes a mounting bracket and a cable that connects to the camera. Although this arrangement looks awkward, it is surprisingly easy to hold.

There are other advantages to moving the flash off of the camera. If you've ever used a point and shoot camera, you've probably seen a phenomenon aptly named *red eye*. Red eye happens when the flash reflects off the cornea in the eye. Moving the flash away from the lens significantly reduces red eye. Most external flash units can be tilted so that they shoot light up instead of straight ahead. This technique is called *bounce flash*, and it produces a softer, more pleasing light than the harsh "deer in the headlights" look that you often get with an on-camera flash. Bounce flash is also very useful for lighting large areas like room interiors.

So what do you do if your camera doesn't have a hot shoe or a flash connector? Several manufacturers make a small, inexpensive device variously called a slave trigger, flash eye, or photo sensor that attaches to any flash unit with a hot shoe. The slave trigger has a light-sensitive device called a photocell on the front. When the photocell "sees" a flash of light—like the one from your P&S camera's built-in flash—it fires the flash unit attached to the hot shoe.

No See, No Flash

When using a slave flash, make sure the photocell can "see" your camera, otherwise the slave flash won't fire. Also, make sure that the slave flash is placed outside your picture area.

Slave triggers are very useful, even if your camera does have a hot shoe. The only problem with slave triggers is that they don't automatically adjust the flash unit's light output, so some trial and error is often needed to get just the right combination of settings and flash location. Figure 6.13 shows two pictures taken with and without a slave flash unit.

Figure 6.13

These two pictures were both taken with a Fujifilm FinePix 6800 camera. The picture on the left was taken with the camera's built-in flash, and the picture on the right was taken with an external flash with a slave flash trigger.

As you can see from the two pictures, the camera's built-in flash doesn't have enough power to cover this large room. The slave flash was bounced off the ceiling to eliminate shadows and provide even illumination of the entire room.

You can use virtually any external flash unit with a slave trigger, but I've found it more convenient to use flash units that have adjustable power settings. These flash units let you adjust the brightness of the flash quickly and easily, so you can achieve a good balance of built-in and external flash without overpowering the subject with light.

CAMERA SUPPORTS

By this point in most photography books, the author would have told you to always use a tripod for every shot, no matter how inconvenient. I'm more pragmatic than that. You should use a tripod when you need one. So when do you need one? Here are a few suggestions:

- In low light conditions with slow (less than 1/30 sec.) shutter speeds
- With telephoto lenses, where the big lens magnifies camera shake as much as it magnifies your subject

- For building interiors and exteriors, scenic pictures, and group photos where it's important for the camera to be perfectly level
- Any time you want to take a sequence of pictures of the same subject or event (the parasailer in Figure 6.5 is a good example)

Other than these (and similar) cases, you have my permission to leave your tripod at home. I ask you to return the favor by buying a good, sturdy tripod. Cheap, flimsy tripods are actually worse than no tripod at all because they offer all the inconvenience of having to carry a tripod, but they don't provide a steady support for your camera.

Full-Size Tripods

Pro-level tripods for 35mm cameras can be very expensive. Fortunately, most digital cameras are much lighter than 35mm cameras, so you don't need a heavy, expensive tripod. Figure 6.14 shows my favorite lightweight tripod, the Bogen model 3405.

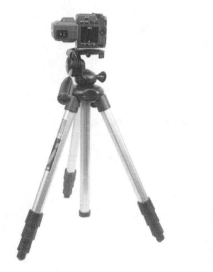
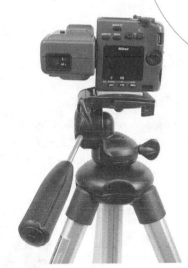

Figure 6.14

Bogen's model 3405 tripod folds down small enough to fit in a suitcase. It's easy to adjust and includes a built-in quick release mounting system.

Several companies make tripods similar to Bogen's, but you should expect to pay at least $65 to $90 for a decent tripod. Larger tripods are usually sold as legs only, so you must purchase the legs and the tilt/swivel mechanism—called a *head*—separately.

The Bogen 3405 weighs less than 4 pounds and includes a permanently attached head with a built-in quick release system. Other manufacturers offer similar systems, but they all work the same way. Instead of fighting with the tripod screw every time you want to attach the camera, you attach a small plate to the bottom of your camera. When you want to attach the camera to the tripod head, you simply lift a lever on the head and snap the camera into the quick-release mechanism. Figure 6.15 shows how a quick release system works.

Figure 6.15

Bogen's quick release system uses a small metal plate (left) that screws into your camera's tripod socket. The plate snaps directly into the tripod head (right). To release the camera, you pull out on the lever underneath the head.

A quick release system makes the tripod much easier to use, so you're more likely to actually use the tripod. If you have several cameras, you can buy additional plates for each camera, and simply leave the plates on the cameras.

Mini Tripods

There are times when you'd like to have a tripod, but weight and size restrictions force you to leave your tripod at home. I keep another Bogen product—the 3007 mini-tripod—in my camera bag at all times. This tiny tripod weighs less than a pound, and it's only a few inches tall, as you can see in Figure 6.16.

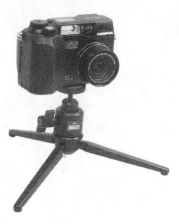

Figure 6.16

The Bogen 3007 tabletop tripod with the model 3009 tilt/swivel head is sturdy enough to hold the heaviest P&S camera.

So what good is a tripod that's only a few inches tall? You'd be surprised. Manufacturers call these tiny tripods "tabletop" tripods, but I've used mine in hundreds of shooting situations, very few of them involving an actual table.

For example, I took some stunning night shots of Times Square (see Figure 14.16) by placing my camera and mini-tripod on top of a newspaper box. I've used it to photograph dark church interiors in Italy, where flash and full-sized tripods are uniformly forbidden. And I've used it to take family photos (with myself in the picture for a change) by using my camera's self-timer feature.

On the Level

Okay, so I've convinced you that you need a tripod. But you need one more inexpensive accessory before you take off on vacation with your digital camera: a level.

The human eye can detect the smallest tilt in a picture, even as little as 1 degree. Unfortunately, it's very difficult to set up a tripod with the legs perfectly level, especially in uneven terrain. That's why you need a level.

I keep two levels in my camera bag. One costs $30, and the other $2. They both do the same thing, but the $30 level is much more convenient to use. Figure 6.17 shows what I mean.

Figure 6.17

The picture on the left shows a $30 two-way level that mounts into a camera's flash shoe. For cameras without a flash shoe, a $2 circular level works just as well.

The $30 level works great on cameras with a flash shoe. It's very easy to see, even in dim light, but it's also expensive and easy to lose. The $2 circular level was designed for leveling machinery and record turntables, but it works fine with digital cameras—as long as you have a flat, level surface on top of the camera.

SUMI'S SNAPSHOT

How do I know when I've adjusted a polarizer correctly?

There's no right or wrong way to use a polarizer, but it is possible to overdo polarization. If the sky looks black on the preview screen or through the viewfinder, back off a little until the sky brightens up a bit.

I left some NiCd batteries in a drawer for a year, and now they're dead. What should I do?

Charge them up, run them down, and then charge them again. A flashlight provides a quick, convenient way to run your batteries down completely.

Can I use more than one slave flash at a time?

Yes, I've taken pictures with 3 or 4 flashes at once. The trick is to keep the flash beams from overlapping so that they don't create "hot spots" in the pictures.

EXPOSURE BASICS

No photography book is complete without a section on exposure, one of the key concepts of photography. In some ways, exposure is a lost art. Before the arrival of automatic cameras, all photographers had to possess at least a basic understanding of exposure technique.

Today's film and digital cameras include automatic exposure features that enable you to take excellent, well-exposed pictures without your knowing the first thing about exposure. But before you decide to skip this chapter and move on to more interesting stuff, listen to this: When you know the basics of exposure, you're able to take better, more consistent pictures, even under difficult lighting conditions.

This chapter covers the following:

- What exposure is, why it's important, and how it is determined
- How to tell the difference between a good exposure and a bad one
- Tips to help you get the best possible picture every time

EXPOSURE—WHAT'S THE BIG DEAL?

There are entire books—big, thick, complicated books—dedicated to the topic of exposure. You can't get the most from your camera—digital or film—unless you understand the basics of exposure. The material presented in this section helps you understand the basics but is not intended to be the last word on the subject.

The Zone System

The last word on the subject of exposure is also one of the first—*The Negative* by Ansel Adams. First published in the 1930s, it has been updated over the years to accommodate advancements in film and camera technology. Along with Adam's *The Camera*, and *The Print*, it is one of the definitive works on photography. All three books contain examples of Adam's groundbreaking, breathtaking photography.

Exposure is the process of exposing film (or an image sensor) to light to create a picture. From the photographer's perspective, not much happens when you take a picture. You compose the shot, press the shutter release, and get on with your life. It's all over in a fraction of a second.

But inside the camera, a complex series of events takes place. First, the camera's autofocus system determines what it is you want to take a picture of, and it focuses the lens on the subject. Next, electronic sensors in the camera determine the proper combination of lens aperture and shutter speed for the current lighting conditions. A diaphragm inside the lens moves into the position determined by the camera's autoexposure circuitry, the camera's shutter opens for an instant, and the film or digital image sensor is exposed to light focused onto the film by the lens. After the exposure, the shutter closes and the lens diaphragm returns to the wide-open position. In a film camera, the film advances to the next frame. In a digital camera, the camera's electronics collect and store the image data captured by the image sensor.

Most digital cameras don't have mechanical shutters like film cameras. Instead, the data stored in the image sensor is wiped clean and the sensor is allowed to collect light for a fraction of a second, using an electronic "shutter." This has the same effect as the mechanical shutter opening and closing.

A correct exposure is one that produces a picture with just the right balance between light and dark. Pictures that are too light are *overexposed*; pictures that are too dark are *underexposed*.

DETERMINING CORRECT EXPOSURE

Four major factors determine what the proper exposure should be for a given scene:

- Light striking the subject
- Lens aperture size (also called the *f-stop*)
- Shutter speed
- Film (or image sensor) sensitivity

The light is the one element you usually can't control, unless you're working with studio lights or an electronic flash.

Virtually all cameras can adjust the lens aperture and the shutter speed, either with manual controls or electronically with no user intervention. Exposure is controlled by selecting a lens aperture and shutter speed that allow the proper amount of light to pass through the lens and onto the camera's film or image sensor. The amount of light necessary for correct exposure is determined by the camera's light metering systems. As you see later, all digital cameras offer fully automatic exposure control, and many allow at least some manual control over exposure.

Film sensitivity is rated using a linear, industry standard called the ISO rating. ISO 400 film is 4 times more light-sensitive than ISO 100 film. Digital cameras don't use film, but their image sensors are also rated using the ISO system. Digital cameras can electronically adjust the image sensor sensitivity to suit the lighting conditions—something you can't do in a film camera without changing film.

What's an ISO, Anyway?

You've probably heard the term *ISO* before, either as applied to film speed ratings, or as part of the ISO 9000 quality measurement system. But what does ISO stand for? We visited the ISO Web site to find out, and here's what we learned:

"Many people will have noticed a seeming lack of correspondence between the official title when used in full, International Organization for Standardization, and the short form, ISO. Shouldn't the acronym be IOS? Yes, if it were an acronym—which it is not.

In fact, ISO is a word, derived from the Greek *isos*, meaning "equal", which is the root of the prefix *iso-* that occurs in a host of terms, such as *isometric* (of equal measure or dimensions) and *isonomy* (equality of laws, or of people before the law)."

So now you know. There's more info at www.iso.ch, including an amazing list of things that have been standardized over the years.

Measuring Light

In the early days of photography, determining the correct exposure was a chore. Users had to either guess at the proper exposure (and experienced photographers got to be amazingly good at this), or they took one or more light readings with a hand-held light meter, and then set their camera's aperture and shutter speed based on the reading taken from the meter.

Modern film cameras (and all digital cameras) have built-in light meters with automatic exposure circuits. Electronic sensors inside the camera analyze the light striking the subject and determine the most appropriate combination of shutter speed and lens aperture to achieve the correct exposure. Digital and film cameras measure the light in different ways, but the end result is the same.

Light Meter Lingo

If you've done some camera shopping, you've probably encountered the terms average metering, matrix metering, multi-area metering, and spot metering. These are terms used to describe different light metering options available in more advanced cameras.

The *averaging meter* is the most basic and most common type of light meter. Several sensors measure the light passing through the lens, and the readings from the sensors are combined to arrive at an average reading. Averaging meters are simple and inexpensive, but they are easily fooled by unusual lighting conditions.

Center-weighted meters improve on averaging meters by measuring the center part of the picture frame. This prevents large light or dark areas from fooling the meter.

Spot meters measure light from a narrow spot in the center of the frame. Spot meters are most useful in manual exposure mode, or in conjunction with an exposure lock button, which is explained in Chapter 8, "Camera Features."

Matrix metering, adaptive metering, and multi-zone metering are different camera manufacturer's terms for similar light metering systems. These systems use several light readings, usually from 3 to 5 different areas in the picture. But instead of averaging the measurements together, the camera's electronics analyze the readings and make an educated guess about the picture.

What a Light Meter Sees

It's important to understand that all light meters base their readings on a middle gray tone. Technically speaking, light meters are calibrated to return an accurate reading off of a surface that reflects 18% of the light striking the subject.

Camera stores sell special 18% gray cards that you can use to take meter readings. You use the card by placing it in front of the subject and taking your light reading off the card instead of the subject.

The sophisticated metering systems in modern cameras are designed to determine an average reading by metering several areas in the frame, and they produce accurate readings in most lighting conditions. But even the most sophisticated metering systems can be fooled by scenes with large light or dark areas.

For example, let's say you're taking pictures on the ski slopes. There's a lot of snow, and it's the middle of the day. The camera sees all that white and adjusts the exposure so that the large white area in the picture is 18% gray—exactly what you don't want it to do. The opposite effect happens when you're shooting a subject that is mostly dark; the camera wants to make the very dark areas 18% gray, and the pictures come out too light.

When you're shooting in extreme lighting conditions, take a test shot or two and see if you need to use your camera's exposure compensation feature (described in Chapter 8) to adjust for the lighting.

F-Stops and All That Photographic Stuff

When discussing exposure, photographers often refer to the amount of under- or over-exposure in terms plus or minus f-stops. *f-stop* numbers measure the amount of light passing through a lens. The standard f-stop numbers are 1.4, 2, 2.8, 4, 5.6, 8, 11, 16, 22, and 32. As you move up the scale, each f-stop passes half as much light as the stop before. For example, a setting of $f/8$ passes half as much light as a setting of $f/5.6$. An image that is underexposed by 50% is said to be "one stop under."

Shutter speeds aren't measured in f-stops, but in fractions of a second. Typical shutter speeds are 1/30 sec., 1/60 sec., 1/125 sec., and so on. As you can see, each step up in shutter speeds is about twice as fast as the previous speed. Because the shutter is only open half as long, it passes half as much light. Each step in shutter speed results in a one-stop exposure change.

JARGON

Aperture or F-Stop?

Beginning photographers are often confused by the terminology of exposure. Shutter speed is easy enough to comprehend, but the terms f-stop and aperture often throw newbie photographers off track. They mean the same thing, but they're opposites, too.

The f/number of lens is a measurement of the lens' focal length (f) divided by its diameter. For example, a 100mm lens that is 50mm in diameter is an $f/2$ lens. All lenses contain a metal diaphragm, often called an iris, that can reduce the amount of light passing through the lens. By closing the iris, the photographer can control the amount of light passing through the lens.

The confusion comes from the fact that lower f/numbers represent larger lens openings (more light), and higher f/numbers indicate smaller lens openings (less light) .

Using Exposure to Enhance Your Pictures

For any given picture, there are several combinations of lens aperture and shutter speed that produce a good exposure. For example, suppose you want to take a picture of a flower in your garden on a sunny day. A typical bright day might require an exposure of 1/500 at $f/8$. The following settings all provide the same exposure:

- $f/2.8$, 1/4000
- $f/4$, 1/2000
- $f/5.6$, 1/1000
- $f/8$, 1/500
- $f/11$, 1/250
- $f/16$, 1/125
- $f/22$, 1/60

All of these settings allow the same amount of light to strike the image sensor, so they all provide an equivalent exposure. Because smaller lens apertures pass less light, they require slower shutter speeds to produce the same exposure.

Controlling Depth of Field

As you saw in Chapter 5, "All About Lenses," larger lens apertures (smaller f-stop numbers) produce images with less depth of field than smaller apertures. Because there are several shutter speed/f-stop combinations that provide the correct exposure for a given scene, you can control the depth of field in your picture by selecting a smaller or larger f-stop as appropriate. As you adjust the f-stop, you need to adjust the shutter speed to compensate.

In many situations—scenic pictures, building interiors, and group photos, to name a few—you want to use a small aperture to get as much depth of field as possible. At other times, you might want a shallow depth of field to isolate a subject from a distracting background. This is a common technique in portrait photography.

Your Eye's Iris

Did you ever notice that some people (usually those who need glasses but won't admit it) squint to see objects in the distance? There's a good reason for this. Squinting creates a smaller opening (aperture) for your eyes to see through. Just like a camera lens, the smaller opening increases depth of field, allowing nearsighted persons to see distant objects more clearly!

In many cases, changing the aperture also affects the performance of the lens. There's no hard and fast rule because each lens design is different. But most lenses perform better at middle aperture settings, from $f/5.6$ to $f/8$.

Blurring Backgrounds

Depth of field is determined by several factors, including the distance between the camera and subject, the aperture, and the focal length of the lens.

You can use shallow depth of field as a tool to eliminate distracting background elements from a picture. Longer lenses have less depth of field than shorter lenses. To throw the background out of focus, use the longest possible focal length.

Controlling Action

You can manipulate the shutter speed to freeze motion or to intentionally blur the action, giving the picture a sense of motion. As an example, the two pictures in Figure 7.1 were taken at two different shutter speed/aperture combinations.

As you can see, the two pictures of the golfer were taken from the same location, just seconds apart. Why are they so different? The picture on the left was taken using a small lens aperture to maximize depth of field, and the picture on the right was taken using a fast shutter speed to freeze the motion of the golfer's swing. Despite the differences in shutter speed and aperture, the overall exposure is the same for both pictures.

Figure 7.1

These two pictures of a golfer in mid-swing show the effect of varying lens apertures and shutter speeds.
The left picture was exposed for 1/15 sec at f/18; the right picture was exposed for 1/500 at f/4.

Thanks to the small lens aperture, the picture on the left has more depth of field. The golf balls in the grass, the trees in the distance, and the net are in sharp focus, but the golfer's arms and left foot are blurred due to the fast motion of her swing. In the picture on the right, the fast shutter speed nearly froze the golfer in mid-swing. The faster shutter speed required a larger lens aperture, which produced less depth of field. As a result, the trees, net, and other background objects are not in sharp focus.

 Hold It!

If you really want to freeze a fast-moving subject, use a flash. Electronic flash produces a very brief (1/1000 to as short as 1/5000 of a second) burst of light that can freeze just about anything short of a speeding bullet.

Incorrect Exposure

Proper exposure is essential because cameras can only capture a limited range of tones. The goal of good exposure technique is to adjust the camera's tonal range to fit the scene being photographed.

The three pictures in Figure 7.2 show how even a small amount of over- or underexposure can affect a picture.

Figure 7.2

The center picture is properly exposed. The leftmost picture is underexposed, and the right picture is overexposed.

The pictures on the left and right are under- and overexposed, respectively, by 2/3 of a stop. As you can see, the left picture looks dark and muddy. The details in the top of the doorframe and in the window are so dark that you can barely see them. The right, over-exposed picture has a different set of problems. There's plenty of detail in the door frame and windows, but the lettering over the door is washed out, and many of the details in the plaster around the window frame are washed out. The center picture strikes a balance between the two extremes, keeping as much detail as possible in both the shadows and the bright areas.

JARGON

Latitude

Many inexpensive point and shoot film cameras have very crude automatic exposure mechanisms that don't handle extremely dark or light subject matter very well. Modern color negative films are designed to tolerate a good bit of exposure error, an attribute the film makers call *latitude*.

Digital image sensors don't have as much latitude as color film, so exposure is much more critical. Fortunately, most digital cameras contain very sophisticated autoexposure features that make it easy to get good pictures in most lighting conditions.

Figure 7.3 shows how exposure affects the range of tones captured in a picture. The three pictures show a standard color chart, called a GretagMacbeth chart, that photographers use to check color and exposure. The GretagMacbeth chart contains eighteen colored squares used for color checking and six gray squares used for exposure tests.

Figure 7.3

These three pictures of a standard color checker chart show the effects of under- and overexposure.

The center picture is correctly exposed. The pictures to either side are minus (left) and plus (right) one full stop of the correct exposure. (At this point, you're hopefully getting the hang of this f-stop stuff!) Although these pictures show the entire color chart, you're really only concerned with the six squares at the bottom of the chart.

The middle image is properly exposed. All six squares on the bottom row appear as unique shades of gray, and there is good contrast between each adjacent pair of gray squares.

Now look at the underexposed image on the left. As you can see, it is considerably darker than the other two images. The white square on the bottom left corner is gray instead of white. The dark gray square (second from the right) is almost the same shade as the black square.

Finally, look at the right image. Notice that the light gray square is nearly white. The black square now appears dark gray.

When you overexposure a picture, all the detail in the bright parts of the picture is lost forever. But when you underexpose a picture, the image detail is still there—it's just not where it's supposed to be. Moderately underexposed shots can often be salvaged using any image editor program.

AUTOMATIC EXPOSURE MODES

Virtually all cameras provide at least one auto exposure mode; most cameras offer several. The autoexposure systems in most cameras are designed to produce well-exposed pictures in a wide variety of lighting conditions. In other words, they improve your odds of getting a good picture on the first try.

Autoexposure technology can determine the technical aspects of exposure, but there are aesthetic considerations that the camera can't decide on its own. Most digital cameras allow the photographer to alter or override the exposure settings chosen by the camera. This provides the photographer with an important creative tool—for those who know how to use it!

Many camera users simply select the fully automatic setting when they buy their cameras and never change it. But in doing so, they're giving up some creative control over their pictures by letting the camera decide what aperture and shutter speed to use. By learning to use the additional modes available on your camera, you can experiment with different shutter speed and aperture combinations to get exactly the effect you want.

Program Mode

The most common type of autoexposure—often called *programmed mode*—automatically determines both the aperture and the shutter speed for each picture. Program mode provides good, reliable autoexposure under most lighting conditions, but it doesn't let the photographer choose the aperture or the shutter speed. Most cameras try to use the largest lens opening and highest shutter speed possible; this helps to avoid camera shake.

Some cameras enable the user to quickly change the aperture/shutter speed combination by rotating a dial or pressing a button. This is useful when you want to override the camera's exposure choice for one or two shots.

Aperture Mode

Aperture priority mode, called *Av mode* by some camera makers, enables you to manually choose an aperture. Aperture mode gives you good control over depth of field because you choose the aperture that best suits the subject matter (see Figure 7.4). As you adjust the lens aperture to the desired setting, the camera automatically adjusts the shutter speed to compensate.

Figure 7.4

A wide angle lens set to a small aperture provides nearly infinite depth of field, as shown by this picture of student geologists in Death Valley. (Canon EOS D30, 14mm lens. 1/200 sec. @ *f*/11)

You need to be careful with aperture mode, though. Choosing a very small aperture in anything less than full daylight results in the camera choosing a slow shutter speed. This can lead to blurry pictures, unless the camera is mounted on a tripod.

Use aperture mode when you want to control depth of field. A shallow depth of field can be used to make a subject stand out against a busy or distracting background (see Figure 7.5).

Figure 7.5

A long lens and wide aperture help you isolate your subject from the background. (Fuji S1 Pro, 300mm lens. 1/750 sec. @ *f*/4)

Shutter Mode

Just the opposite of aperture mode, *shutter priority mode* (called *Tv*, or *time value, mode* on some cameras) enables you to select a shutter speed; the camera then selects the appropriate aperture. Shutter priority is most useful when you want to set an unusually low or fast shutter speed. Slower speeds blur motion, and higher speeds freeze motion (see Figure 7.6).

Figure 7.6

A fast shutter speed freezes action, as shown in this picture of a Cormorant making a splash-down.
(Canon EOS D30, 400mm lens. 1/320 @ *f*/5.6)

SUMI'S SNAPSHOT

My camera has P, A, and S modes, but it also has several other modes represented by little icons on the mode dial. What are those modes, and what do they do?

Many cameras have several mode settings designed for specific types of pictures. These modes enable you to tell the camera what type of picture you want to take. These modes vary from one camera maker to another, but the following table describes a few typical pre-programmed setting modes:

Mode	Effect
Portrait	Selects small aperture to insure shallow depth of field
Sport	Selects highest possible shutter speed to freeze action
Night	Selects slow shutter speed and enables flash; this prevents black backgrounds when shooting flash pictures at night
Scenery	Selects small aperture to insure large depth of field

Some cameras have an "Auto" ISO setting. What does this do?

Cameras with this setting can automatically adjust the sensitivity of the image sensor. This allows the camera to automatically switch to a higher ISO setting when there's not enough light to take a picture at a lower setting.

Why can't I just leave the ISO setting on its highest setting? I always shoot ISO 800 film in my camera, and I prefer the higher sensitivity.

High ISO settings like high-ISO films—provide increased sensitivity, which enables you to take pictures in available light without a flash. But with both film and digital cameras, the higher ISO settings also produce noticeable grain in the pictures. You should always use the lowest possible ISO setting in your digital camera.

CAMERA FEATURES

Newcomers to digital photography are often amazed—
or perplexed—at the sheer number of knobs, buttons,
dials, and other controls on a typical digital camera.
All those knobs, buttons, and dials do something—
but what?

In this chapter, you get a guided tour of those knobs,
buttons, dials, and menu screens. Along the way, we
point out features that are common to most cameras,
and we also show you some neat features that make
certain cameras unique. If you haven't purchased a
camera yet, this chapter might point out some features
that you just can't live without.

This chapter assures you that although digital cameras
have many more controls than film cameras, they aren't
necessarily harder to use—they're just different.

Although all digital cameras have similar controls, the
placement and operation of camera controls vary
widely among manufacturers. Some cameras are a
pleasure to use, others have quirks that might drive
you nuts. If you're planning to advance beyond the
fully-automatic, point-and-shoot mode of photography,
you want to learn as much as you can about camera
controls.

There's a lot of material to cover in this chapter, so this tour is split into five parts:

- Viewing and focusing
- Exposure
- Flash
- Shooting
- Image playback

FRAMING AND FOCUSING FEATURES

It doesn't matter how many pixels your camera has or how good the lens is if you can't accurately compose and focus your pictures. In this section, we'll show you some camera features and controls designed to make framing and focusing easier and more accurate.

Viewfinders Versus LCD Screens

As you saw in Chapter 2, " Which Camera to Buy?" there are several basic types of digital cameras, including point-and-shoot, SLR, and virtual SLR cameras. The viewfinders in SLRs and virtual SLRs are about 90 to 95 percent accurate, so you can be fairly sure that what you see in the viewfinder is what you'll get in the final picture. The same isn't true for point and shoot cameras with optical viewfinders.

Optical viewfinders have two advantages over LCD displays or the camcorder-style electronic viewfinders found on virtual SLRs. First, optical viewfinders are relatively bright, especially when compared to SLR viewfinders. This makes it easy to compose your pictures, even in dim light. Second, optical viewfinders don't use any battery power; LCD and EVF displays are very power-hungry.

There are two main downsides to optical viewfinders: They aren't very accurate, and they can't show focus.

Look at any P&S camera, and you see that the viewfinder window is positioned some distance from the camera's lens. The view through the viewfinder and the picture seen by the camera aren't exactly the same. Camera makers compensate for this error—called *parallax error*—as much as they can. But the correction is usually made at the camera's infinity focus setting, so that the viewfinder and lens agree when taking pictures of distant objects like scenery. The closer your subject is to the camera, the greater the parallax error. The end result is that subjects that appear to be centered in the viewfinder are actually off to one side of the picture, especially at close camera-to-subject distances.

Second, optical viewfinders are always in focus, but the camera's lens is not. It's possible to make a viewfinder with a focus indicator (called a rangefinder), but rangefinders are very complex and expensive to build.

For critical shots where you want to make sure that the subject is framed just the way you want, you need to use your camera's LCD display. The image you see on the LCD display is nearly identical to the one the camera captures when you press the shutter release. Most

LCD displays show the center 90 percent of the picture, so objects just outside of view on the LCD preview might in fact be in the final picture.

The LCD display on most cameras can be used for image preview and for checking pictures after you've taken them. Because they use so much power, virtually all cameras have a button that enables you to turn the LCD on and off as needed.

Camera makers have taken good advantage of the LCD to add features that aren't possible with conventional film cameras. For example, Figure 8.1 shows the LCD display from a Toshiba PDR-M81 camera.

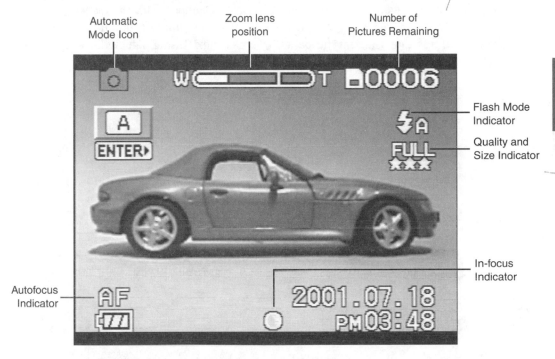

Figure 8.1

The LCD display from a Toshiba PDR-M81 camera contains plenty of useful information about the camera's settings, battery condition, memory space remaining, and flash mode.

Toshiba's display shows virtually everything you want to know about the camera at a glance. In fact, there's so much information on the screen that it can get in the way; fortunately, you can turn it off with the press of a button.

Starting at the top left, the camera icon tells you that the camera is in automatic mode. The "A" directly beneath the camera icon indicates that the camera is in program autoexposure mode; pressing the camera's Enter key pops up a menu of other modes, including Aperture and Shutter priority exposure modes. The "AF" at the lower left indicates that the camera is in auto focus mode, and the battery icon at the lower left corner shows that the battery is fully charged. The white dot in the lower center of the picture indicates that the lens is in focus. The date and time appear at the bottom right corner.

Back up at the top of the screen, the horizontal scale shows the current position of the zoom lens, from "W" (wide) to "T" (tight). The number 0006 indicates the number of pictures remaining on the camera's memory card. The flash symbol with the "A" indicates that the flash is set for automatic mode, and the "FULL" indicator with the three stars indicates that the camera is set for full-sized images in the highest-quality setting.

Many cameras feature a second, smaller LCD display, usually located on the top of the camera. The small LCD screen usually shows a frame counter, battery status, and flash mode. The second display is always on, but uses very little power.

For example, Figure 8.2 shows the status LCD on an Olympus E-10. The display shows the flash mode, white balance mode, picture quality setting, frame counter, and the shutter speed and aperture settings. The panel is located next to the viewfinder eyepiece and includes a button that illuminates the LCD when working in dark locations.

Figure 8.2

The Olympus E-10 has a small LCD panel that displays important information at a glance.

Fujifilm's cameras have a clever feature that displays horizontal and vertical lines on the display (see Figure 8.3).

Fujifilm's display grid uses two horizontal and two vertical lines to divide the screen into 9 zones. The lines make it easy to hold the camera level, which is especially important when you're photographing scenery, buildings, and other subjects with strong horizontal or vertical lines that appear crooked if the camera isn't perfectly level. The lines also make it easy to compose pictures using the rule of thirds, a compositional aid used by many photographers. The rule of thirds is covered in detail in Chapter 14, "Difficult Pictures Made Easy."

Figure 8.3

Most Fujifilm cameras feature a grid overlay display that aids composition and makes it easy to hold the camera level.

Zoom Lens Controls

Zoom lenses are a great convenience, because they enable you to adjust the camera's field of view. By increasing the focal length, you can make the main subject appear larger; decreasing the focal length provides a wider field of view and makes the subject appear farther from the camera. Without a zoom lens, you have to move the camera closer to or farther away from the subject to achieve the same effect—and that isn't always possible.

Most P&S cameras have a motorized power zoom lens. When you press the zoom controls, tiny motors inside the lens adjust the position of the glass elements in the lens to adjust the focal length. Power zooms are operated by a two-position switch, usually on the back of the camera. Figure 8.4 shows some typical power zoom controls.

The zoom control on the Olympus 3040 shown in Figure 8.4 is typical of most point and shoot cameras. The zoom control is a spring-loaded switch that normally remains in the center (off) position. Pushing the switch towards the "W" (wide angle) mark zooms the lens to a wider position; pressing towards "T" (telephoto) zooms in. The Olympus zoom control is located in front of the shutter release button, making it easy to change the zoom position without removing your finger from the shutter release. Most camera makers put the zoom controls on the rear of the camera, where it can be operated with your thumb.

Zoom Wide/Telephoto Control

Zoom Ring

Figure 8.4

The Olympus C-3040Z (left) and Canon PRO-90IS (right) both feature motorized zoom lenses.

Canon's PRO-90IS takes a different and unique approach. The zoom control is a large, knurled ring located at the front of the lens. You rotate the ring one direction to zoom in, and in the opposite direction to zoom out. The farther you turn the ring, the faster the lens zooms. The variable speed zoom is a nice touch, but the location of the zoom control precludes one-handed operation. On the plus side, using both hands reduces camera shake, an important factor, considering the Canon's big 10X zoom lens.

Some digital SLRs—like the Olympus E-10 and Minolta Dimage 5 and Dimage 7—use a manual zoom ring like the one shown in Figure 8.5.

Figure 8.5

Minolta's Dimage 5 and 7 feature a 7X zoom lens, operated by rotating the rubber grip in the middle of the lens.

Like the Canon PRO-90IS, the location of the zoom ring also requires you to hold these cameras with both hands. Unlike the Canon, these are manual, non-motorized zoom lenses. They're much quicker to adjust than motorized lenses, because you can simply turn the zoom ring to adjust the zoom. Because they don't have motors, they don't draw any power from the battery.

Focusing Controls

Virtually all digital cameras include automatic focusing, which provides fast, accurate focusing in most shooting conditions. But there are times when even the most sophisticated autofocus system fails. This is especially true when the camera can see more than one object in the lens; when this happens, the camera has no way of knowing which object to focus on.

Camera designers know this, so they've come up with several ways to modify or override autofocus for tricky situations. Figure 8.6 shows Nikon's novel solution to the problem.

Figure 8.6

Nikon 900 series cameras feature five user-selectable focusing points that help deal with off-center subjects.

Nikon's AF area selection control enables you to choose one of five zones; the camera then focuses on the selected zone. In Figure 8.6, the center zone (which is right over the door of the car) is selected, so it's a little hard to see. The other four zones appear as white squares on the LCD display; the active zone appears in red. Nikon's automatic focus selection mode works much the same way, but the camera automatically selects the closest subject; the automatically selected focus zone shows in red on the LCD so you can verify the camera's focus point selection.

Manual Focus

Despite the convenience of automatic focusing, there are times when you want to manually focus the lens. This is especially true when you are photographing small objects that are very close to the camera. Figure 8.7 shows a good example.

Figure 8.7

Shots like this picture of a dragonfly pose a real problem for autofocus systems.

This picture fools most autofocus systems for several reasons. First, the dragonfly is off-center in the picture, perched on a very thin reed. The reed's small surface area isn't large enough to catch the attention of the camera's autofocus system. The dragonfly occupies only a very small percentage of the total picture frame, making it almost invisible to the camera's autofocus system.

When faced with a shooting situation like this, you have to make a choice: You can fight with the camera's autofocus system until the dragonfly takes off, or you can switch to manual focus and get the picture in a second or two.

Trying to determine sharp focus on a tiny 1.5" LCD screen in bright sunlight isn't easy. To make matters worse, the manual focus controls on some digital cameras are difficult to use. Fortunately, some camera makers take manual focus seriously and offer tools to help you find perfect focus, even in less-than-perfect conditions.

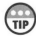

Don't Touch That Dial!

Most digital cameras don't have a dedicated focusing dial or knob like you'd find on a conventional camera. In most cases, you use a menu option or button to put the camera into manual focus mode; after that, you focus using two buttons on the camera's keypad. One button focuses closer, the other farther away. Video game skills help here, because you're almost guaranteed to miss getting the camera in focus on the first try.

Olympus' 3040Z features a novel focusing aid that magnifies the center portion of the image and displays it full screen while you're adjusting focus. This is a great feature that sounds much more complicated than it is. Figure 8.8 shows how it works.

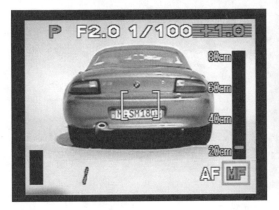

Figure 8.8

The higher-end Olympus P&S cameras, such as the 3040Z shown here, feature an automatic focus magnifier tool that makes manual focusing a snap.

When you switch the camera into manual focus mode, the camera displays a distance scale on the right side of the screen, with "AF" and "MF" icons just below. The center of the picture is framed with a white bracket that shows the area of critical focus. Pressing the left keypad arrow switches the camera into autofocus mode; the right arrow switches back to manual. The keypad up and down arrows are used to focus the lens. When you press the up or down keys, the camera magnifies the center of the image; when you release the buttons, the image returns to normal size.

 Manual Focus Controls

A few cameras—mostly higher-end SLR and virtual SLR cameras—have dedicated focusing controls. These ring-shaped controls work like their counterparts on a 35mm SLR camera. They perform the same function as the manual focus buttons found on P&S cameras, but they are much faster and easier to use. Minolta's Dimage 5/7 cameras and the Olympus E-10 are two good examples.

Manual focusing on the Dimage 5 and 7 cameras is done using a large metal ring located at the rear of the lens, just behind the zoom control (refer to Figure 8.5). To switch to manual focus, you press a button on the side of the camera, look through the viewfinder, and adjust the focusing ring. Like the Olympus C-3040Z, the Dimage 5 and 7 can magnify the center of the image as a focusing aid, but the Minolta cameras don't automatically turn on the focusing magnifier like the Olympus.

The Olympus E-10 has the benefit of being a true SLR camera (see Figure 8.9). When you look through the viewfinder, you see the actual image passing through the lens, not an electronic re-creation of the image. The Olympus optical viewfinder is bright and sharp, so it's easy to tell when an image is in focus and when it isn't.

Figure 8.9

The Olympus E-10 features a silky-smooth manual focus control located on the lens barrel.

Like the Minolta, the E-10 has a large focusing ring mounted directly on the lens. It looks like the manual focusing ring found on film SLR cameras, but the E-10's focusing control is electronic, not mechanical. It is amazingly smooth in operation, and enables you to achieve perfect focus quickly and easily.

Infinity Focus

Sometimes you don't need to focus at all. Because of their small image sensors, digital camera lenses have very short focal lengths. As you recall from Chapter 7, "Exposure Basics," short focal lengths produce images with more depth of field than larger focal lengths. Some cameras have so much depth of field—especially those with wide-angle settings—that focusing is often unnecessary.

If you're taking pictures of distant scenery or buildings, you might find it convenient to lock the camera's focus at it's farthest setting. This setting is called infinity focus, often shown by the symbol, ∞. When you select the infinity setting on your camera, the camera locks focus at the farthest point and deactivates the autofocus circuits. This feature is useful for shooting landscapes, cityscapes, and other distant objects, especially in low light.

EXPOSURE FEATURES AND CONTROLS

As you saw in Chapter 7, good exposure is one of the keys to good photographs, especially with digital cameras. Camera makers know this, so they provide users with a variety of tools to help get the best possible exposures under the widest variety of lighting conditions. In this section, you learn what those tools are and how they work.

Programmed Exposure Modes

Programmed exposure modes optimize the camera's settings for specific shooting situations. These include sports shooting, nighttime shots, portrait pictures, and landscape photos. Figure 8.10 shows the program mode dial on a Canon PRO-90IS camera.

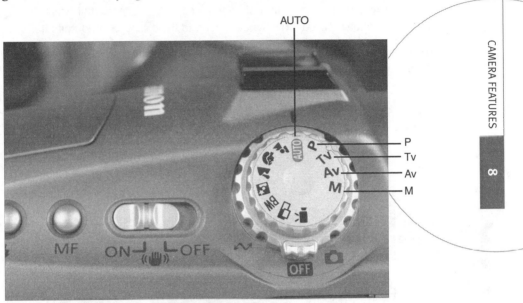

Figure 8.10

Canon's PRO-90IS looks intimidating but simplifies picture-taking for beginners.

As you can see from the picture, Canon's mode dial is loaded with icons and letters. Different manufacturers have different programmed setting modes. The following paragraphs discuss the modes on the Canon PRO-90IS.

The "M," "Av," "Tv," and "P" settings select manual, aperture priority, shutter priority, and program exposure modes as described in Chapter 7.

The "AUTO" setting— found on most Canon film and digital cameras—puts the camera into fully automatic mode. This mode is similar to "P" autoexposure mode, but setting the full auto mode disables some manual controls and enables automatic flash mode.

The first setting after the full auto setting is called Pan Focus mode, and is represented by an icon of a person in front of a mountain. When you select this mode, the camera zooms out to the widest setting for maximum depth of field, and it locks focus at infinity. According to Canon, everything from 2 feet to infinity is in sharp focus with these settings.

The next selection on the dial is Portrait mode. Portraits look their best when the subject is in sharp focus and the background is as blurred as possible. Selecting portrait mode sets the lens at its widest setting to ensure the least possible depth of field. This mode also turns on the camera's red-eye reduction flash mode, which we'll discuss later in this chapter.

The icon with the mountain on it selects Landscape mode. This mode uses the smallest possible lens aperture to achieve the maximum possible depth of field. Unlike the Pan Focus mode, landscape mode doesn't force you to use the widest zoom setting.

The next stop on the dial is the Nighttime mode. In this mode, the camera turns the flash on, but the camera uses a slow shutter speed to bring out details in the background. This technique is also called Slow Sync mode, and it's discussed in detail later in this chapter.

The last three modes on the dial select Black and White mode, Panoramic Stitch mode, and Movie mode. Each of these modes is discussed later in this chapter.

Canon's mode dial is convenient and easy to use, but some cameras don't have a mode dial. Instead of using a dedicated dial, Toshiba's PDR-M81 uses an onscreen menu, as shown in Figure 8.11.

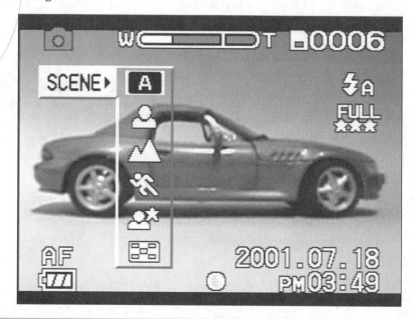

Figure 8.11

Toshiba's PDR-M81 uses a clever onscreen menu system instead of a mode dial. Pressing the camera's Enter key pops up this menu of pre-programmed shooting modes.

To select one of the programmed shooting modes, you press the camera's Enter key and use the up and down arrows on the keypad to select one of the special modes.

The Toshiba PDR-M81 has many of the same modes as the Canon. The Toshiba also includes a "Sport" setting, indicated by an icon showing a runner. When you select this mode, the camera uses the highest shutter speed possible to freeze action.

These special settings modes are great tools for beginning photographers, because they pre-set the camera to the ideal settings for certain shooting situations. Experienced photographers might laugh at them, but they've also been known to use them from time to time when no one is looking.

Exposure Compensation

Despite the best efforts of your camera's autoexposure system, there will be times when you'll want to override the settings the camera has chosen. This is especially true when you're shooting in unusual lighting conditions, or when you want to achieve a specific effect, but the camera has something else in mind.

Most cameras provide a simple exposure compensation feature, often called EV (for Exposure Value) compensation. The compensation control enables you choose to add or subtract exposure from the autoexposure settings determined by the camera. Some cameras require you to press a button (usually marked with the ± symbol) while you turn a knob or press keys on the keypad. Other cameras—like the Olympus 3040Z shown in Figure 8.12—let you press the up and down keypad keys to change exposure compensation on-the-fly.

Figure 8.12

The +1.0 on the Olympus 3040 LCD screen (left) indicates that a one-stop exposure increase is chosen. Nikon's 990/995 cameras (right) use a dedicated button (just above the mode dial in the right center of the picture) marked +/- to set exposure compensation.

The "no-button" approach to exposure compensation enables experienced users to quickly change exposure settings, but it often confuses new users who don't realize that they've changed an important setting.

As you can see from Figure 8.12, Nikon uses a +/- button for exposure compensation. To change the exposure settings, you hold down the +/- button while turning the knob on top of the camera.

Most Nikon cameras include a useful feature called program shift that enables you to change the camera's automatically selected shutter speed and f/stop combination without changing the overall exposure setting. To do this, turn the top-mounted dial without pressing the +/- exposure compensation button. As you turn the dial, the camera steps through all the possible shutter speed/aperture settings that are valid for the current lighting conditions. Program shift is very handy when you want to select a particular aperture or shutter speed without changing the camera to a different exposure mode.

Exposure Bracketing

Sometimes, even the most advanced photographer can't decide on the best exposure settings for a particular shot. This can happen in tricky lighting situations like sunsets and night shots, or when you're trying to establish a particular mood in your picture.

In situations like this, pro photographers rely on a time-tested technique called *exposure bracketing*. Like the name implies, bracketing involves taking a series of pictures above, at, and below the camera's light meter reading. Pro photographers often use bracketing with color slide film, which has a very narrow latitude. Bracketing guarantees that the photographer gets one usable shot, even in difficult lighting situations, but it uses three times as much film.

Many digital cameras include an automatic exposure bracketing feature. Figure 8.13 shows the bracketing display from a Fuji FinePix 6800 camera.

Figure 8.13

The automatic exposure bracketing display from a Fuji FinePix 6800 shows you the results of three different exposure settings so you can choose the best one.

To use the exposure bracketing, you first select a bracketing amount from a menu on the camera. Next, switch the camera's shooting mode to auto-bracketing. When you press the shutter release with bracketing enabled, the camera takes three pictures in quick succession. The camera then displays the three images on the LCD screen and asks you to pick the one you want to keep. This feature saves space on the memory card because you keep only one of the three pictures. Some cameras keep all three pictures, so you can choose the best shot after you transfer the pictures to your PC. This enables you to make exposure judgments using your computer's larger (and more accurate) monitor.

White Balance

If you look at a piece of white paper in sunlight, fluorescent light, and incandescent light, the paper still appears white to you. This happens because human eyes have an amazing ability to adjust to different types of light. But there are very substantial differences between those three types of light.

For example, outdoor daylight contains much more blue than the incandescent light produced by a typical household light bulb. Your eyes automatically adjust for these differences, but the image sensor (or film) in a camera doesn't know what type of light it is working with.

As a result, it is necessary to tell the camera what type of light you're shooting in, so that the camera can make the proper adjustments to compensate for differing light sources.

All cameras include an automatic white balance mode. In this mode, the camera analyzes the color composition of each picture and automatically adjusts the color balance for you. But auto white balance isn't perfect, so it's often necessary to manually select the proper white balance for a particular type of light. Figure 8.14 shows the white balance settings menu from a Canon camera.

Figure 8.14

Canon's PRO-90IS and G1 cameras offer five preset white balance settings, an automatic white balance mode, and the manual white balance mode shown here.

As you can see from the picture, Canon provides seven white balance modes, represented by the icons at the bottom of the screen. Here's what the different modes do:

- **Automatic**—The camera evaluates the color balance of each picture and decides on the correct white balance. This is okay for general purpose shooting, but some cameras have problems with mixed light sources.

- **Sunlight**—This setting adjusts the color balance for bright sunlight.
- **Cloudy**—This setting is useful on overcast days or when taking pictures in the shade on sunny days.
- **Incandescent**—This setting adjusts the white balance for standard indoor light from conventional (not fluorescent) lighting.
- **Fluorescent**—This setting adjusts the white balance to compensate for the greenish cast produced by some fluorescent lamps.
- **Flash**—This setting adjusts the color balance to match the camera's built-in flash.
- **Manual**—This setting enables you to manually set the white balance.

The manual white balance mode is very useful when shooting under mixed lighting conditions. To use this mode, you point the camera at a white piece of paper or other white object so that the white area is inside the square in the center of the screen. This tells the camera what "white" is, and the camera automatically adjusts itself to compensate for the current light conditions. This is a very useful feature when you're shooting with a mix of natural and artificial light.

Still not sure which one to use? A few cameras offer a white balance bracketing mode. This mode works like exposure bracketing, but it takes several pictures with different white balance settings instead of different exposure settings.

FLASH CONTROLS

Virtually all digital cameras include a built-in electronic flash, sometimes called a strobe light. Electronic flash serves two purposes. The most common use is as the sole source of light where there's not enough available light to take a picture. The other use is as a fill-in light, useful for removing hard shadows when taking pictures of people outdoors on a sunny day.

Although flash enables you to take pictures you couldn't take otherwise, it introduces a new set of problems for the photographer. Ways to use flash are discussed in Chapter 14. The biggest problem with flash pictures is a phenomenon called *red-eye*, which makes subjects' eyes appear red. Red-eye happens when light bounces off the eye's retina and back out through the eyes. The blood vessels inside the eye cause the reflected light to appear red, causing an eerie effect.

Flash technology is improving, and most camera makers provide several flash modes that enable you to maintain lighting control over your pictures while minimizing red-eye. Here's a run-down of the different flash modes commonly found on digital cameras:

- **Auto**—Fully automatic mode; the camera decides when the flash is necessary, and fires the flash automatically.
- **Manual**—Forces the camera to use the flash, even when there's enough light to take the picture without flash. This mode enables you to use the flash as a fill-in light to remove harsh shadows when shooting in sunlight.

- **Slow Sync**—When shooting with the flash on, most cameras judge exposure by measuring the light from the flash, not the light from other subjects in the background of the picture. Slow-sync mode causes the camera to expose the picture as if the flash was turned off to capture details in the background. At the end of the exposure, the camera fires the flash to illuminate the foreground subject.

- **Red-Eye**—Turns the flash on with red-eye reduction. There are two different types of red-eye reduction. The more effective type fires the flash two or three times before actually taking the picture. This causes the subjects pupils to close slightly, reducing the amount of light reflected off the retina. The other, less effective type turns on a small white light on the camera. Although it uses less power than the multiflash technique, the small light doesn't usually produce enough light to reduce red-eye.

- **No Flash**—This mode disables the flash, even when the camera thinks you need it. It's most useful for shooting sunsets, nighttime cityscapes, and other low-light shots where a flash would either be ineffective or would ruin the picture.

A little flash goes a long way. This is especially true when using the flash in fill-flash mode. Too much flash overexposes the main subject, and too little leaves harsh shadows on the subject's face. On some cameras you can adjust the amount of flash using a control called *flash exposure compensation*. This control works very much like the exposure compensation control described earlier, but it only affects the amount of flash.

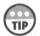

Flash Falloff

While the flash from your camera may look very bright, built-in flash units only work within 10–15' of the subject. Beyond that, the light fades fast. External flash units are much more powerful (they should be, some weigh as much as the camera!) and have ranges up to 50'.

SHOOTING CONTROLS

"You press the button, and we'll do the rest." (Kodak advertising slogan, 1890)

We can't help but wonder what Kodak founder George Eastman would think of today's digital cameras and all their buttons. There's one button that George would understand immediately—the shutter release, the most important button on the camera. But old George would likely be amazed what that one button can do. Digital cameras offer a variety of shooting modes, so that shutter release button can do more than just take a single picture.

Virtually all cameras have a multi-frame mode, similar to the motor-drive mode on film cameras. When you press and hold the shutter release, the camera takes a series of pictures. This is a great feature for photographing fast-moving subjects, but it burns up a lot of memory storage in a hurry.

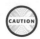

Slow As She Goes

New camera owners are often surprised to learn that their new digital camera can't operate as fast as their old film camera. Most consumer film SLRs can take 1.5 to 3 frames per second until the camera runs out of film. Consumer digital cameras typically take about one frame per second, up to a maximum of five or ten pictures. Why the difference?

Because a digital camera is all electronic, you might expect it to be faster than film. Digital cameras are slower because the image processor chip inside the camera has to scan the image sensor, build the image data into a file, and save the file onto the camera's memory card. This takes time. Faster processor chips can provide faster operation, but increasing the speed of the processor also increases the power requirements for the chip.

Movie Mode

Many digital cameras provide a movie feature that can capture short (usually 30 second) movies. The movies can be transferred to your PC and viewed using a movie viewer program, usually with Apple's QuickTime program. Movie mode is handy for capturing a quick, short video when you don't have your camcorder with you, but it's no replacement for a real camcorder.

Panoramic Stitching

One of the advantages of digital photography is that it makes after-the-fact editing and image manipulation so easy. That's especially true when it comes to panoramic photos. Panoramas are made by combining images from several exposures into one very wide-angle view. It can be done with film, but it's tricky and costly. It's a snap to do with a digital camera.

To take a panoramic series, you place the camera on a tripod and take several pictures as you rotate the camera across the scene. Some cameras include a panoramic stitching mode that helps you position the camera for each shot by showing the edge of the previous shot. This is a big help, because it enables you to make sure that the pictures line up the way you want when you get back to your computer.

The next step is to transfer the image to your PC, where you use a panoramic stitching program to piece the images together. Figure 8.15 shows how a typical stitching program works.

As you can see from the screen images, you select the pictures you want and place them in the order you want. After you've selected the images and their order, you click the Stitch button, and the program does the rest. Figure 8.16 shows the resulting image.

Figure 8.15

Canon's PhotoStitch program automatically combines several images to create a single panoramic image.

Figure 8.16

A panoramic view of Les' messy office/studio. This image was created by stitching together eight separate pictures.

This isn't a feature you'll use all the time, but it creates a neat effect that you can't easily accomplish with a film camera.

 Watch That Horizon!

Before you take a panoramic series, put your camera on a tripod, and make sure the camera is level to the ground. Then lock the tripod's tilt control to keep the camera from moving up and down as you rotate it for the panorama. If the camera isn't perfectly level, you end up starting over because the camera points too far up or down by the time you take the fourth or fifth picture!

Remote Controls

The shutter release is the most important button on the camera, but sometimes you need to control the camera from a distance. This is helpful when taking group pictures with yourself in the group. It's essential when working at very slow shutter speeds, because the motion of your hand pressing on the camera shutter release can cause the camera to shake, blurring your picture.

Most camera manufacturers offer wired or wireless remote controls, either as an accessory item or bundled with the camera. Figure 8.17 shows a typical wireless remote control.

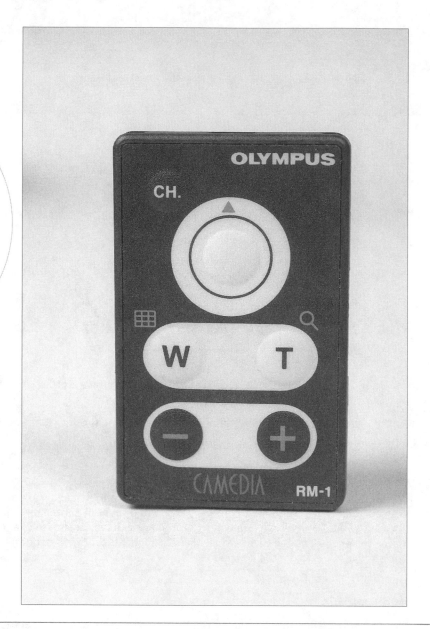

Figure 8.17

Olympus is one a few manufacturers to include wireless remote controls with most of their cameras.

The Olympus remote control is more elaborate than most; it includes a large button that operates the shutter release, two buttons to zoom in and out, and two additional buttons that work with the camera's menu system. The Olympus remote works with most Olympus cameras, but it can't operate the non-motorized zoom lens on the E-10 camera.

Canon's higher-end cameras come with a clever remote control software package—called RemoteCapture—that lets you control the camera from a PC attached via a USB cable (see Figure 8.18).

Figure 8.18

Canon's RemoteCapture software enables you to control the camera from an attached PC. Images can be stored on the PC instead of the camera's memory card.

As you might have guessed from Figure 8.18, most of the product photos for this book were taken using a Canon D30 and the RemoteCapture software. Software like RemoteCapture is a tremendous time-saver when you plan to shoot lots of photos from a single location. RemoteCapture enables you to save images onto the attached PC instead of the camera's memory card, so you don't have to worry about running out of storage during a shoot. Fuji provides a similar program with some of their cameras, including the S1 SLR.

One of RemoteCapture's best features is the graph to the right side of the image display. This graph is called a histogram, and it is an invaluable tool for checking exposure and lighting. Histograms are explained in detail in Chapter 18, "Imaging Software—What Can It Do?"

PLAYBACK FEATURES

One of the big advantages of digital cameras is that they let you see what you just shot. Apart from the immediate gratification, in-camera playback is a very useful tool when you want to make absolutely sure that you capture exactly what you want. This is especially useful at family reunions, graduations, and other one-time events at which you won't get a second chance to take the picture.

CAUTION

Watch That Battery Meter!

It's a lot of fun to play back pictures you just took at parties and family gatherings. But keep in mind that the LCD screen is the biggest battery-burner in the camera. If you over-do the playback, you might run out of battery power just before Uncle Sid drops the cat into the punch bowl.

Digital cameras can hold hundreds of pictures on a memory card. Sifting through several hundred pictures to find the exact one you want can be a chore. Fortunately, virtually all cameras provide a Thumbnail Playback mode, which shows several (usually your choice of four or nine) pictures on the screen at once. Figure 8.19 shows a typical thumbnail display.

Figure 8.19

Thumbnail Playback mode makes it easy to navigate through dozens or hundreds of pictures on your camera's memory card.

The small LCD screen on digital cameras makes it difficult to see any fine details in your pictures. Most cameras provide a playback magnifier that lets you zoom in on an individual picture so you can check focus, exposure, and framing details. Figure 8.20 shows a typical playback magnifier.

Sometimes it's helpful to know the exposure details for an individual picture. This is especially true when you're shooting pictures for a Web page, catalog, or other publication for which you're shooting a group of pictures over a period of several days or weeks.

Many cameras can display detailed exposure settings during playback (see Figure 8.21).

Figure 8.20

A playback magnifier in action. The magnifier helps you see fine details, even on a small LCD screen.

Figure 8.21

Nikon's playback mode provides detailed exposure and focusing information, as well as a histogram display.

Big Screen Viewing

Most digital cameras include a video-out feature that enables you to connect the camera to any standard video monitor for playback. This is a nice feature when you want to show your pictures to more than one or two people at time. Most cameras turn off the LCD display when you connect the video-out cable, so the batteries last longer, too.

SUMI'S SNAPSHOT

How do I know when to use exposure compensation?

As a rule of thumb, you need to use exposure compensation when there's a large area of extreme light or dark in the picture. White beaches and snow scenes, for example, usually require plus 1½ to 2 stops of compensation. When in doubt, take a test shot and play it back. If it's too dark, dial in +1; if the picture is too light, set compensation to −1. After a while, you'll be able to "eyeball" the amount of compensation required. Just make sure you set the exposure compensation back to 0 when you're finished, or your next set of pictures will be too light or dark!

I'd really like to take panoramic pictures, but my camera doesn't have a panoramic mode. What can I do?

Panoramic stitching programs can build panoramic pictures from any group of images, even if the camera doesn't have a panoramic mode built-in. Take a series of photos while you rotate your camera on a tripod, and make sure that the pictures overlap slightly.

When I connect my digital camera to a TV for playback, the images are not very sharp. What's wrong?

Nothing. The analog color TV standard was designed back in the 1940s. It simply can't handle the level of detail contained in a digital image.

PART **II**

CHOOSING A PRINTER

CHAPTER 9

INKJET PRINTERS

Inkjet printers have come a very long way since the first Hewlett-Packard DeskJet and Canon BubbleJet printers appeared on the market more than 10 years ago. Originally designed as a low-cost alternative to laser printers for the home market, inkjets now own the lion's share of the printer marketplace and are widely used in both home and small-office environments.

This chapter covers

- How an inkjet printer works
- Why ink cartridges are so darned expensive
- What types of paper and media are available

INKJET DOMINANCE

Take a walk through any computer or office supply store, and you'll see that inkjets outsell all other printer types by a wide margin. Inkjet printers are inexpensive, quiet, reliable, and relatively small. But the number one reason that inkjets are so popular is that they can print in color.

Over the past 10 years, the price of entry-level laser printers has fallen from over $1,000 to under $300. The price of color laser printers has fallen, too—but even a low-end color laser will set you back $1,800 or more. Laser printers are much more complex than inkjets, so it's unlikely that we'll see bargain-priced color laser printers anytime soon.

Although the original generation of inkjets could only print in black, today's best inkjet printers provide accurate color printing to rival more expensive printing technologies like laser and dye-sublimation.

Laser printers produce excellent prints on plain paper, but they have a complex paper path that precludes printing on heavy paper. Dye-sublimation printers use special, expensive paper that resembles photographic paper. Although dye-sub printers produce excellent photo-quality prints, they can't be used at all for text printing. Inkjets have a straight paper path that allows them to accept a wide variety of paper thicknesses and printing materials. The inkjet printing process doesn't heat the paper during printing, so it can be used to print on almost any type of paper.

There are many players in the inkjet printer market, but the four leaders are Canon, Epson, Hewlett-Packard (HP), and Lexmark. Together, these four companies offer a wide range of printers from sub-$100 units designed for casual home use to $10,000 units that can produce 4-foot-wide poster-sized prints (see Figure 9.1).

Figure 9.1

Epson's Stylus Photo 1280 printer accepts paper up to 13 inches wide.

HOW INKJETS WORK

Despite the differences in cost, all inkjet printers operate in much the same way. Inkjets have very few moving parts, so they're relatively inexpensive to build.

A small motor called a *stepper motor* pulls paper into the printer. Unlike conventional motors that turn with a constant motion, stepper motors move in well-defined increments, or steps. This stepping motion lets the printer move the paper in very small increments.

As the paper passes through the printer, it passes below one or more printer heads. The print head is the point where the ink meets the paper. Monochrome printers have a single print head, and color printers have as many as six heads (see Figure 9.2). Each head has several tiny holes called nozzles; ink cartridges above the nozzles provide a supply of ink.

Figure 9.2

This is a close-up of an inkjet print head. The actual size of the head is about 3/8'' (1 cm) on each side.

The print heads move back and forth on a metal shaft, their motion regulated by another stepper motor. As the heads move back and forth across the paper, ink sprays out of the nozzles and onto the paper; hence the name ink jet. Each nozzle produces a tiny dot on the paper, often as small in diameter as a human hair. It takes hundreds of dots just to make up a single letter; it takes millions of dots to make an 8 by 10-inch photo.

The printer heads create an image on the paper by passing back and forth over the paper while the stepper motor moves the paper through the printer. Think of the printer as a sort of robotic paint sprayer; the paper moves from top to bottom while the print heads move from side to side. To speed up printing, most printers use an array of nozzles that can produce dozens of dots on a single pass of the print head.

One of the main comparison points for inkjet printers is the number of distinct dots it can print in an inch; this number is called *dots per inch*, or DPI. Smaller dots packed closer together produce a sharper, more realistic image than large, loosely spaced dots.

More Is Better, Right?

When you go shopping for an inkjet printer, you hear a lot of talk about dots per inch, or DPI. Printer makers use DPI as a sort of horsepower rating for printers. But the DPI rating by itself isn't always a meaningful way to compare printers.

Printers with higher DPI ratings print sharper, more detailed photos than printers with lower ratings. But high-DPI printers run slower and use more ink than lower-rated printers. This increases print times and ink costs, but returns only a small improvement in quality.

There are subtle differences in the way different printers push the ink out of the cartridge and onto the paper (see Figure 9.3). Thermal inkjet printers heat the ink until it boils, using tiny heating elements. This process requires the inks to be heat resistant because the ink is momentarily heated to a very high temperature before it is delivered to the paper.

Epson's printers use a *piezoelectric element* that vibrates when electricity is applied. The vibration acts as a tiny pump, causing a small amount of ink to be ejected onto the page. Piezoelectric technology doesn't heat the ink, so the inks don't need to be heat-resistant. The Piezoelectric method is somewhat more precise than the thermal method, and it allows for smaller, more consistent ink droplets.

Printing Text on a Photo Printer

Early photo-quality printers had a well-deserved reputation for being lousy text printers. This is because those printers didn't have a black ink tank, so they simulated black by printing with all three (or six) colors at once. The resulting "black" was usually a murky green. Because they used all the colors to simulate black, they printed very slowly and used a lot of ink when printing black.

Virtually all modern photo-quality printers have a separate black ink tank, and most printers enable you to select a "black only" mode when printing text. These printers operate much faster than their predecessors, and they don't use nearly as much ink.

Inkjet printers produce millions of colors using only a few colors of ink. They do this by placing cyan, magenta, and yellow dots very close to one another. The eye can't make out the individual dots, so it sees the overall color produced by the dots, and not the dots themselves. Smaller droplets allow for more precise colors. Six-color printers actually have

four colors (cyan, magenta, yellow, and black). The fifth and sixth colors are lighter shades of cyan and magenta. The lighter inks make up for the printer's inability to print very small amounts of ink. The result is smoother, more accurate color reproduction.

Figure 9.3

Epson 1280 ink cartridges. The smaller cartridge on the left contains black ink; the larger cartridge on the right contains five colors of ink in separate chambers.

Betcha Didn't Know...

Piezoelectric elements are usually made of quartz. They are essentially tiny electronic motors that vibrate when power is applied to them. Piezoelectric crystals have been used in electronic circuits since the earliest days of radio, but Seiko and a few other Japanese companies pioneered the use of piezoelectric elements in wristwatches in the early 1970s.

Epson's printers use a piezoelectric print head, and competitors Canon and HP use heated ink bubble-jet technology. And who owns Epson? Here's a clue: The company's full name is Seiko Epson.

The quality of print produced by an inkjet printer is determined by several factors:

- Size and precision of the ink dots
- Precision of stepper motors
- Quality of controller electronics and software
- Consistency of ink
- Smoothness of paper

As you might expect, the first three items on the list also have a direct bearing on the cost of a printer. But the mechanical parts of the printer receive their marching orders from the printer's controller circuitry, usually a small, special-purpose microprocessor. The controller is responsible for orchestrating a complex ballet of paper motion, head motion, and ink spray. The controller is also in charge of receiving image data from the host computer and converting that data into printed images.

More expensive printers can move their stepper motors in smaller increments, allowing them to produce sharper, more precise images.

Although the printer plays a central role in determining print quality, the ink and paper are equally important. Inkjet ink must meet very high quality standards. To ensure color accuracy, there can be little or no color variation between different production runs of ink. These factors combine to make ink fairly expensive, especially when compared to the relatively cheap and long-lived toner cartridges used in laser printers.

Danger: Low Ink Supply!

Over the life of a typical inkjet printer, most users will spend more money on ink and paper than they did on the printer itself. As printer technology advances, printer makers design new ink cartridges to deliver the latest technology. This creates an interesting problem in the supply chain.

Cartridges for brand-new printers are often hard to find, and expensive when you do find them. At the other extreme, ink cartridges for older, out-of-production models can be difficult if not impossible to find. This is especially true for less-popular models and brands. Users in the middle of the bell curve—those users with very popular but not cutting-edge printers—don't have a problem locating ink.

The moral of this story is this: Before you decide to buy a particular model of printer, make sure you'll be able to buy ink for it. This is even more important if you live in a small town or rural area when there isn't a computer superstore on every corner.

Paper also plays an important part in the printing process. Common copier or laser printer paper is made from relatively coarse fibers. The large size of the fibers creates microscopic gaps in the paper. This causes the paper to act like a sponge when used with liquid inks. As soon as the ink hits the paper, it spreads out into the gaps, creating large, splotchy dots instead of small, well-defined dots.

High-quality papers designed for inkjet printers use smaller, tightly-packed fibers, so there aren't as many gaps to soak up ink. These papers are often marketed as "premium" or "high resolution" inkjet papers. Some premium papers have a coating over the paper base; the coating is smoother and whiter than the paper itself. The coating keeps the ink from soaking into the paper, which results in sharp, well-defined dots. The coating is often much whiter than ordinary paper, so coated papers produce prints with better contrast than ordinary papers.

Photo-quality papers are the highest-quality inkjet papers you can buy. They have a smoother finish than conventional papers and produce the highest-quality prints. Most photo papers are thicker than conventional paper; the heavier weight and glossy finish closely resembles the weight and finish of standard photofinishing paper. Of course, quality costs money; an 8 by 11-inch sheet of heavyweight photo quality paper costs about 50 cents.

All inkjet printers operate in several different print modes, depending on the type of paper in use. Most printers have a plain paper mode for your ordinary, non-photo printing, and one or more high-quality modes for printing on photo paper.

All printer manufacturers recommend their own brand of paper for use with their printers. In our experience, you can use any brand of quality inkjet or premium inkjet paper in almost any printer operating in plain paper mode. Photo-quality mode is another story, however. Most printers work best when used with the manufacturer's own paper. This is especially true when printing at very high DPI settings. Each manufacturer has a unique, carefully orchestrated balance of ink chemistry, paper composition, and ink drying times. Using a different type of paper often upsets this balance.

The type, size, and variety of papers needs to be part of your printer buying decision. Some printer makers offer an incredibly broad selection of paper sizes, weights, and surface finishes, and others offer only a few.

ALL ABOUT INK

The inkjet printer market is very competitive, so printer makers continually update their product lines. The result is a buyer's market where prices are falling and quality is increasing every few months.

One place you won't see a big price drop is ink cartridges. Printer makers know that after you buy their printer, you're locked into buying their ink cartridges as long as you own the printer. Figure 9.4 shows some typical ink cartridges.

Figure 9.4

Color ink cartridges for Epson (left) and HP printers. This Epson cartridge contains five colors; the HP contains three.

As you can see from Figure 9.4, there's quite a bit of difference between the two cartridges. Epson's ink cartridges are just that; they're small tanks full of ink. The five holes on the bottom of the tank are valves that allow ink to flow out of the cartridge when the cartridge is installed in the printer. When you remove the cartridge, the valves are closed and no ink can flow out.

Many HP ink cartridges—like the one on the right in Figure 9.4—include the print head as part of the cartridge. (The print head shown in Figure 9.2 is part of an HP print cartridge.) When you replace one of these cartridges, you're also replacing the nozzles. According to HP, placing the nozzles on the ink cartridge reduces maintenance costs and increases reliability.

 Do-It-Yourself Ink?

Several companies make aftermarket ink refill kits to work with many popular printers. These kits include all the tools and ink you need to refill your empty cartridges. They're attractively priced—a typical ink refill costs about 1/3 the price of a new ink cartridge.

Of course, the refill kit makers claim that their inks are the same ones used by the printer manufacturers, so their ink can't possibly harm the printer. The printer makers claim that there is a carefully orchestrated chemical interaction between their ink and paper that can't be duplicated with third-party inks and papers.

The choice is yours—you can certainly save money using refill kits, but you have to decide if the savings are worth the potential hassle. Keep in mind that most printer manufacturers void your warranty if they suspect problems caused by third-party inks.

Some printers use separate ink tanks for each color. The advantage of this approach is that you replace each ink tank as that color runs out. With multi-color ink cartridges, you must replace the entire cartridge when any one color runs out of ink. This means that you're almost always throwing away some perfectly good ink with each cartridge. The multi-tank design saves ink, but you need to keep as many as six different ink cartridges on hand, instead of the two (black and color) used by most photo printers.

Some Assembly Required

Some low-end printers can only produce photo-quality prints if you purchase an optional photo-quality printing kit. This kit typically includes a replacement print head with a different ink cartridge than the one supplied with the printer.

Unless you're on a very tight budget and want to buy your printer a piece at a time, you're better off buying a photo-ready printer if you plan to print photos—which is why you bought this book, right?

SOFTWARE FEATURES

When you're shopping for a printer, you can walk into a store and look at the printers, press the buttons, and even open the covers and look inside. Many stores even let you print sample pages so you can compare output from several printers. But there's one thing you can't see from the in-store demos, and it's one of the most important components of the printer: the user interface.

All printers require driver software to communicate with the computer's operating system. But some drivers are much more sophisticated than others. For the examples in this section, we've used the Epson Stylus Photo 1280 driver as an example. Drivers vary widely from one manufacturer to another, and even across models in a manufacturer's product line. The 1280 is near the top of Epson's model line, so it contains features that might not be available in lower-end models. Our examples show the Windows print driver, but the Macintosh driver is nearly identical. Here's a quick tour of the Epson driver.

As you can see from Figure 9.5, the Stylus Photo 1280's driver is very complete. The four tabs at the top of the driver screen split the settings into four separate screens, but this screen contains the most-often changed settings. The pull-down list at the top shows the different types of media the 1280 can use; photo paper is selected in the example. The ink level indicator at the lower right of the window is an excellent feature; it shows the status of the printer's ink cartridges. Notice that the Print Preview box is checked—we'll come back to this setting later.

Figure 9.6 shows the 1280's paper selection tab. Because the 1280 is a wide-carriage printer, it can accommodate a large variety of paper sizes from 4"×6" all the way up to 13"×44". The 1280 is one of a few printers on the market that can print edge-to-edge on the paper without a white border; this option is selected with the No Margins check box at the top right.

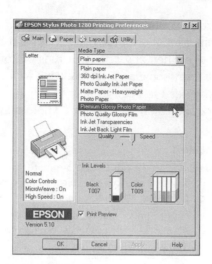

Figure 9.5

Epson's printer preference screen shows everything you need to know about the printer at a glance.

Figure 9.6

The paper selection tab offers a wide selection of paper sizes.

Most print drivers enable you to select one of several quality settings for each print job. Epson's driver goes one step further by letting you create and save your own color and quality level settings (see Figure 9.7). This lets you tweak the printer's settings for a particular program output size, and then save the settings so you can re-use them later. The color controls at the right side of the screen are not normally used; selecting any of the color management modes hides the color controls. The Flip Horizontal feature is useful for printing t-shirt transfers and window signs on clear film.

Figure 9.7

Epson's Advanced settings display gives you complete control over the printer's quality and color balance settings.

The Print Preview feature is one of Epson's best features (see Figure 9.8). If I were President, I'd require all printer makers to include this by law.

Figure 9.8

The Print Preview feature enables you to see how your image fits onto the page.

If you've ever used a photo printer, odds are good that you've tried to print a portrait-format picture on landscape-format paper—or vice versa. Epson's Print Preview feature makes sure that you've selected the right orientation for your print, and it shows you exactly how your image fits onto the current paper size. If the image looks good, you can click the Print button and the image is sent to the printer; if you need to make a change, you can click Cancel and fix the problem before you waste your time, ink, and paper on a bad print.

Epson's software stays with you until your print pops out of the printer. Figure 9.9 shows the print monitor screen, which tracks the progress of your print. It also shows the ink levels. At the end of each print job, the monitor screen tells you how many more pages you can print before the ink runs out.

Figure 9.9

Epson's print monitor keeps track of printing progress and ink levels.

SUMI'S SNAPSHOT

How many pages can I print on a typical ink cartridge?

This is tough to answer, and even the printer manufacturers skate around the answer. The reason it's so hard to answer is that the answer depends on the subject matter, the print quality setting, and the paper type. Higher quality settings use more ink than lower settings. Text pages use less ink than photos.

I print a lot of pictures, and I sometimes burn through an ink cartridge in a few hours. Is there a more economical solution?

What you need is a continuous inking system, or CIS. These systems are made by third-party manufacturers. They consist of a set of special CIS cartridges and several large, external ink tank. CIS systems are expensive, but they can save thousands of dollars in ink costs. Beware, though—these systems are only appropriate for very high-volume users.

I've read that inkjet prints don't last very long. How long can I expect my prints to last?

Early inkjet printers did have a problem with ink fading. Newer printers use lightfast dyes and better papers to produce prints that last much longer. Most manufacturers claim a minimum of 5 to 7 years before noticeable fading; Epson claims that the archival inks and special papers used in their Stylus Photo 2000 printer will last up to 20 years.

DYE-SUBLIMATION PRINTERS

Inkjet printers dominate the color printer marketplace, but they aren't the only game in town. Another, less well-known technology called *dye sublimation* produces high-quality photographic prints from digital images.

Most people have never heard of dye sublimation (called *dye-sub* for short). That's because early dye-sub printers were very expensive to buy and operate. Several manufacturers now market smaller, less-expensive dye-sub printers, many designed specifically for the home market.

This chapter covers the following:

- What dye-sub is all about
- How dye-sub printers work
- Why dye-sub might be the next big thing in printing

WHAT IS DYE SUBLIMATION?

Sublimation is a term you might remember from your high school or college physics class. It describes the conversion of a substance from a solid state to a gaseous state, without passing through the liquid state. Water, for example, goes from solid (ice) to liquid (water) to vapor (steam) as it is heated. Carbon Dioxide, on the other hand, goes directly from solid (dry ice) to CO_2 gas without passing through the liquid state. Dye-sub printers take advantage of this quirk of physics to produce digital prints with no visible pixel dots.

HOW DYE-SUB PRINTERS WORK

Like inkjet printers, dye-sub printers contain dyes that are transferred from the printer to the paper to produce an image. And like inkjets, dye-sub printers use cyan, magenta, and yellow dyes. A few high-end printers also use black dye.

Unlike inkjets, the dyes in dye-sub printers are dry and solid. Instead of a liquid ink cartridge, dye-sub printers use a ribbon to hold the dyes. The ribbon is made of a plastic film; the dye is embedded in the ribbon. The ribbon is divided along its length into alternating, equal sections of cyan, magenta, and yellow. Most ribbons also contain a fourth section of clear coating that is added to protect the three dye layers.

The ribbon is supplied on a pair of spools, and it moves in the same direction and speed as the paper. A heating element behind the ribbon applies heat to the ribbon, which transfers the dye to the paper. The amount of dye transferred depends on the state of the heating element at any instant. The printer produces an image by varying the heat on the heating element as it scans across the page. The ribbon is designed to produce a fixed number of prints; after it is used up, it must be replaced.

Dye-sub printers can only apply one color at a time. To print a complete image, the paper moves back and forth through the printer four times; once for each dye layer, and again for the protective clear coat. Figure 10.1 shows a dye-sub printer in action.

In the sequence of photos, you can see that the printer applies one layer of dye, then moves the paper back down and applies the second and third layers. After the three dye layers are complete, the paper makes one more pass through the printer to receive a clear protective layer.

This sounds much more complicated than it actually is. The paper moves very quickly, so dye-sub printers typically print much faster than inkjet printers. The example print in Figure 10.1 took about 90 seconds from start to finish.

Figure 10.1

The Olympus P400 dye-sub printer moves the paper up and down as it applies each layer of dye. It's fast and fun to watch!

DYE-SUB PRINTERS PROS AND CONS

The major advantage of dye-sub printing comes from the sublimated inks. During the printing process, the dyes are absorbed deep into the paper, rather than placed on top of the paper. This produces dots with very smooth edges, compared to the sharp-edged dots produced by inkjets. The result is a digital print that doesn't look digital.

Because the inks are absorbed into the paper, they are more resistant to fading than inkjet dyes. The clear coating on dye-sub prints adds an additional layer of protection, so dye-sub prints are nearly waterproof.

Dye-sub printers are designed for photographic output, and aren't appropriate for use as text printers. This means that you can't use a dye-sub printer as your only printer. But given the low price of quality inkjets, this isn't really an issue.

The only other downside to dye-sub printing is the price. Dye-sub printers cost substantially more than inkjets. Supplies are expensive, too, but prices are coming down rapidly. A few years ago, an 8"×10" dye-sub printer cost over $5,000; the Olympus P400 shown in Figure 10.2 costs around $1,000. Consumables (paper and ribbon) cost about $1.75 for an 8"×10" print—considerably more than an inkjet, but less than you'd pay for a quality enlargement at your local photo shop.

Low DPI, Great Prints

When comparing dye subs to inkjets, you'll see that dye-sub printers have much lower DPI ratings than inkjet printers. The Olympus and Canon printers featured in this chapter are both rated around 300 DPI, yet they produce prints that compare favorably to prints from 1200 DPI inkjet printers.

This is because the dye-sub prints don't have any visible dots, so the prints appear smoother and more realistic than an inkjet print with a comparable DPI rating.

A TOUR OF TWO PRINTERS

There aren't a lot of dye-sub printers on the market, but the following sections take a closer look at two of the most popular products.

Olympus P400

The $1,000 Olympus P400 is designed for use by advanced amateur and professional photographers (see Figure 10.2). The P400 produces prints up to 7.6"×10.2" in about 90 seconds. The lightweight, interface flexibility, high speed, and quality output has made the P400 a favorite tool of event photographers.

The P400 is large but weighs only 26 pounds. Most of the printer's bulk is vertical, rather than horizontal. Although it looks large, it occupies the same amount of desktop real estate as a standard inkjet printer.

The P400 has both serial and parallel interfaces, so you can use it with virtually any PC or Mac. A front-panel switch enables you to quickly switch between the two interfaces.

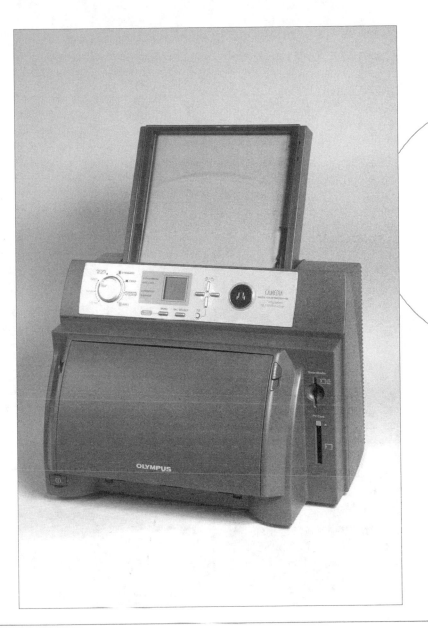

Figure 10.2

The Olympus P400 dye sublimation printer.

The P400 also includes SmartMedia and PC Card memory sockets on the lower front panel (see Figure 10.3). The PC Card socket can accept Compact Flash or Sony Memory Stick memory cards with an inexpensive adapter. A small monochrome LCD screen on the front panel enables you to view the contents of the memory card, and you can print images on the P400 directly from a memory card without the use of a computer (see Figure 10.4) .

Figure 10.3

Using the Olympus P400's two memory card slots, you print pictures directly from memory cards.

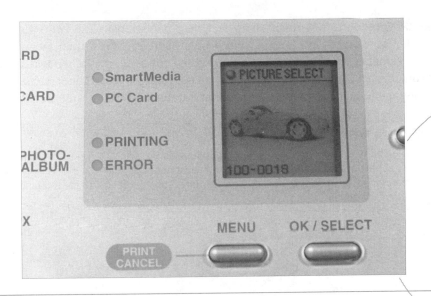

Figure 10.4

A small LCD screen displays preview images from the memory cards.

Canon CP-10

At the other end of the dye-sub scale, we have Canon's tiny CP-10 Card Photo Printer. The CP-10 weighs just over a pound and prints on credit-card sized 4.4"×2.1" paper. Like the Olympus, it prints using a three color ribbon and includes a clear protective overlay layer. Figure 10.5 shows the CP-10 next to a Canon S20 digital camera.

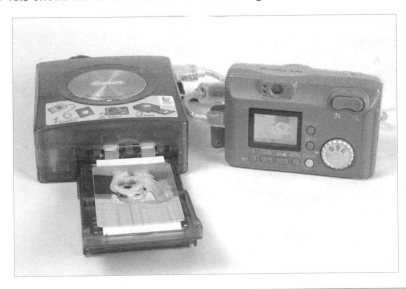

Figure 10.5

Canon's tiny CP-10 printer makes 4"×2" prints directly from Canon digital cameras.

The CP-10 produces amazingly sharp and clear prints. Unlike the P400, the CP-10 only operates as a standalone printer, and it only operates with certain (newer) models of Canon cameras. It includes cables to connect the printer to several models of Canon digital cameras; all printing is done directly from the camera. These Canon cameras include a printing menu in the camera's software that is designed to work with the CP-10.

Photos To Go

The ability to print from the camera, coupled with the printer's small size, makes it a big hit at parties and family gatherings. Prints cost about $.50, and the printer can hold enough ink and paper to make up to 36 prints. Consider this your personal portable digital photo lab.

SUMI'S SNAPSHOT

Why are dye-sub printers so expensive?

Dye-subs sell in very low volumes compared to other color printers, especially inkjets. As a result, they don't enjoy the large production volume and the economies of scale that come with large volume sales.

Is the dye-sub market going to gain ground on inkjet?

Probably so. Sony recently entered the dye-sub market with a $189 printer that produces 4" × 6" prints at a cost of about $.40 each. This is more than competitive with inkjets on a per-print cost basis.

Why haven't I heard about dye-sub printers before now?

Most dye-sub printers come from camera manufacturers, not from traditional printer makers. Although these companies have lots of clout in the photo business, they are relatively minor players in the printer business.

SHARING PRINTERS WITH WINDOWS

If you have more than one PC in your home or office, you probably have a Local Area Network, or LAN. This chapter shows you several ways to share printers using your LAN. If you have more than one PC but you don't have a LAN, you really should look into installing one. For less than $90, you can buy a networking kit that includes everything you need to network two or more PCs.

This chapter covers

- Windows networking basics
- How to share a printer in Windows 98, Windows Me, Windows 2000, and Windows XP
- How to use a shared network printer in Windows
- How to install and use a dedicated print server

PEER NETWORKING IN A PAGE OR TWO

All versions of Windows since Windows 95 include built-in support for peer networking. A *peer network* is simply a network consisting of two or more PCs. It's called a peer network because the two PCs are equals. The other major type of network is a server-based network. In a server network, one computer (the *server*) provides services like file and printer sharing for all the other PCs (called *clients*) on the network.

In a peer network, any PC can be a server, and any PC can be a client. This provides a lot of flexibility, because it enables you to share files, printers, and even an Internet connection with all the PCs on your LAN.

Home and small office networks first became popular at the beginning of the Internet boom. Before the Internet, there wasn't really a compelling reason to install a network in most homes. When the Internet suddenly became an essential part of daily life, many families found themselves fighting over the one PC with Internet access. An inexpensive home LAN solves the sharing problem and restores domestic tranquility by letting everyone share the Internet connection.

Look Ma, No Wires!

If you're concerned about running cables all over your home or office, you'll be glad to know that you might not have to run any cables at all. New networking technologies can create high-speed network connections over the existing phone wiring in your home or office.

If you have a laptop computer, there are wireless networking products that enable you to carry your computer around your home or office with no wires at all.

There are lots of other uses for home LANs beyond Internet sharing, especially if you have more than one printer in the house. Having your PCs on a LAN gives you access to any printer from any PC. This is especially useful if you have one text-quality printer and a separate photo-quality printer. With both printers available to all the PCs, you can use either printer from any PC. Figure 11.1 shows a typical home network with two PCs and two printers.

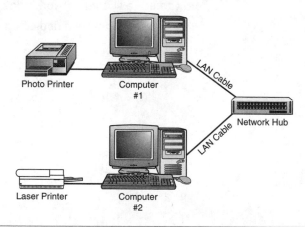

Figure 11.1

A typical home LAN might have two PCs and two printers.

SHARING PRINTERS ON A WINDOWS NETWORK

If your network is installed and working properly, you should be able to use any printer from any PC on the LAN. If you're sure that your network is set up correctly, you can skip to the section "Sharing a Printer," later in this chapter. If you're not sure, the following section provides a checklist of things you need to do before you can share printers.

Printer Sharing Checklist

When you install a network card in your PC, Windows automatically installs all the software you need to share files and printers over the network. If you're not sure if the networking software is installed properly, follow these steps on all the PCs on your network:

1. Open the Windows Control Panel, and double-click the Network icon. The Network dialog box appears (see Figure 11.2).

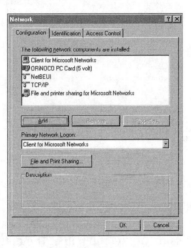

Figure 11.2

The Network Control Panel lets you view and change your computer's network settings.

2. Make sure that the Client for Microsoft Networks and File and Printer Sharing for Microsoft Windows items appear in the network configuration as they do in Figure 11.2. If either item is missing, click the Add button. Windows prompts you to insert the Windows installation CD.

3. Click the File and Print Sharing button, and make sure that printer sharing is turned on (see Figure 11.3).

4. Make sure that the I Want to Be Able to Allow Others to Print to My Printer(s) box is checked. Click OK to return to the Network control panel dialog box.

5. Click the Identification tab. You'll see a display like the one shown in Figure 11.4.

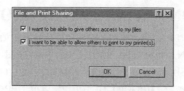

Figure 11.3

You can control file and printer sharing separately.

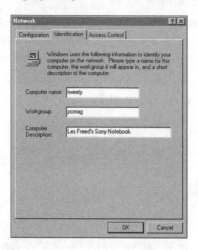

Figure 11.4

The Network Identification settings screen lets you give your computer a name.

6. Give each computer a unique name (I use Warner Brothers character names for my computers, but you can give them any names you like). Make sure that all the computers have the same workgroup name. The default workgroup name is WORKGROUP, but you can use any name you like.

7. Click the OK button. If you made any changes, the system must reboot.

Windows Versions

The examples shown here are for Windows 98 and Windows Me. Windows 2000 and Windows XP are slightly different, but the process is basically the same.

Sharing a Printer

When you share a printer connected to one of your PCs, that printer becomes available for use by all the other PCs on your network. To make the printer available to other users, follow these steps:

1. Open the Printers control panel, and right-click the printer you want to share.

2. Select Properties from the pull-down menu. The Printer Properties display appears (see Figure 11.5). The example here shows a Windows 2000 printer properties page; the Windows 98 and Windows Me displays are slightly different. Our reasons for using the Windows 2000 display will become clear in a moment.

Figure 11.5

The Printer Properties display takes you to the Printer Sharing display.

3. Click the Sharing tab. A display like the one shown in Figure 11.6 appears.

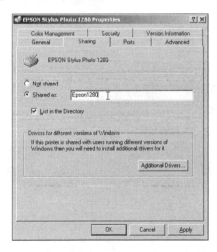

Figure 11.6

You can turn printer sharing on and off with the Printer Sharing display.

4. Click the Shared As button, and give the printer a name. On Windows 98 and Me systems, you can also assign a password that users must enter to use the printer. On Windows 2000 and Windows XP systems, you can set a password using the Security tab on the Printer Properties display.

5. Windows 2000 and Windows XP automatically download the appropriate printer driver as needed to other Windows 2000 and Windows XP machines. You can use this feature to install drivers for other operating systems. To do this, click the Additional Drivers button and select an operating system (usually Windows 95/98); Windows installs the appropriate printer drivers for the other operating system.

Oops, Wrong Disk!

When you click OK, Windows might ask you to insert the Windows 2000 Server CD. Don't panic. This is a bug in Windows 2000; what it really wants is the driver CD for your printer!

6. Click OK to close the Printer Properties display. Your printer is now shared on the network.

Connecting to a Shared Printer

Now that you've shared your printers, you're ready to use them from your other PCs. You need to install the shared printer on each of the PCs from which you plan to print.

During the installation process, you might need the printer driver floppy disk or CD that came with your printer. If the shared printer is connected to a Windows 2000 or Windows XP machine and you've installed the appropriate drivers for the client PC, Windows automatically downloads the driver from the Windows 2000 machine.

To use a shared printer from a PC on the network, follow these steps:

1. Click Start, and then select Settings, Printers. A list of the printers currently installed on your PC is displayed. Double-click Add Printer to install the shared printer. The Add Printer Wizard starts, as shown in Figure 11.7.

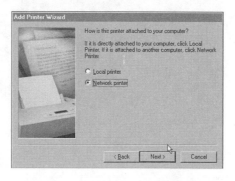

Figure 11.7

The Add Printer Wizard installs the drivers for the shared printer.


CHOOSING A PRINTER

PART 2


2. Click Network Printer, Next.

3. Windows asks you to enter the network path of the new printer (see Figure 11.8). Leave the printer name blank, and click the Browse button to open the printer browser.

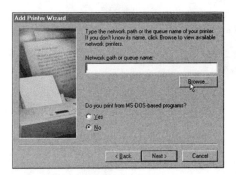

Figure 11.8

Give each printer a unique but descriptive name.

4. In the Browse for Printer dialog box that appears, Windows displays a list of all the computers on the LAN. Click the + sign next to the computer with the shared printer; a list of all the printers on that machine is displayed (see Figure 11.9).

Figure 11.9

Windows can help you find a shared printer using the Browse for Printer dialog box.

5. Windows fills in the name of the printer, but you can change the name if you want. You can also decide if you want the network printer to be your default printer (see Figure 11.10).

6. If you want, you can print a test page to make sure that the new printer is installed correctly. Click Yes or No, and then click Finish (see Figure 11.11).

Windows installs the driver files for the network printer. If Windows can't locate the driver files, you are prompted to provide the driver CD. The network printer is now installed and ready to use.

Figure 11.10

Naming the new printer.

Figure 11.11

Print a test page to make sure the new printer is installed correctly.

The Limitations of Networked Printers

Shared network printers operate very much like local printers attached to your PC. Because the print data must travel over the LAN, there might be a short delay after you click Print. The larger the image, the longer the delay is likely to be.

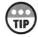

Is It Printing?

In most home and small office networks, you're able to see or hear the remote printer, so you can check on the printer's progress. If the printer is out of sight and/or earshot, you can check your print job's progress by double-clicking the printer's icon in the printer control panel. Another good indication that the printing is actually taking place is that the printer icon appears in the System Tray (which is in the lower-right corner of your toolbar).

If your printer driver has special features like an ink supply monitor, print preview, or progress monitor, those features might not work over the network.

USING A DEDICATED PRINT SERVER

Windows printer sharing lets you share any PC-attached printer with other users on the LAN. But there are two limitations to this approach. First, the shared printer is only available on the network when the attached PC is turned on and running. Second, the printer must be located relatively close to the PC, usually within 10 feet or so. This limits the number of places you can put the printer.

Network print servers enable you to share printers without using a PC. You can put the printer any place you like, as long as you can get a network cable to the print server. Figure 11.12 shows a diagram of a typical home network with two printers connected to a print server.

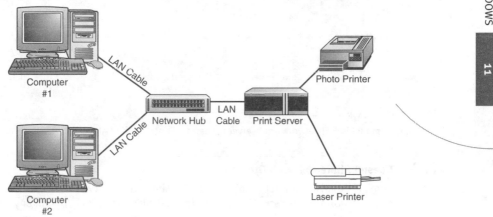

Figure 11.12

When you use a print server, you can put the printers wherever you want.

Most home network equipment manufacturers offer several models of network print servers. The Linksys unit shown in Figure 11.13 has a single parallel printer port and sells for about $130. Linksys and other vendors also make print servers with as many as 3 parallel ports. Some vendors even offer wireless print servers that work with wireless LANs.

 USB Printers Need Not Apply

The current crop of print servers can only connect to parallel printer ports, not to USB ports. If your printer only has a USB port, you can't connect it to a printer server.

Print servers usually require a special driver on each PC on the network. The driver adds a special network port to the PC so that Windows knows how to send data to the printer. As with PC-attached shared printers, you must install the appropriate printer driver on each PC that uses the shared printer.

Figure 11.13

This Linksys model PPSX1 network print server connects a printer to the LAN without using a PC.

 Doesn't Share Well with Others

Some inexpensive printers can't be shared using a print server. These printers are often called *Winprinters* or *controllerless printers* because they don't contain any controller circuitry of their own. Most photo-quality printers contain their own controllers and can be used with print servers.

CHOOSING A PRINTER

PART 2

156

SUMI'S SNAPSHOT

Can I mix wired and wireless computers on the same LAN?

Yes. Wireless access points can connect to an existing wireless LAN. This arrangement enables you to use Ethernet cables for your desktop PCs and a wireless connection for your laptop.

Can't I just run a long cable from one of my PCs and put my printer off in a corner or a closet?

You can try. Parallel printer cables don't work well beyond 12 feet or so. USB cables can go to about 16 feet. Longer cables are available, but they don't always work properly.

SHARING PRINTERS ON A MACINTOSH NETWORK

Macintosh computers have always been known for their simple, effective networking. This chapter shows you how to do the following:

- Create a Macintosh network
- Share a printer on your Macintosh network

NETWORKING YOUR MACS

All Macintosh computers leave the factory with nearly everything you need to set up a small local area network using Ethernet cable. The only things missing are the network cables and a common connection point, called an *Ethernet hub* or *Ethernet switch*. Hubs use older, simpler (and less expensive) technology than switches, but on a small network, either one works fine.

Look Ma, No Wires!

If you don't want to run wires all over your home or office, Apple and several other vendors offer wireless connection equipment that enables you to connect later model G3 and G4 desktops, Powerbooks, iMac, and iBook computers using radio signals instead of wires.

Apple's own wireless products are called AirPort. All AirPort products are compatible with IEEE 802.11b (also called *WiFi*) wireless products from other vendors, so you can use any WiFi-equipped notebook computer with an AirPort network.

SHARING MAC PRINTERS

Macintosh networking has undergone some radical changes over the years. The earliest Macs had a port called a LocalTalk connector, which allowed any Mac to connect to a LocalTalk network. Apple and most third-party printer makers included LocalTalk ports on their products, making it extremely simple to share printers on Mac networks.

As Ethernet became the corporate LAN standard in the late '80s, Apple added Ethernet network connectors to their entire product line. All Mac computers and Apple laser printers now include an Ethernet interface as standard equipment.

With the arrival of the G3, G4, iBook, and iMac computers, Apple abandoned the venerable (and, by this time, obsolete) LocalTalk connector, replacing it with a USB connection. Unfortunately, Apple didn't initially provide a way to share USB printers over the network. This meant that you could only share printers with built-in Ethernet connections on the network.

Apple eventually added USB print sharing to Macs running OS 9 or later. Apple hasn't gone out of its way to let people know that USB printer sharing exists, so many Mac users aren't aware that it can be done. The USB printer sharing software is not installed on Macs at the factory, but it is available as a free download from Apple's Web site.

The most popular (and affordable) photo-quality printers come with USB—and not Ethernet—interfaces.If you want to share that USB photo printer on your Mac network, you have to know the secret handshake that makes it all happen. Here it is:

1. Connect the printer to one of the Macs on your LAN, and install the appropriate printer driver.

2. Don't put that driver disk away; install the same driver on all the Macs that will use the shared printer.

3. Install Apple's USB sharing update on all the Macs that will use or share the printer. From the Control Panel, select Software Update. If the Software Update control panel can't locate the update, go to www.apple.com, click Support, click Downloads, and search for "USB Printer Sharing". Trust us, it's there.

4. On the Mac with the shared printer, Select USB Printer Sharing from the Apple menu. The display shown in Figure 12.1 appears.

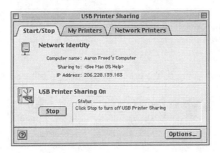

Figure 12.1

The USB Printer Sharing screen lets you turn printer sharing on and off.

5. Click the Start button to turn on printer sharing. Then, click the My Printers tab (see Figure 12.2).

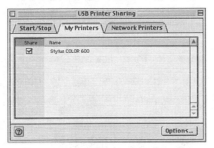

Figure 12.2

The My Printers tab shows the sharing status of all the printers attached to your Mac.

6. Click the check mark next to the printer name, and close the USB Printer Sharing window.

On each Mac that will use the shared printer, follow these steps:

1. Select USB Printer Sharing from the Apple menu, and then click the Network Printers tab. You'll see a display like the one shown in Figure 12.3.

2. Click the Add button. Then expand the Local Network and Local Services tab. You should see the shared printer on the other Mac, as shown in Figure 12.4.

Figure 12.3

The Network Printers tab lets you connect to a printer attached to another Mac.

Figure 12.4

In this example, we're selecting the shared printer we want to use.

3. Click the shared printer, and then click the Choose button.

4. Open the Chooser and select the driver for the shared printer. Make sure the USB port appears in the printer port window (see Figure 12.5).

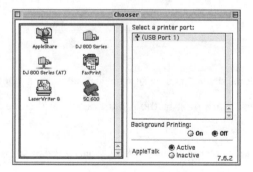

Figure 12.5

The shared printer appears in the Chooser, just like a locally connected printer.

That's it. You can now use the shared printer over the network.

SUMI'S SNAPSHOT

My older Macs are running OS 8.6. Can I use a shared USB printer?

No. USB printer sharing runs on only OS 9 and OS X. To use a shared USB printer, you need to update your Mac.

Can I use USB printer sharing over an AirPort wireless LAN?

Yes, you can—as long as the portable computer has OS 9 or later installed. You still need to install the USB Printer Sharing software.

PART III

USING YOUR CAMERA

CHAPTER 13

HOW TO TAKE GREAT PICTURES

What makes a good picture? A bad picture? A great one? The answer depends on what you expect when you take the picture.

Most photography books contain a section on how to create artistically creative pictures, and we get to that in Chapter 15, "Moving Beyond Snapshots." But for most people, a good picture is one that captures a memory. That memory might be a special moment during a trip or family event, or it might be one of the thousands of ordinary things we see in our daily lives.

The difference between a bad picture, a good picture, and a great picture is often a matter of small details. With years of experience, you'll learn to spot these details. To help you take great pictures right away, we've compiled a list of basic photographic techniques that help you take better pictures.

Our goal in this chapter is to increase your photographic success rate so that you get a higher percentage of great pictures and a lower percentage of bad ones. (Of course, the beauty of a digital camera is that you don't have to pay for the developing costs of a bad picture; you can just delete it immediately.) In this chapter, you learn

- What makes a good picture good
- What makes a bad picture bad
- How to take better pictures

WHAT MAKES A GOOD PICTURE GOOD

It's not what you think.

A good picture is one that captures what the photographer intends the viewer to see. It extends the photographer's vision into the eye of the viewer. It captures a moment in time, often a moment that has special meaning for the photographer, the viewer, or both.

A good picture doesn't have to be technically perfect. A visit to any art gallery with a photographic collection proves this to be true. But most of us aren't taking photos for a museum exhibit. We're taking picture for ourselves, our family and friends, and maybe for work.

Most amateur photographers want to be able to take sharp, clear photos with a high rate of success. That means taking more good pictures and fewer bad ones. Each time you press the shutter release button, you should feel confident that the image you just captured is exactly what you intended it to be, whether it's a picture of your kid's birthday party or that once-in-a-lifetime sunset you saw on vacation.

Every camera comes with a user's manual that tells how the camera's controls work. It also tells you how to put in the batteries, turn on the camera, and how to operate the camera's controls. What those manuals don't tell you—and this is the whole point of this chapter—is how to take consistently good pictures. Over the years, I've learned what works and what doesn't. Later in this chapter, I pass on some tips and techniques that can make you a better photographer.

WHAT MAKES A BAD PICTURE BAD

Many things make a bad picture bad, and we show you how to avoid them later in this chapter. But the worst picture of all is the one you missed because the camera wasn't set up properly or because you didn't understand how some aspect of the camera works.

Some pictures turn out badly because the photographer expected more than the camera could deliver. Watch any major sporting event, and you see hundreds of flashes going off in the stands at key points in the game. The problem is, the range of an average point and shoot camera's built-in flash is about 15 feet. Even if the flash could reach that far, the lens on a P&S camera can't possibly pick up any detail on the playing field—yet thousands of fans are snapping away up there in the stands, thinking they they'll have some *Sports Illustrated*-quality pictures to show their friends.

Sometimes, the difference between a good picture and a bad one is a matter of subtleties. As an example, look at two pictures of my son, Aaron, and his friend Will in Figure 13.1. Both pictures were taken a few seconds apart on their first day as college students.

 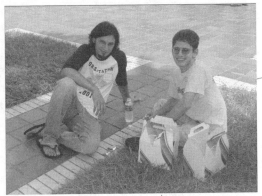

Figure 13.1

These two pictures show how a few minor changes in framing and exposure can have a drastic effect on the quality of the picture.

As you can see, both pictures are very similar, but the right picture stands out as being much better than the left one. There are two subtle differences between the pictures.

First, the left picture is framed too loosely. As a result, you can see the feet of some other students above Aaron's head. By zooming in very slightly, I was able to eliminate the feet without cutting off any part of Aaron or Will's bodies. As an alternative, I could have moved a little to the right—if I hadn't been standing next to a tree.

Second, although the pictures were taken on a sunny day, my subjects are sitting in the shade. In the left picture, the camera adjusted the exposure for the bright areas behind Aaron and Will, leaving them in relative darkness. I could have manually overridden the camera's autoexposure setting to compensate, but that would have blown out the detail in the bricks. Instead, I used the camera's built-in flash to fill in the harsh shadow areas.

TAKING BETTER PICTURES

Over the past 30 years, I've taken tens of thousands of pictures with all kinds of film and, more recently, digital cameras. The first thing I learned about digital cameras is that being a good film photographer doesn't automatically make you a good digital photographer. Digital cameras are different than film cameras, and they often require different techniques to achieve the best results.

The rest of this chapter lists a few key concepts and techniques that enable you to take better pictures. I've kept this list intentionally short, so that I could concentrate on the most important and effective tips and techniques.

You Can't Take Pictures Without a Camera

This might seem obvious, but you can't take great pictures if you leave your camera at home. Some people seem to be afraid to take their cameras out into the real world. You

paid a lot of money for your digital camera, and the only way to get your money's worth out of your camera is to take pictures with it!

If you're afraid of damaging your camera, buy a small protective case (not a bulky camera bag.) They're inexpensive and offer good protection against dust, light rain, and scratches. Many cases have storage compartments for extra batteries and memory cards, so you can carry everything you need in one small package. If you need to carry other stuff with you, you can safely put the camera—in its case—inside a larger bag.

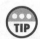

Watch the Heat!

If you live in a hot climate, don't leave your camera in a hot car. The temperature inside a parked car can exceed 130 degrees, which is hot enough to damage the image sensor and LCD screen in your camera.

Be Prepared

That old Boy Scout mantra is especially true in photography. If you're planning to take pictures, you need to be prepared. That means bringing along enough memory storage and battery power to meet your expected picture-taking needs.

To hold retail prices down, most cameras come with a very small memory card that holds only a few pictures. In most cases, you need to purchase an additional memory card for your camera. Individual needs vary, but as a general rule you should have enough memory to take 40–50 pictures at your camera's highest quality settings.

Two for One?

As consumers, we've learned that most things are cheaper when you buy them in larger quantities. That extra-large-size shampoo might be a better deal than the small bottle, but memory cards are an exception to the rule.

For example, a 128Mb memory card costs more than twice as much as two 64Mb cards, which in turn costs more than two 32Mb cards. Higher-density cards cost more to produce, and they're more convenient to use because you can take more pictures without changing cards; but you pay a premium price for the convenience.

There are good reasons to stick with less expensive, lower-density cards. By splitting your memory investment across two or more cards, you cut your losses if one of the cards is lost or damaged. And if you buy a second camera, you can use one card in each camera.

Hold Your Camera Level and Steady

This might sound like an obvious thing to do, but it's one of the most common causes of bad pictures. If possible, use both hands to hold the camera, especially when you're shooting at full zoom or in low light conditions with a slow shutter speed. By using both hands, you reduce camera shake and get sharper pictures.

If your picture has strong vertical or horizontal lines, it is very important to keep the camera parallel with the horizon; otherwise, your pictures appear tilted. Unfortunately, it's easier to

see the tilt in a finished picture than it is in the camera viewfinder. Many viewfinders and LCD screens provide framing lines that you can use as a guide to help keep the camera level.

Steady As She Goes!

For telephoto and low-light shots when you don't have a tripod, try tucking your elbows up against your ribs. Although it looks awkward, this position really does help keep the camera steady. As an alternative, you can often steady the camera by placing it on or up against a solid object like a fence or pole.

Look Before You Shoot!

This is another obvious pointer, but it's an important one. After you've composed your picture, look behind and around your main subject for other objects in the picture. When taking a picture in which a person is the subject, make sure there are no distracting objects (like a tree, sign, or lamp post) "growing" out of your subject's head.

If you're taking a full-body people picture, make sure that you don't cut your subjects off at their shoes. For head-and-shoulder portrait shots, leave some space above the subject's head, but not so much that half the picture is sky or ceiling.

Watch out for reflective objects like windows, mirrors, and shiny objects in the background. This is especially important when taking flash pictures; the reflection fools the camera's light meter, resulting in a very underexposed picture.

Use the Appropriate Image and Quality Settings

All digital cameras have settings that enable you to adjust the number of pixels in the image (usually called resolution or image size), and a setting that enables you to adjust the amount of data compression used to store the image (usually called image quality). Smaller images take up less space than larger ones, so you can get more images on a memory card by using the smaller image size. Similarly, highly compressed (lower quality) images take up less space than high quality images.

Unless you know that you don't need the higher resolution, you should always shoot with your camera set for the largest image size and the highest quality setting. You can always downsize a large image (using photo editing software on your PC) to make it smaller, but you can't recapture the image detail that is lost when you shoot at a small image size.

JPEG or RAW?

Many cameras have an uncompressed storage mode (usually called TIFF or RAW mode) that stores the image without compressing it. These modes are useful when you want to capture the absolute best possible image, but they require 3 or 4 times as much storage space on the camera's memory card. Uncompressed images also take longer to download and take up more room on your hard drive.

RAW or TIFF images are useful for making very large prints, but you won't **see** a huge quality improvement over your camera's highest-quality JPEG setting.

If you're shooting specifically for the Web or e-mail, you can safely use one of your camera's lower-resolution settings. Shooting in a smaller image size enables you to save more images on your memory card, and it saves you the drudgery of having to open, resize, and save each image on your PC.

Review Your Photos

One of the great things about digital photography is that you can see your pictures just seconds after taking them. This instant review feature enables you to make sure that you got a good picture, and it's a nice feature to have at family gatherings, weddings, and other special events. But you can also use your camera's instant review feature to make you a better photographer.

If you're not sure how a picture turned out, check it on the LCD screen before you lose the opportunity to re-shoot the picture. But don't overdo it. The LCD screen is a major source of battery drain, and if you review every shot, you might run out of batteries before you run out of photo opportunities.

Extending Battery Life

Most digital cameras include an automatic review feature that shows each picture on the LCD screen for a few seconds after you take the picture. Although this is a nice feature, it also consumes a lot of battery power. Unless you really need to see each picture, turning the review feature off can double your battery life.

Anticipate the Moment

Digital cameras suffer from an annoying problem called *shutter lag*, which is the delay between the time you press the shutter release and the time the camera actually takes the picture. All cameras suffer from some shutter lag, but point and shoot cameras—both film and digital—are the worst offenders. The lag is caused primarily by the camera's autofocus mechanism. The problem with shutter lag is that you're never quite sure when the camera is actually going to take the picture.

In extreme cases, the camera might take a second or two to lock focus, or it might not be able to focus at all. In the meantime, you're standing there with your finger on the button, waiting for something to happen. This is especially frustrating when you're shooting impatient or fast-moving subjects like kids, animals, and sporting events. Fortunately, there's a workaround that can help you get better pictures in spite of the lag.

On most cameras, you can lightly press the shutter release button (about halfway down) to pre-focus the camera. After the camera is focused, keep your finger on the button until you're ready to take the picture, then press the button all the way down. The camera takes the picture without refocusing, thus eliminating most of the shutter lag. This technique takes some practice, and there is still a small amount of lag after you press the button all the way down.

Easy Does It!

Speaking of the shutter release button, be careful not to press it too hard. Pressing too hard or too fast can cause the camera to shake, which results in blurry pictures.

This is especially important when you're shooting in low light conditions with a slow shutter speed.

The pre-focus technique can be a lifesaver when you're waiting to take one of those once-in-a-lifetime shots where you won't have a second chance. For really important pictures, you should take a few practice shots before the actual event to make sure that the camera is actually able to focus.

Stayin' Alive

Here's every photographer's nightmare scenario: You're at an important event—your son's high school graduation, for example—waiting for your son to walk up and receive his diploma. You have fresh batteries and plenty of memory in the camera. You've taken a few test shots, so you know you're in a good position and that the lighting is okay.

As your son walks up to the stage, you confidently raise the camera to your eye—and the camera is dead as a doornail.

Most cameras have an automatic power-off feature that turns the camera off if you haven't taken a picture for a few minutes. This feature can save you from accidentally running your battery down when you forget to turn the camera off, but it can also turn the camera off while you're waiting to take a picture. You can temporarily override this feature by lightly pressing on the shutter release button.

For really important events, you might want to disable the automatic power-off feature so you won't miss a shot.

Dealing with Tricky Lighting

The light metering and autoexposure systems in most digital cameras are amazingly accurate, but they're not infallible. Although most autoexposure systems produce perfect exposures 90% of the time, you need to know when to recognize that other 10% so that you can override the camera's exposure choice.

Backlighting

Backlit subjects are the most problematic subjects you're likely to encounter. Backlighting happens with the light behind a subject is brighter than the light in front. The bright light behind the subject causes the camera to expose the image for the bright light, which often makes the foreground subject too dark. Figure 13.2 show how autoexposure systems can be fooled by a bright sky.

The sample pictures were taken on a cloudy day. Some of the clouds were almost black; others were bright white. In the first picture, the camera was set for multi-zone metering, which measures the light in several parts of the pictures to determine an average. Because

the sky is a large part of the picture, the camera decided that it needed to set the exposure to maintain the white in the clouds. Although the resulting photo has plenty of dynamic range (the dark clouds show up dark and the light clouds are nearly white), the main subject is too dark.

Figure 13.2

In the left picture, the bright sky fooled the camera's exposure system, resulting in a dark picture. In the right picture, I used center-weighted metering to expose for the Balanced Rock (in Arches National Park, Utah), ignoring the sky.

For the second picture, I used the camera's center-weighted metering feature to take the light reading off the rock itself. Center-weighted metering measures the light from the center of the picture, in this case ignoring the jumble of light and dark clouds behind the subject. Some cameras have a spot meter feature, which is similar to center weighting, but with a smaller metering area.

The resulting picture is much brighter, with good detail in the subject. The sky is somewhat overexposed, but this is unavoidable with backlit subjects. The detail in the lightest clouds is completely gone, but the darker clouds are still visible, maintaining the ominous tone of the sky.

If your camera doesn't have a center-weighted or spot metering option, there's another technique you can use to compensate for backlighting. Before you take the picture, tilt the camera down or zoom in to exclude the bright sky from the picture, then press the shutter release half way. This causes the camera to lock the exposure reading without the sky in the picture. Holding the shutter release pressed half-way, recompose the picture, and then press the shutter release to take the picture.

Locking Exposure

On many cameras, this technique locks both the exposure and the focus. Some cameras have a separate button marked AE Lock (for autoexposure lock) that holds the exposure reading separate while allowing you to re-focus with the shutter release button.

Extreme Contrast

Scenes with large amounts of contrast are problematic for digital cameras. The image sensor in a digital camera can capture a wide range of tones, but some scenes simply contain more contrast than the image sensor can handle. Although this most often happens when you're shooting a light subject on a dark background (or vice versa), it also happens when shooting outdoors on a very sunny day. In these situations, you must decide whether you want to expose for the shadows or the highlights. Figure 13.3 shows the problem in pictures.

Figure 13.3

Extremely contrasting scenes like this one force you to choose between properly exposed highlights (left) or shadows (right).

In the first picture, the camera made what is technically a perfect exposure. The brightest area of the picture along the top edge of the roof is perfectly exposed, and the shadow areas—the doorway behind the sign and the window frame—are very dark, as they should be. The problem is, I wanted to emphasize the wooden ladder and the Chili peppers (two New Mexico trademarks/clichés), but they are lost in the shadows. This is a case where what I want and what the camera wants isn't the same.

For the second picture, I zoomed in and metered off the ladder and peppers, then used the camera's AE lock button to hold the exposure while I zoomed out, recomposed the shot, and took the picture. In the second picture, the highlights along the edge of the roof are somewhat blown out, and the sky lost that nice deep blue from the first picture. But the ladder and peppers are now out of the shadows. As a bonus, the sign is much more readable.

Watch Your Focus!

Like automatic exposure, modern autofocus mechanisms are very accurate and usually reliable. But like autoexposure, your camera's autofocus circuits can't read your mind. In some situations, the autofocus system chooses to focus at a point in front of or behind your main subject, leaving your main subject out of focus. This is especially common in pictures where the main subject is not in the center of the picture. Figure 13.4 shows the problem in pictures.

Figure 13.4

In the left picture, the camera's autofocus circuit focused on a point behind the subjects. On the right, I pre-focused on one of the girls to keep them in sharp focus.

Most digital cameras focus on the center of the frame. When presented with an off-center subject like the two sisters in Figure 13.4, the camera dutifully did as it is programmed to do—it found the object in the center of the frame and focused on it. Unfortunately, this wasn't what I wanted.

Before you press the shutter release, look to see what is in the very center of the viewfinder. If it isn't part of your main subject, point the camera directly at the main subject, press the shutter release half way, and then recompose your shot and take the picture.

As was mentioned earlier, pressing and holding the shutter release locks both focus and exposure on most cameras. Some cameras have separate autoexposure and autofocus lock buttons, so you can lock focus on one part of the picture and take your exposure reading from another.

SUMI'S SNAPSHOT

I tried the outdoor flash technique, but my subjects were still too dark. What happened?

The built-in flash units on many P&S cameras are relatively weak. They're designed to provide enough light to take pictures indoors. Unfortunately, outdoor sunlight is very bright, and it takes a great deal of flash power to fill in harsh shadows, especially if you're more than a few feet from the subject. A more powerful external flash can help—if your camera is equipped to accept an external flash.

While waiting to take pictures at my daughter's piano recital, the batteries went dead after only a few pictures, even though the battery indicator showed a full charge just a few minutes before.

This is a common problem with Nickel Cadmium and Nickel Hydride rechargeable batteries. Both types of batteries die very suddenly with almost no warning. The battery charge indicator on most cameras can only give you a few minute's warning. When you see the low battery indicator, change batteries at the first opportunity.

My 64Mb memory card usually holds about 40 pictures. I took my camera to a party the other night and only had room for 30 pictures. What happened?

It sounds like your camera has an automatic ISO setting that automatically increases the camera's ISO sensitivity in dim light—like at that party. As the ISO speed increases, so does the noise level, which is visible as grain in the pictures. Noisy pictures require more storage space than standard pictures, which is why you only had room for 30 pictures.

CHAPTER 14

DIFFICULT PICTURES MADE EASY

Back in Chapter 1, "Going Digital," I mentioned that digital cameras make difficult pictures easy. In this chapter, you learn how to take those difficult shots.

Each topic in this chapter includes a sample picture or two, a description of the technique involved, a list of the necessary equipment, and a few tips and pointers to help you master the techniques.

In this chapter, we show you how to take great

- Portraits
- Scenic and travel pictures
- Building interiors
- Telephoto close-ups
- Tabletop close-ups
- Nighttime scenics
- Action pictures

PORTRAITS

Portrait photography is one of those things that is much more difficult than it seems like it should be. Making a good portrait requires good equipment, good technique, and a good rapport with the subject. But most importantly, you need good lighting.

Commercial portrait photographers typically use several flash units with light diffusers. Most portrait photographers have a standard lighting setup that they use for the majority of their portrait work. Because they work with the same lighting setup every day for many years, they've had time to fine-tune the lighting setup to give the best results.

Most amateur photographers don't have the time and resources required to use such a complicated lighting setup. But the good news is that you can take great portrait shots with a much simpler setup.

On-Camera Flash

It's possible to take a good portrait picture with an on-camera flash. If you're shooting with a built-in flash, it's important to be aware of the hard shadow created by the flash. Take a few shots, check the shadow, and reposition the subject, camera, and background to minimize the shadow. Figure 14.1 shows a head and shoulders portrait taken with a built-in flash.

Figure 14.1

This portrait was taken with a built-in flash. The head-on angle of the flash produces a dark shadow behind the subject.

As you can see from Figure 14.1, the narrow light source from a built-in flash produces a very dark, hard shadow behind the subject. Keeping the subject close to the background helps to minimize the shadow. Although the picture is correctly exposed, it appears dark because of the shadow.

Off-Camera Flash

If your camera has an external flash unit, you can purchase an extension cable that enables you to move the flash off to one side. For the image in Figure 14.2, I used a 4-foot extension cable to move the flash about 3 feet to the right. The resulting picture is much better than the first.

Figure 14.2

Moving the flash off to the right eliminates the shadow on one side of the subject, but it creates an even deeper shadow on the opposite side.

The off-camera flash technique partially solves the background shadow problem, but it creates a new problem, too. In Figure 14.2, the background is lit on the subject's left, eliminating the shadow on that side. But now there's an even deeper shadow on the other side. The off-camera flash also produces a slight shadow on the subject's facial features, but this isn't a bad thing. The shadows give definition to the face and produce a more realistic portrait.

Two Flashes Are Better Than One

If you have a slave flash (see Chapter 6, "Essential Accessories"), you can use the slave to light the background. You need to experiment with the brightness and position of the slave flash to achieve the best results, but it's well worth the trouble, as you can see in Figure 14.3.

Figure 14.3

A slave flash placed behind the subject helps eliminate shadows and makes the subject stand out against the dark background.

The slave flash solves all of our shadow problems. The background shadows are completely gone, and the resulting picture has a more natural look.

Technique Checklist: Portraits

Essential items:

- A plain background

Optional items:

- External flash (or two)
- Extension cable (for off-camera flash)

- Wireless slave trigger (for multiple-flash setups)
- Light stands (for flash units)
- Tripod

Tips and tricks:

- The background is almost as important as the subject. A busy background distracts the viewer from the subject.
- Use a long focal length (35mm equivalent of 85–105mm). Shorter focal lengths tend to elongate noses and facial features and make for less flattering pictures.
- Choose a large aperture to reduce depth of field, but make sure you have enough depth of field to cover the subject's face from the nose to the ears.
- Place the camera slightly above the subject's eye level. Lower camera angles are very unflattering.
- If you're shooting with an on-camera flash, choose a relatively dark background to minimize the shadow behind the subject. Have the subject look slightly off-camera to prevent red-eye.
- Use one or more external flash units to provide even light with no shadows. Raising the flash units above the subject's head reduces background shadows, but be careful not to create shadows under the nose and eyes.
- Use a tripod to keep the camera level.

SCENIC AND TRAVEL PHOTOS

Most people wouldn't think about going on vacation without a camera. At any national park or large city, you're likely to see people snapping away at just about everything. But getting really good travel and scenic pictures is much more difficult than it looks.

In this section, we examine a few pictures and see what makes them work—or not.

Include an Obvious Subject

When you're photographing beautiful scenery, it's important to remember that your photos need a main subject, something that draws the viewer in and makes them interested in the picture. Without a focal point, your pictures are dull and uninteresting. Figure 14.4 shows how easy it is to take a boring picture of an interesting subject.

Is this a picture of the arch, or the trail leading to the arch? It's hard to tell. The focus and exposure are perfect, but the only thing you can tell from this picture is that the arch is tilted. Figure 14.5 is much better.

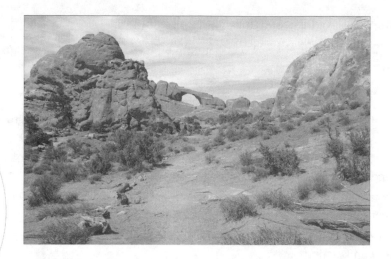

Figure 14.4

This picture of Skyline Arch is technically okay, but the picture lacks a focal point.

Figure 14.5

Getting closer provides a clearer view of the arch. The tree and the hiker give the picture a sense of scale.

By moving closer and including a few foreground subjects, the second photo tells us that this is a really big arch. The vertical elements (the tree and the hiker) in the picture give the viewer vertical reference point, which in turn emphasizes the arch's tilt.

The image in Figure 14.5 also obeys the Rule of Thirds (see Chapter 15, "Moving Beyond Snapshots"), which says that the main point of interest (in this case, the arch) should fall along the intersection of lines that divide the picture into thirds.

Give the Viewer a Sense of Scale

When you're photographing scenery, it's important to give the viewer a sense of scale. Without a reference point, the viewer has no way to know how big the subject is. Figure 14.6 shows two similar pictures with vastly different senses of scale.

Figure 14.6

These two pictures of the Grand Canyon show the importance of scale.

The two pictures were taken just moments apart from the same location. The picture on the left doesn't give any impression of the vastness of the canyon. The right picture is very similar, but it includes some people at an observation area that overlooks the canyon. The people are dwarfed by the vastness of the canyon, giving the picture a sense of scale.

Small Things in Big Places

When you're visiting a large city like New York, your natural inclination is to try to capture the big picture of the big city. But unless you take a cab across the river to New Jersey, you can't capture all of New York—or any big city—in one picture.

Sure, you can—and should—take the usual tourist shots of the Statue of Liberty, Times Square (my personal favorite), the Empire and Chrysler buildings, and South Street Seaport. But then your vacation album will look pretty much like everyone else's New York vacation album.

Instead of looking for the big picture, look at the small things that make each place unique. The essence of a city is often seen in small details (see Figure 14.7).

Figure 14.7

When you can't take one picture of the whole city, take lots of pictures of the things that make the city unique—like these shots of New York City.

Bad Weather Can Make Good Pictures

Many people think that you can only take great travel pictures in bright, sunny weather. But like it or not, bad weather might be part of your travel experience. Make the best of bad weather. The dramatic skies and diffuse light caused by bad weather can make for dramatic—and unusual—pictures. Figure 14.8 shows two examples.

Figure 14.8

Inclement weather can provide some unique and unusual photo opportunities, like these pictures of Great Sand Dunes and St. Mark's Square in Venice.

Photographing Large Buildings

Large buildings can be very challenging to photograph, especially in crowded cities. A wide-angle lens enables you to take pictures of most buildings at close range, but the results might not be pretty, as you can see in Figure 14.9.

The picture in Figure 14.9 is dramatic, but it's not a very accurate portrait of this magnificent building. The picture was taken with a wide-angle lens. As we've seen before, wide-angle lenses must be held parallel to the ground. If you tilt the lens up—as I did in this picture—parallel lines appear to converge at a point above the building, which distort this building's strong vertical features.

Fortunately, the Basilica faces a large square. By moving away from the church, I was able to use a small telephoto lens (105mm) to get a much better picture of the church (see Figure 14.10).

Figure 14.9

Wide-angle lenses can make tall buildings look like they're falling backward, as seen in this shot of the San Marco Basilica in Venice.

Figure 14.10

A telephoto lens offers a much more accurate perspective—if you have enough room to get away from the building.

As you can see, the church is no longer falling down, and you can see the church's famous domes and spires in all their glory. As a bonus, the telephoto lens shows a compressed perspective of all the people (and pigeons) between the camera and the church, adding an interesting human (and animal) element to the photograph.

Technique Checklist: Travel and Scenery

Essential items:

- None, other than your camera and some scenery

Optional items:

- Tripod (for early a.m./late p.m. shots when the light is best)
- Wide-angle adapter (for that elusive big picture)
- Telephoto adapter (for isolating distant details)
- Waterproof camera bag (for those inevitable rainy days)
- Polarizing filter (for reducing reflections on windows)

Tips and tricks:

- Avoid cliché, (picture-postcard shots. If you want a postcard picture, buy a postcard. Find an unusual angle or aspect of your subject and make the image your own.
- Use a low or high camera angle to stand out. Most people take all of their pictures from eye-level. Explore other possibilities. Low-angle shots emphasize the height of buildings and natural features; higher angles tend to make large objects look smaller.
- When shooting wide-angle shots, use a small aperture to increase depth of field. This ensures that everything in your picture is in sharp focus. Keep in mind that small apertures require longer exposures, so watch the shutter speed and use a tripod if necessary.
- Remember that longer focal lengths and larger lens apertures reduce depth of field. You can use this to your advantage to isolate interesting architectural or scenic details.
- Early morning or late afternoon is best. Every photography book says so. Before dawn and after sunset, the sky glows with soft light. The diffuse light doesn't cast a shadow, making it ideal for scenic photos. At sunrise and sunset, the sun is very low in the sky, which makes for dramatic photos. But that doesn't mean you can't take great pictures the rest of the day. Mid-day, the sun is bright and straight overhead, where it casts harsh shadows on buildings and scenery. Watch out for these shadows, and work around them.
- When shooting in harsh light, check your first few exposures and watch for blown-out highlights. Adjust your camera's exposure compensation if you're getting consistently overexposed pictures, but remember to turn the exposure compensation off when you're finished shooting.
- Try to include your friends and family in your pictures, but leave enough room so that you can tell where they are. We've all seen loads of pictures of Aunt Selma in front of this place or that—without seeing the place behind her.

BUILDING INTERIORS

Done properly, a good interior photograph can make the Simpsons' place look like Buckingham Palace. Unless you're shooting a very large room, you probably need a wide-angle adapter for your camera. Wide-angle lenses often distort vertical lines near the edges of the picture, so be aware of this when composing your pictures. The distortion is most noticeable when the camera is tilted up or down, so try to keep the camera as level as possible. A tripod is a big help, and it also enables you to shoot with available light at slow shutter speeds. Watch out for horizontal tilt, too. Even the slightest tilt to the camera can make the room look like a scene from *Titanic*. A camera level is almost essential. If your camera has horizontal or vertical framing guide lines, you can use them instead of a level.

Lighting Is Key

Unlike film cameras, digital cameras can automatically adjust to almost any light source. This makes it easy to shoot building interiors with a mix of daylight, fluorescent, and incandescent lighting.

It's always best to shoot room interiors during the day, so you can take advantage of the natural daylight entering the room. Keep in mind that any incandescent lights in the room appear yellowish when the primary room light is daylight. You can use a flash to help light the room if the light coming in the windows isn't adequate, but you might find that your camera's built-in flash does more harm than good. An external flash bounced off the ceiling can often provide enough fill-in light to light the room without casting harsh shadows.

Nighttime interior shots can be very dramatic, and many rooms have a completely different look when lit with artificial light. If the primary light source is incandescent lights, don't try to use a flash because the flash adds a blue cast to the light. If you need additional light, use one or more floor lamps with the shades removed, but be sure to place the floor lamps behind the camera or behind a large piece of furniture where they aren't in direct view of the camera.

Figure 14.11 shows two interior shots taken with a mix of natural and artificial light.

As you can see, the wide-angle adapter lens caused a slight curvature of the straight lines on the left side of the fireplace in the left picture and at both edges of the right picture. This type of distortion is hard to avoid with add-on wide-angle adapters, but the alternative is to spend about $2,000 more for a digital SLR with a high-quality wide-angle lens.

When you're shooting in public buildings, you don't have any control over the light, so you have to work with whatever light you have. Many historic buildings are very dark inside, which requires the use of slow shutter speeds. I enjoy photographing historic churches, which is made challenging by the fact that many historic churches (and other old buildings) usually don't allow the use of flashes or tripods.

It's possible to get good, sharp pictures inside dark buildings without a tripod, but don't expect to get a large percentage of usable shots. If you can't use a tripod, I've found it helpful to rest the camera on top of a bench, or to hold the camera up against a column or other structural member.

Figure 14.11

These two interior photos contain a mix of daylight and artificial light.

If your camera has an image stabilization feature, this is a great opportunity to use it. The picture in Figure 14.12 was taken in a dark New Mexico church using an image stabilized lens.

Figure 14.12

This New Mexico church interior was photographed handheld using an image-stabilized lens.

As you can see, the image stabilizer enabled me to take a sharp, clear picture, even though the shutter speed was a very slow 1/8 second.

Technique Checklist: Building Interiors

Essential items:

- Tripod
- Camera level (or framing lines on LCD display)
- Wide-angle adapter

Optional items:

- External flash with off-camera cord or wireless trigger
- Floor lamps borrowed from another room

Tips and tricks:

- Use a small aperture to get the most depth of field. This usually results in a very slow shutter speed, so you need the tripod, even in brightly-lit rooms.
- Try to remove as much clutter from the room as possible, especially if you're taking pictures for a real estate listing.
- Turn on all the room lights, but make sure the lights don't fool the camera's light meter. Check each picture on the LCD display before you move on to take the next picture. Dimmed lights appear very yellow. If any of the lights are on dimmers, turn them up to their maximum brightness.
- Hide electric cords so they're out of view.

TELEPHOTO CLOSE-UPS

Many photographers love telephoto lenses. Visit a zoo or wildlife park on any given weekend, and you'll see lots of amateur photographers with big telephoto zoom lenses. Telephoto lenses are fun to use. They enable you to take close-up pictures of subjects that you can't—or shouldn't—get close to. They're especially useful at zoos, sporting events, concerts (if you're allowed to bring in a camera at all), and for isolating details in travel and scenic photography.

Using a Telephoto Lens

Most digital cameras come with a zoom lens that offers a range of focal lengths, usually from a moderate wide-angle (equivalent to a 28mm lens on a 35mm camera) to a moderate telephoto (equivalent to a 135mm lens.) Many camera makers and third-party lens makers offer add-on telephoto lenses for digital cameras (see Chapter 6 for details) that double or triple the effective focal length of the camera's built-in lens. Other cameras—such as the Olympus C-700UZ and Canon PRO-90 IS (see Chapter 2, "Which Camera to Buy?")—come with 10X zoom lenses that provide coverage equivalent to a monster 370mm lens on a 35mm camera.

What's the difference? The two pictures in Figure 14.13 show the same bear, photographed from the same spot, at 160mm and 500mm equivalent 35mm focal lengths. (Note for the technically curious: The bear pictures were taken with a Canon EOS D30, using a Canon 100–400mm lens. As was explained in Chapter 2, the D30 effectively multiplies the lens' focal length by 1.6, making the 100–400 an effective 160–640mm lens.)

Figure 14.13

These two pictures of a polar bear chilling out at the Denver Zoo were taken at 160mm (left) and 500mm (right) 35mm-equivalent focal lengths.

As you can see, the longer focal length provides a much closer view of the bubble-blowing bear. You can see that the black spots on the bear's head are actually flies, which is probably why the bear kept ducking his head under the water.

Although everyone loves telephoto lenses, relatively few people understand how to use them properly. Telephoto lenses magnify distant objects, but they also magnify camera movement. The movement causes pictures to be blurred, especially at lower shutter speeds. Telephoto lenses are heavier than standard lenses, which makes them hard to hold steady for any length of time.

As a general rule, you need a tripod if the shutter speed is less than the focal length of the lens (in 35mm equivalent). For example, let's say you're shooting with a 200mm lens. Your picture will be sharp if the shutter speed is 1/200 sec. or faster. The longer the focal length, the faster the shutter speed must be to prevent blur. Rules were made to be broken, and this one is no exception. If you have a steady hand and good technique, you can shoot at half the shutter speed and still get good results.

Some camera manufacturers (Canon, Nikon, and Sony, to name three) make cameras and lenses with an image stabilization feature(see Chapter 5, "All About Lenses") that enables you to leave the tripod at home and still get good, sharp pictures. The Canon lens I used for the bear pictures has this feature. Image stabilization enables you shoot handhelds at speeds 8 times slower than conventional lenses, with no loss in sharpness due to camera shake.

If your camera or lens doesn't have image stabilization, do yourself a favor and buy a light-weight tripod for your telephoto shots.

Photographing Animals in the Wild

One of the reasons photographers love zoos is that you can get close-up pictures of exotic wild animals without the travel, expense, and danger normally associated with shooting lions, tigers, and (of course) bears. But it's much more rewarding—and challenging—to capture wildlife in the wild. If you're fortunate enough to live near or travel to a place with plenty of wildlife, you might want to try your hand at wildlife photography.

Wildlife photography can be very difficult and even dangerous. Unless you are photographing large, relatively tame animals at close range, you need a fairly large lens, at least a 300mm 35mm equivalent for animals, and a 400mm or larger for birds.

From a technical perspective, photographing animals in the wild isn't much different than shooting animals in the zoo—with three important exceptions. Here are a few simple rules for nature photography in the wild:

- You're not at the zoo, so don't expect animals to show up and pose just because you're out in the woods with your camera. Patience is more important than technique.

- If and when the animals do show up, remember that these are wild animals that might not be used to people. Some wild animals—even small ones—can be very dangerous, especially when startled or frightened. Don't get too close.

- Don't feed the animals. It's not good for them and it can be dangerous to you. If you live in an area where bears are active, don't even bring food with you.

All About Bears

The definitive (okay, it's not definitive, but it's very funny) work on the fear of bears can be found in Bill Bryson's *A Walk In The Woods* (ISBN 0767902521), a hilarious but moving tale of two forty-something guys' attempt to hike the Appalachian Trail.

Technique Checklist: Telephoto Close-Ups

Essential items:

- Digital SLR with telephoto lens
- Digital camera with large built-in zoom lens
- Digital camera with telephoto adapter lens
- Tripod or monopod

Optional items:

- Remote Shutter Release

Tips and tricks:

- You can hand-hold your camera at the zoo, but a tripod is a must-have item if you're shooting birds or animals in the wild. Even if you have enough light to shoot at a fast shutter speed, your arms will get tired from holding that heavy telephoto lens.

- Many wildlife and sports photographers use a monopod, a sort of one-legged tripod. Although a monopod isn't as steady as a tripod, it often provides more than enough support to keep the camera steady. Monopods enable you to pick up your camera and move quickly.

- Watch your shutter speed. Even if your camera is mounted on a steady tripod, you still need enough shutter speed to freeze fast-moving animals. 1/125 second is usually the minimum.

- Be aware of the limited depth of field. Telephoto lenses have very narrow depth of field, so you need to continually re-focus on moving animals.

PHOTOGRAPHING SMALL OBJECTS

Thanks to the popularity of eBay and other online auction services, many people find that they need to photograph a small object—a piece of jewelry, an antique lamp, or other household object—for their auction page. Judging from the quality of the pictures on most auction sites, most people don't have a clue how to do this.

First and foremost, you need a clean, uncluttered background, just like professional photographers use. This can be as simple as a table or countertop, a plain bed sheet or other fine-weave cloth (don't use a towel or blanket—these have too much texture), or a large sheet of paper.

If your object is flat (like a piece of jewelry or a book), you can lay it down flat on the background and photograph it from above. For taller items, you need to build a background.

Professional photographers use a seamless paper background, which looks like a giant paper towel holder. Seamless paper comes in a variety of widths and colors, and it makes an excellent photographic background. If you need to photograph small objects on a regular basis, the small investment in a few rolls of seamless paper and a paper holder frame is well worth the money.

If you're handy with a hacksaw, you can build your own seamless stand using 1 1/4" PVC pipe and a few pipe tees for about ten dollars—a tenth the cost of a commercially-made stand.

For very small objects, you can use a chair instead of a paper stand. Drape the background material over the back and onto the seat of the chair. For larger objects, use two chairs side-by-side.

Lighting is key to successful close-up shots, and reflective objects like glass and shiny metal can be very difficult to light. You can use the camera's built-in flash for flat objects like books, but three-dimensional objects usually require at least two lights to prevent hard shadows. For small objects, a pair of desk lamps—one on each side of the object—usually does the trick. Figure 14.14 illustrates how lighting can make or break a close-up photo.

On-camera flash

Single incandescent lamp

Two incandescent lamps

Two lamps, dark blue background

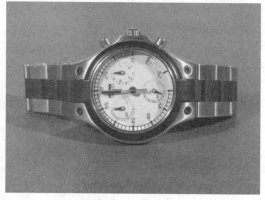

Figure 14.14

These pictures show why flash doesn't work for shiny objects. Experiment with light positions and backgrounds until you get the look you want.

The first picture in Figure 14.14 was taken with an on-camera flash, using an Olympus E-10. The flash's reflection off the watch's crystal is very distracting, and it caused the camera to underexpose.

For the second picture, I used a single 150 watt reflector lamp, placed to the camera's left. The watch is now evenly illuminated, except for a shadow on the watch face. A second lamp filled in the shadow, as you can see in the third picture.

While I was playing with lighting, I moved the watch to dark blue background, just to see how it would look. It turns out that the light gray background I originally chose was a better match for this particular subject.

Macrophotography

Virtually all digital cameras feature a close-focus, or *macro* mode that enables the camera's lens to focus at a very close distance. Technically, a macro lens is one that produces a life-size or larger image on the film plane (or image sensor), but many manufacturers have stretched the term to include any lens that focuses closer than a couple of feet.

Macro lenses are not usually found on 35mm P&S cameras because the viewfinder can't accurately show the critical framing and focusing required by macrophotography. Digital cameras—with their ability to provide a live Image preview—are ideally suited for close-up work.

Some cameras' macro modes work only at the longest zoom setting, and others work only at the widest setting. A few cameras can close-focus at any zoom setting. The longer zoom is preferable, because it enables you to work a little farther away from your subject.

So how close can you get with a macro lens? Some cameras do better than others. The pictures in Figure 14.14 were as close as the Olympus E10 could get. Figure 14.15 shows the same watch taken with a few other cameras for comparison.

Figure 14.15

How close is close enough? These pictures were as close as one could get with (left to right) the Canon D30 (with 50mm macro lens), Sony DSC-85, and Nikon CoolPix 995.

As you can see from Figure 14.15, some cameras can get in much closer than others. The Sony DSC-85 can focus very close—practically on its own front glass—but only at the wide-angle setting. Nikon's Coolpix 995 can also focus very close, and it can do so at almost all zoom settings. This enables the Nikon to take extreme close-up views without any accessory lenses. The Canon 50mm *f*/2.5 macro lens (which I used to take virtually all of the product photos in chapters 1–6) produces extremely sharp pictures, but it requires a $200 adapter ring to focus closer than a few inches.

Lighting gets very tricky when you're working very close to the camera. It's often difficult to do close-up photography with existing light because the camera is so close to the subject that it often blocks the light. A built-in flash isn't much help in close-up work because

at very close camera-to-subject distances, the subject is actually outside the area covered by many on-camera flash units. Even when the subject is covered by the on-camera flash, the light from the flash is often too strong, which results in very overexposed images.

Depth of field decreases drastically at very close distances, so framing and focus are very touchy. Small apertures increase depth of field, but require longer exposure times. A tripod is usually necessary to prevent blur caused by camera shake. Many photographers use a remote control or their camera's self-timer when taking close-up shots to reduce camera vibration caused by pressing the shutter release button.

Technique Checklist: Small Objects and Macro Close-Ups

Essential items:

- Camera with macro focus feature
- Tripod

Optional items:

- Remote control or self-timer feature
- Off-camera flash
- Seamless paper or other plain background

Tips and tricks:

- When shooting outdoors, try holding an off-camera flash to the side of or even behind flowers, leaves, and other small objects.
- Use a small tabletop tripod when photographing insects on the ground.
- A small reflector (or a piece of aluminum foil or Mylar) can be used to provide fill-in light when shooting outdoors.

NIGHTTIME PHOTOS

If there's one area where digital cameras put film to shame, it's nighttime photography. Exposure for nighttime subjects like cityscapes and sunsets is very difficult to measure with a light meter. The bright objects in the picture typically fool the camera's metering system into thinking that there's plenty of light, so the camera exposes for the bright lights, leaving the rest of the picture in the dark.

If your camera has a live image preview feature, you can get a rough idea of the proper exposure before you take the picture. Even if your camera doesn't have live preview, you can use the image review function to check your exposure and make adjustments if necessary.

With most cameras, it's helpful to use the exposure compensation setting to add a +1 compensation as a starting point. Different cameras and different lighting situations require different settings, so consider my +1 setting as suggestion, not a commandment.

Figure 14.16 shows what you can do with a digital camera after dark.

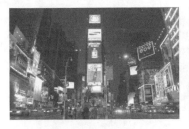

Figure 14.16

Three after-dark scenes taken with digital cameras.

At this point, you're probably expecting me to tell you that you need a tripod to take shots like these. Usually you do, but none of these three pictures were taken with a tripod. The Times Square picture was taken with a Nikon 995 resting on top of a newspaper box. Times Square is so bright at night that I was able to shoot at a relatively fast 1/15 second. The shrimp boat and sunset pictures were both handheld, but were taken at ISO 400 with a Fuji S-1, which resulted in shutter speeds well above 1/100.

The best way to learn how to do nighttime shots is to get out and do it. Every scene is different, so experimentation is the key. Do use a tripod or other handy supporting object if your shutter speed is slower than 1/15 second.

Technique Checklist: Nighttime Pictures

Essential items:

- None, other than your camera

Optional items:

- Tripod
- Remote control or self-timer feature (prevents camera shake)
- Mosquito repellent

Tips and tricks:

- Color balance is a mixed bag at night, so leave your camera on auto white balance. You can always adjust it in your image editor later.
- Use your camera's slowest ISO speed. This results in longer exposures, but the exposures have much less noise. Some cameras have a long-exposure noise reduction feature that reduces CCD noise; use it, if available.
- Moving objects—such as passing cars and airplanes—leave interesting light trails, but you need a very long exposure—at least one second and preferably three or four—to get a really effective trail. Unfortunately, some cameras can't shoot at such a slow speed.

- Many cameras have a slow sync flash mode that combines a long nighttime exposure with a flash picture. This enables you to take a properly exposed picture of a person in the foreground, but the camera will keep the shutter open long enough to also expose for the background. This is a great feature that can produce stunning results, but it requires some experimentation.

ACTION PHOTOS

Moving subjects present a special challenge for digital camera users. Besides the usual photographic challenges (exposure, framing, lighting, focus, and so on), action photos—especially telephoto action shots—require a keen sense of timing and a little bit of luck.

Shutter lag is a big problem in action photos. If you're not sure when the camera will fire, it's impossible to time your pictures to coincide with the action. The best you can do is to use the partially-pressed shutter release technique (see the section titled "Anticipate the Moment" in Chapter 13, "How To Take Great Pictures") to reduce shutter lag as much as possible. With practice, your trigger finger will learn to automatically compensate for the shutter lag.

To freeze fast-moving subjects, choose a high shutter speed. To give the impression of motion, choose a lower shutter speed and follow the action in the viewfinder. Figure 14.17 shows the dramatic difference between these two approaches.

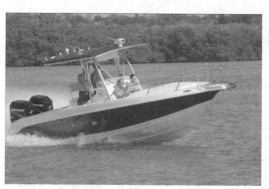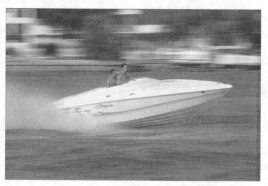

Figure 14.17

These two boats are moving at about the same speed and are roughly the same distance from the camera, but the pictures are dramatically different.

Both pictures were taken from the same position, using the same camera and lens, and both boats were moving at about 40 MPH. In the left picture, I used a high shutter speed (1/1000 sec.) to freeze the boat and water—you can even make out individual drops of water in the image. This technique is most appropriate for sports photography, where you want to capture as much detail with as much sharpness as possible. Note that the fast shutter speed required a large lens aperture (f/4), which reduced the depth of field. The shallow depth of field blurred the trees in the background.

For the right picture, I chose a relatively slow speed of 1/60 sec. As the boat passed by, I followed the boat's movement in the camera viewfinder, keeping the boat in the same relative position in the viewfinder as it passed by. The camera movement coupled with the slow shutter speed produced a moving blur in the background, which emphasizes the speed of the boat. The boat itself is fairly sharp, although it isn't as sharp as the boat in the left picture. The water spray behind the boat is also very blurred, again emphasizing the speed of the boat.

In many cases, the amount and quality of available light dictates your maximum shutter speed. Remember that telephoto lenses magnify camera motion, so you might need a tripod or monopod when shooting sporting events or other fast-moving subjects in artificial light. If there's not enough light to get a usable shutter speed, consider using a higher ISO rating to make up for the low light level, but be prepared to see more grain in your pictures.

Technique Checklist: Telephoto Action Shots

Essential items:

- Telephoto lens
- Tripod

Optional items:

- Flash (for small indoor events)

Tips and tricks:

- When shooting sporting events, be prepared to move out of the way if the action spills off the playing field.
- Watch out for stadium lights when shooting from low angles. Lights in the picture fool the camera's autoexposure circuit.
- Most pro sports arenas are very well and evenly lit, so you can usually shoot In manual exposure mode without having to constantly re-adjust the camera. This technique ensures that your pictures are consistent, but make sure you're happy with the manual settings before the game starts. Take a few shots and review them to make double-sure.

MOVING BEYOND SNAPSHOTS

Many photographers reach a plateau after they master the basic picture-taking process. Knowing all there is to know about equipment, exposure, focusing, and other technical aspects of photography doesn't guarantee that you're able to take good photographs.

After you've learned the basic techniques presented in Chapter 13, "How to Take Great Pictures," and Chapter 14, "Difficult Pictures Made Easy," you might want to explore the more creative aspects of photography. Plenty of books are devoted to the artistic side of photography, and we can't cover all the related topics in the limited space we have here.

But by learning just a few basic concepts, you can improve your photography by leaps and bounds. The topics in this chapter are selected to help you get past the snapshooter stage in your photographic career.

In this section, we cover the following:

- Basic rules of composition
- When to break the rules
- Positioning foregrounds and backgrounds

RULE #1: THERE ARE NO RULES

Is photography art? This question has divided the arts community since the first photographs were taken over 100 years ago. My short answer to the question: Some photographs are, some aren't. A great photograph doesn't have to be artistic; it just has to convey what the photographer wants to show.

Most photography books—and this one is no exception—contain an obligatory chapter on the basics of composition. These basic rules have their roots in the principles of art, and especially in visual design.

An Oldie But Goodie

One of the definitive works on graphic design is *Language of Vision* by Gyorgy Kepes. Although it was first published in 1944, it is still very relevant today.

Photography is a communication tool, just like a telephone, a word processor, or a pencil and paper. A successful photograph is one that conveys the message the photographer intended to send. Sometimes that message is deep, soulful, and complex. More often, the message is much simpler; it's a picture of a pretty spot we saw on vacation, an interesting sunset, or a simple picture of the kids at play. These photographs don't necessarily have any deep meaning; they simply document the places and people we see in our everyday lives.

Easy with That Knife, Vince!

It's easy to take photography way too seriously. Some people become too critical of their own photography, especially when they start to learn about composition and other advanced techniques.

Don't let these rules get in the way of your enjoyment of photography. Ignore the rules completely when you're taking family photos—your boring, predictable photos of family vacations, of the kids growing up, and of other mundane events will be priceless memories in a few years—and you won't care that they're not artistically perfect!

Whatever your photographic ambitions, the basic rules of composition can help you take better pictures. Sometimes the rules help; at other times they simply get in the way. Don't be constrained by the rules; break them as needed to get the pictures you want.

RULE #2: KEEP IT SIMPLE

A photograph should have one definite subject, although it may also have one or more secondary subjects that add interest to the main subject. Any other elements in the photograph distract the viewer from the main subject, so you should attempt to eliminate them as much as possible. This can be done by framing the main subject to exclude distracting background elements, or you can use shallow depth of field to place background elements out of focus. Figure 15.1 shows a good example of a photograph with a well-defined main subject.

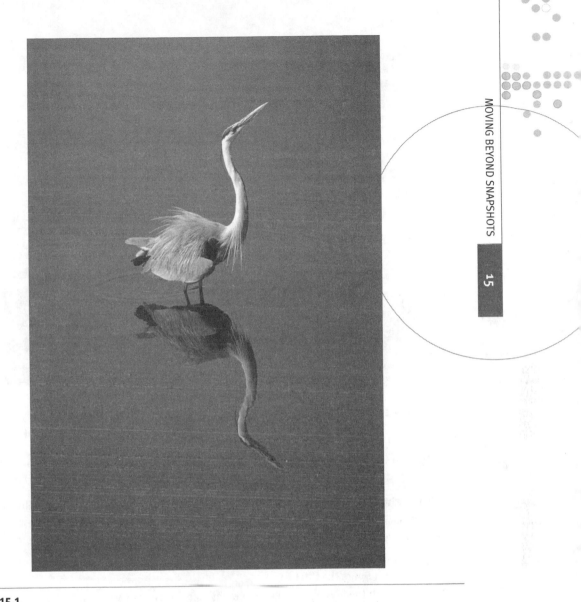

Figure 15.1

A single, simple subject like this Great Blue Heron makes a very effective photograph.

I've taken thousands of bird photographs, but this is one of my favorites. The exposure, focus, and color balance are nearly perfect, but these are secondary to the fact that the bird is in an unusual pose, with a near-perfect reflection in the water.

This was one of about 60 pictures I took of this bird and another heron. The two birds were settling a territorial dispute. The unusual angle of the bird's head is heron talk for "This is my turf, and you're invading my space." The other pictures didn't work nearly as well as this one; Figure 15.2 shows two similar pictures that aren't nearly as effective.

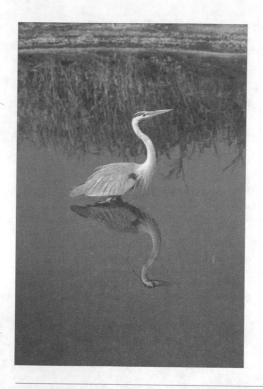

Figure 15.2

Although they are similar to Figure 15.1, these two pictures don't work as well.

The left picture is very similar to Figure 15.1. It doesn't work as well because the bird's posture isn't nearly as interesting, and the shoreline and grass behind the bird are distracting.

The right picture shows both herons, but it's not clear which bird is the main subject of the picture. This photo might have worked better if not for the little bit of shoreline (which is what the birds were fighting over) that sticks out into the right side of the frame.

 Don't Spare the Bits!

One of the joys of digital photography is that it enables you to take tons of pictures of the same subject with no additional expense. Assuming you have enough storage space, don't be afraid to take several alternate views of the same subject. Reviewing those pictures carefully is one of the best ways to improve your photography. Keep the keepers and delete the losers.

RULE #3: PLACE THE MAIN SUBJECT OFF-CENTER

When composing a photograph, many people instinctively put the main subject in the center of the picture. This often leads to boring pictures. Many photographers use a technique called the *Rule of Thirds*, which states that the main subject should be placed in an area

defined by dividing the picture frame into thirds, both vertically and horizontally. The ideal placement is one where the subject is centered on the intersection of two lines.

The heron in Figure 15.1 nearly follows this rule; the bird's head is in the top third of the picture vertically, and in the right third of the picture horizontally. Figure 15.3 shows how the rule of thirds can help you make effective compositions.

Figure 15.3

The Rule of Thirds suggests that your subject be located off-center in the picture, as shown in these two photos of a young brown pelican.

As you can see, the right picture is more effective than the left. In the left picture, the pelican is centered among some rocks; in the right picture, I moved the camera to the left to place the pelican in the right third of the frame. By doing so, I increased the amount of water in the picture, which adds an interesting contrast to the hard surface of the rocks.

Watch Focus and Exposure!

When working with off-center subjects, remember that most cameras take their light reading and focus information from the center of the frame. Use the press-and-hold shutter release technique from Chapter 13 to make sure your camera focuses and exposes for the subject, not the background!

Like the other rules in this section, the Rule of Thirds isn't meant to be an absolute. Some subjects don't lend themselves to this treatment, so feel free to ignore this rule when it doesn't fit your subject. Figure 15.4 shows a Rule of Thirds picture that doesn't seem to fit the rule—but it does.

Although it doesn't strictly adhere to the Rule of Thirds, Figure 15.4 places the focal point of the picture on the bottom third of the frame. Strictly adhering to the rule by placing one of the rows of palm trees off-center would have ruined the symmetry of the picture.

Figure 15.4

Despite the dead-center appearance of this picture, the focal point (the building at the end of the walkway) is in the lower third of the frame.

RULE #4: INCLUDE THE FOREGROUND IN SCENIC SHOTS

This might be the toughest rule of all to follow, but it's one that really does matter. When you're in the middle of some gorgeous scenery, your brain tells you that everything is beautiful. But the problem is, it's only beautiful because your eyes and brain are working together to put the entire area into a complete experience. When you take a picture, you're only capturing a small part of that experience, and it can be difficult to convey all that natural wonder in a single photograph.

You can help your viewers understand the scene better by including a point of reference in the photo. Back in Figure 15.4, you saw how you could improve a photograph by including

one specific part of a scene in the picture. You can further improve your scenic pictures by including a foreground as part of the picture, as you can see from Figure 15.5.

 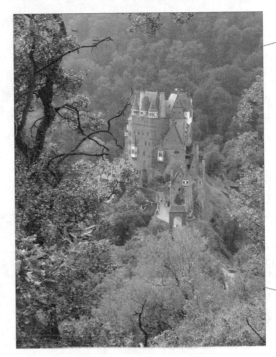

Figure 15.5

By zooming out to include some of the foreground, the right picture improves on the first by giving the viewer a sense of place.

The left picture is a nice picture of the Burg Eltz castle (in southern Germany), but the right picture is a more complete picture. The Eltz Castle is unique among German castles in that it was built in a valley, rather than on a hilltop. The wider view shows the viewer that the castle is way down in the valley, a fact lost in the closer view on the left.

RULE #5: USE A FRAME

This is one of those rules that you can only use when the opportunity presents itself. Found frames—like the ones shown in Figure 15.6—can add interest and a sense of place to your pictures. They can also be fun, because they provide an out-of-the-ordinary view of places and people.

The left picture shows the Cologne Cathedral, as seen from the Cologne train station. The cathedral is enormous—far too large to photograph with the point-and-shoot digital camera I was carrying. By shooting through the glass front of the train station, I was able to capture (to my satisfaction, anyway) the enormity of the church. The crush of people coming and going adds an additional element to the picture.

Figure 15.6

Natural frames like the two shown here can add an extra dimension to your pictures by placing the viewer at the photographer's point of view.

The right picture (taken by my wife, Becky), shows the view from inside one of the cliff dwellings at Bandelier National Monument.(If you look closely, you'll see some guy with a camera standing at the bottom of the ladder.) It's an interesting vantage point, and one that I would have missed.

Lighting Your Frame

Exposure can be tricky when you're shooting through a frame. If the frame is close enough, you can use fill-flash to light the frame, as Becky did inside the cliff house.

Sometimes the frame *is* the picture, as is the case with Figure 15.7.

The deserted storefront (in the ghost town of Rhyolite, Nevada) tells a story of a boom town gone bust. The town was abandoned shortly after it was built, and the buildings were left to deteriorate—doubtless with the help of numerous vandals over the years. Today, the storefront serves as a picture frame for the Amargosa Valley behind it.

Figure 15.7

This abandoned storefront nicely frames the mountains behind it.

RULE #6: USE LINES AND PATTERNS

Lines and patterns are part of our visual vocabulary. We see them all the time, but we often fail to notice them. Isolating natural and man-made lines and patterns can make for striking photos, as the examples in Figure 15.8 show.

Some of these photos jumped out at me when I saw them, but others weren't as obvious. I was sitting in a German train station for a half-hour before I noticed the parallel lines of the track, train car, and station roof. I managed to take this picture about 30 seconds before the train—which had been parked there the entire time I was waiting—pulled out of the station.

I knew the three pelicans was a great shot the moment I saw it while shooting sunsets on the beach. Fortunately, my 35mm film camera was up to the task of focusing on and determining the correct exposure for the fast-moving birds in a fraction of a second. I had time to take just one picture before they moved out of view.

I had photographed the brightly colored newspaper boxes at least four times as a color test for new digital cameras. I finally realized that they made a neat picture in and of themselves. Unfortunately, they were replaced with uniform (and uniformly ugly) green metal paper boxes about a month after I took this picture.

The gondolas didn't strike me as a particularly good photo opportunity when I took it, so I didn't spend a great deal of time on framing and composition. Now I wish I had. Although this is a nice picture, it would have been much better if it had been taken from a higher angle, which would show more boats and less of the hotel behind them. I keep a copy of this picture on my office wall as an excuse to get back to Venice as soon as possible.

Figure 15.8

Lines and patterns make interesting photos—when we take time out to notice them.

RULE #7: USE THE HORIZON TO INDICATE SCALE

Most scenic pictures include the horizon. Conventional photographic wisdom says to never place the horizon at the center of the picture. The picture in Figure 15.9 breaks that rule because the horizon is in the center of the picture.

Figure 15.9

The Seven-Mile Bridge (in the Florida Keys) is massive. In this picture, the bridge fades off into the horizon, which accentuates the size of the bridge.

I broke the horizon rule for several reasons. To place the horizon higher in the picture would have meant leaving out the clouds—one of my favorite elements in the picture. Placing the horizon lower would have included even more of the sky—and there's already plenty of it. The dead center horizon with the bridge converging from the right tells you that this is one very long bridge—as anyone who's been stuck in Florida Keys traffic can tell you!

DIGITAL IMAGES FROM FILM

So far, we've concentrated on creating digital images using a digital camera. But many amateur and professional photographers prefer to create their digital images the old-fashioned way—using a film camera.

In this chapter, you learn how to create high-quality digital images with your existing film camera. This chapter covers

- Analog film in a digital world
- Choosing a film scanner
- Using flatbed scanners for film
- Shooting film for scanning

ANALOG FILM IN A DIGITAL WORLD

Back in the dark ages before digital cameras, film was king. In the more than 100 years since the invention of roll film, an enormous, multi-billion dollar industry has evolved to cater to the needs of photographers. There is a staggering number of 35mm and Advanced Photo System (APS) film cameras in the world, and the odds are good that you own one or two of them yourself.

Many people are surprised to learn that it's possible to get very high-quality digital images from 35mm and APS film. In fact, a good quality digitized 35mm film image is often superior to the image from even the highest-quality consumer digital cameras.

Film images can be digitized using a device called a *film scanner*. Unlike the more common (and less expensive) flatbed scanners, film scanners are designed specifically to scan color negative and slide films. Most scanners feature an automatic film handling mechanism that enables you to scan several slides or negatives at once.

There are two ways to have your film images scanned: You can purchase a scanner and do it yourself, or you can take your film to a photo lab or camera store that offers a scanning service. We explore both options later in this chapter.

WHY FILM?

If the world is going digital, why would you want to work with film? Conventional cameras store images on film, which costs money to buy and process; most digital cameras store their images on reusable flash memory cards. Digital cameras are immediate; film has to be processed and printed (or processed and scanned) before you can see the images. Despite the drawbacks, many serious amateur and professional photographers prefer to work with scanned film images when there's no need for immediacy. Here are some of the reasons:

- High-quality scanned film images have a higher resolution and better dynamic range than even the most expensive digital cameras. A typical $1,000, 4000 DPI film scanner can produce a 20-million (yes, that's twenty!) pixel image with 12 bits per pixel.

- Shooting film enables photographers to work with their existing, familiar equipment. Shooting film gives photographers the option to work in both the digital and film worlds.

- Equipment costs are much lower than comparable digital equipment, especially when you compare 35mm SLR cameras to their digital counterparts. For the price of a typical digital SLR camera, you can buy a high-end film SLR body *and* a high-quality film scanner and still have money left over. There's also a wider variety of cameras and lenses to choose from in the film world.

- Digital cameras have a very short product life; film cameras have a 5–7 year product life. This means that film equipment holds its resale value, but digital gear depreciates very quickly.

- Film is a better choice if you need to make large numbers of prints, because the film printing process is much faster and cheaper than the digital process. This will change as the price of digital printing services drops, as we'll see in Chapter 20, "Outsourcing Your Printing."

Scanned film images are stored in the same JPEG and TIFF file formats as digital camera images, so photographers can use the same software tools to work with digital and scanned film images. For many photographers (myself included), the arrival of relatively inexpensive film scanners and high-quality inkjet and dye-sublimation printers has eliminated the need for a chemical darkroom with its hazardous and expensive chemicals and time-consuming printing process.

Instead of a chemical darkroom, photographers now work in a digital darkroom, where they can sit in a comfortable chair in a well-lit room instead of hunching over enlarging equipment in total darkness. The comfort and convenience are big improvements, but they're not the main attraction.

The digital darkroom gives photographers an enormous array of tools to manipulate images in ways that were time-consuming or downright impossible to do in a chemical darkroom. Photographers now have complete and consistent control over cropping, color balance, and tonal range. They also have a vast range of special effects at our fingertips, and can try those special effects on the screen before they commit them to paper.

For the professional photographer, the move to the digital darkroom puts the photographer back in control of his or her own work. Because of the time and expense involved in the chemical printing process, most pros leave their film processing and printing to an outside lab. The digital darkroom gives photographers the option to do some jobs in-house, which can be a lifesaver for jobs requiring fast turnaround, elaborate special effects, or both.

For most amateur photographers, the digital darkroom is the only option. Chemical darkrooms require a large commitment in terms of space and expense. Color processing chemicals have a very short shelf life, and many people don't want hazardous chemicals in their houses. The digital darkroom is clean, quiet, and relatively inexpensive.

Many photographers keep an archive of images stored on negatives or slide film. A film scanner gives new life to those old images. Many scanners include features to help restore images from dirty, scratched, or faded film.

CHOOSING A FILM SCANNER

Shopping for a film scanner can be very confusing. Although there are relatively few film scanners on the market, there are large price differences between them. There are two basic classes of scanners: desktop and drum.

Unless you have lots of money to spend ($4,000 and up), you can rule out high-end drum scanners. These very expensive scanners are designed primarily for graphic arts professionals who need the highest possible image quality for production-quality prepress and printing work.

Desktop scanners are more appropriate for use by amateur and professional photographers. These scanners typically use a CCD imaging chip to scan images from film. Prices range from about $400 to $1,500 for 35mm scanners and up to $2,800 for scanners that can handle 6-cm (2 1/4") film. Unless you shoot 6-cm film or have a large archive of 6-cm negatives to scan, choose one of the 35mm models.

Many first-time film scanner users are dismayed at the amount of time it takes to scan a frame of film. The time varies among different brands and models of scanners, and high-DPI scans take considerably longer than lower resolution scans. Plan to spend at least 2–3 minutes to select, scan, and save each image. Add another minute or so if you use the scanner's dust and scratch removal feature.

You encounter two key numbers when shopping for a scanner. The scanner's dots per inch (DPI) rating describes the scanner's maximum resolution. Typically, higher is better. The latest models on the market scan at 4000 DPI, which produces a 20-million pixel image from a 35mm film frame. 4000 DPI is overkill for most applications, so all scanners can also operate at a lower DPI rating.

The second number you're likely to see is the Dynamic Range rating, usually expressed as a number like 3.5. This number describes how many distinct levels of gray the scanner can detect. A higher number is better. There's no industry standard for rating dynamic range, so take these numbers with a grain of salt. The maximum dynamic range is of most concern to photographers who shoot slide film; the lower contrast levels recorded by color negative film don't push the envelope of dynamic range, anyway.

But there's also a third number you should know about. Some scanners create images with 8 bits per pixel. Because there are three color values (red, green, and blue) for each pixel, these scanners produce 24-bit images. A few scanners create 12 or 14 bits per pixel; the resulting images have 36 and 42 bits of information per pixel. Some photo editing programs can't handle images with more than 8 bits per pixel, but most newer programs can. The additional color information isn't strictly necessary. In fact, the human eye can't distinguish the difference between a 24- and 42-bit image, but the additional color information produces prints with more accurate colors.

Most scanners include film holders for both slides and film strips. Virtually all 35mm scanners can also accept 24mm APS film with an adapter. Some manufacturers include an APS adapter with the scanner, and others offer it as an extra-cost option.

Figure 16.1 shows a typical 35mm/APS film scanner from Canon.

Canon's FS4000US costs around $1,000 and includes film holders for 35mm negatives and slides as well as an APS adapter. Several other manufacturers including Minolta, Nikon, and Polaroid offer similar products.

Like most 35mm scanners, the FS4000US uses red, green, and blue CCD image sensors to create a color image. The FS4000US also includes dust and scratch removal technology that saves hours of retouching time when scanning dirty or scratched originals.

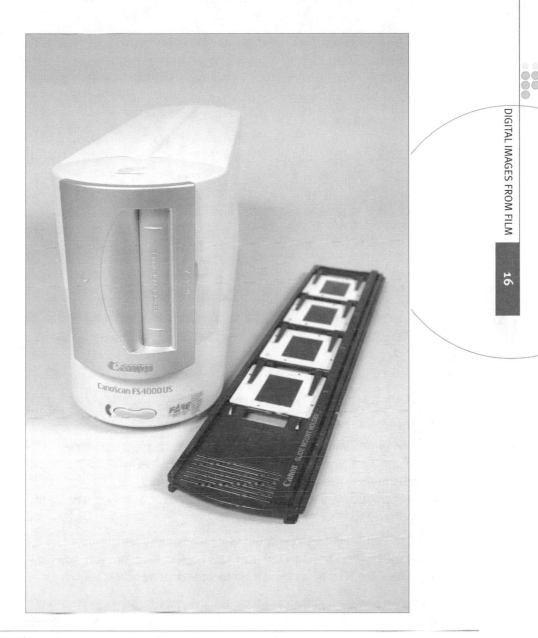

Figure 16.1

Canon's FS4000US film scanner can scan 6 negatives, 4 slides, or an entire roll of APS film at once. The 35mm slide holder is pictured here.

The FS4000US includes USB and SCSI interface ports, so it works with virtually any Mac or PC manufactured in the past five years. Canon includes scanning software for Macs and PCs with the FS4000US. The Canon FilmGet software operates as a TWAIN driver on PC systems, so you can use it with any TWAIN-compatible graphics program (see Figure 16.2).

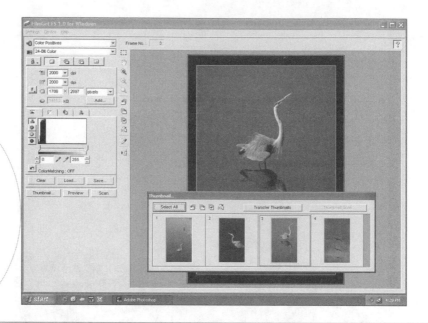

Figure 16.2

Canon's FilmGet software enables you to scan several images at once. This example shows the 4-slide 35mm film holder.

Scanning on the Cheap: Flatbed Scanners

If you need to scan photographs but don't want to spend the money for a film scanner, you might want to consider a flatbed scanner. Prices of flatbed scanners have fallen through the floor in the past couple of years. Despite the bargain prices, most flatbed scanners can produce very good quality scans from color prints—as long as the print is clean and sharp.

A flatbed scanner can't produce the same high-quality images as a film scanner, but the quality is more than good enough for many uses. Flatbeds are very popular in families with kids, where they can be an invaluable tool for creating school projects.

Unlike film scanners, flatbed scanners are designed to scan images from printed objects like photographs and magazine pages. The scanner contains a light source underneath the document glass, very much like a photocopier. When you press the scan button, the scanner shines a light on the page to be scanned.

Unfortunately, you can't use a flatbed to scan negatives or slides because the light source is on the wrong side of the film. A few scanner manufacturers offer a special lid called a transparency adapter that replaces the scanner's top cover. The transparency adapter has a light source in it, enabling you to use the flatbed scanner to scan transparent media like slides and negatives. Figure 16.3 shows an Epson flatbed scanner with a transparency adapter installed.

Figure 16.3

This Epson scanner is shown with an optional transparency adapter installed.

Flatbed scanners are much less expensive than film scanners because they are simpler to build and because they sell in much larger quantities than film scanners. Expect to pay about $250 for a top-notch flatbed scanner with film scanning capabilities, and add about $100 for the transparency adapter.

So what do you get for 1/3 the price of a film scanner? You get an excellent flatbed scanner that does an okay but not great job on film. The image sensors in flatbed scanners can't provide the very high resolution needed to extract the finest detail out of film.

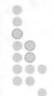
Typical flatbed scanner sensors operate at 1200 DPI, about a third the resolution of a 4000 DPI scanner. That doesn't sound like a lot of difference, so let's look at it another way. A 24×36mm film frame scanned at 4000 DPI produces a 21-megapixel image, and the same frame scanned at 1200 DPI produces a 1.9-megapixel image.

The film holders provided with most flatbed scanners are often difficult to use, and there's no way to scan more than one frame of film at a time. This isn't a big deal if you're only scanning a few negatives or slides at once, but you wouldn't want to use a flatbed to archive that shoebox full of slides you've been keeping all these years.

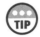

Film Isn't Forever

All films fade over time. The chemical dyes used in slide and negative films break down over time, causing fading and color sifts. Heat, light, and humidity accelerate the aging process, so you should store your negatives and slides in a cool, dark place.

If you have a slide collection that you haven't seen for several years, you might want to get it out of storage and scan in the best slides. Digital images don't age. On the other hand, who knows if you'll be able to read a CD-ROM on the computers of the near future—say, five or ten years down the road?

Images scanned on a flatbed with a transparency adapter can be very good, as long as you don't need a lot of resolution. Figure 16.4 shows the same image scanned on the Epson flatbed scanner and the Canon FS4000US. To keep the playing field as level as possible, both images were scanned at 600 DPI—the maximum optical resolution of this particular Epson scanner.

Figure 16.4

At 600 DPI, there's not much difference between the Canon FS4000US (left) and the Epson Perfection 1200 Photo.

One very big plus for flatbed scanners is that they can typically handle very large film. For example, the Epson Perfection scanners can accept film up to 4"×5". High-resolution scanners for 4"×5" film cost $4,000 and up, so a flatbed is the only choice for many large format photographers. Fortunately, the large film size produces very large and detailed image files, even with a moderate 1200 DPI resolution.

Scanning Old Film

Not many photographers shoot 4"×5" film, but many old family heirloom negatives were taken with Kodak Brownie cameras and other 620-size film. These negatives are typically 2 1/4" high and 2 3/4" to 3 1/4" wide—so they don't fit in a 35mm film scanner.

Shooting Film for Scanning

You can use a film scanner to scan virtually any well-exposed negative or slide. But if you're shooting film specifically for scanning, there are a few things you can do to get better results:

- As a rule, color negative film is easier to scan and produces scans with a smoother tonal range than slide films.
- Negative film is cheaper to buy and process (if you don't have prints made) and is usually easier to find than slide film.
- Some film manufacturers make color negative films (like Kodak's SUPRA 100 and 400 films) designed specifically for scanning.
- Color slide films produce images with more contrast than negative films, and are a good choice when shooting subjects with relatively flat lighting.
- Some color slide films (like Fuji Velvia and Kodak E100SW) have very saturated colors that are exaggerated even more when you scan them. These films are great for scenery and product photography, but be careful using these films to take pictures of people.

SUMI'S SNAPSHOT

I have a large number of old slides. Many of them are faded. Can they be saved?

Unless they're physically damaged, you can save those images. Look for a scanner with Applied Science Fiction's Digital ICE3 (pronounced "Ice Cubed") feature. ICE3 includes features that can remove dust, dirt, and scratches, restore faded color, and even reduce grain.

I have an older manual focus, manual exposure SLR. Can I use this camera to produce good scans?

Virtually any 35mm camera can produce high-quality scans as long as the images are in sharp focus and are reasonably well-exposed.

Do any flatbed scanners have the Digital ICE3?

No, because the grain removal part of ICE3 isn't appropriate for flatbeds. But you can get flatbeds with ROC (Restoration of Color) and the ICE dust and scratch removal features. These are very useful for scanning old photographs from prints.

P A R T **IV**

WORKING WITH DIGITAL IMAGES

PREPARING YOUR COMPUTER FOR DIGITAL IMAGING

Digital imaging places different demands on a computer system than other tasks such as Web surfing, word processing, or game playing.

Most computers sold for the home and small office market offer remarkable performance at a pretty good price. But small office/home office (SOHO) computers are often built to meet a price point, not a specific performance level.

In this chapter, you learn how much computer you need to perform common digital imaging tasks, and we offer some advice for upgrading the system you already have.

This chapter covers the following topics:

- How fast is fast enough?
- How much memory do you need?
- How much disk space do you need?
- All about CD-R drives
- Calibrating your monitor for accurate color

HOW FAST IS FAST ENOUGH?

Experienced computer users and first-time buyers alike often stumble over the key measure of computer performance: CPU speed. Computer makers (and buyers) treat CPU speed as a sort of horsepower rating for computers. Although CPU speed is important, it's not really necessary to have the latest and greatest high-speed CPU for most digital imaging applications.

If you go shopping for a new system, you see that most manufacturers offer a wide range of nearly identical systems at a wide rage of prices. As you move up the product line, you get a faster CPU, more memory, a larger hard drive, and a more elaborate graphics card. When you get near the top of the product line, incremental increases in CPU speed cost several hundred dollars each. This is because the latest, highest-speed CPU chips are in high demand and short supply. Chip makers routinely charge a premium price for the highest-speed CPU chips to help recover the enormous development costs that go into making those chips.

Unless you need the absolute latest, fire-breathing CPU, you can save several hundred dollars by opting for a system a few notches down from the top of the line. For example, I have two desktop PCs in my office. One has a CPU that's 50% faster than the other. I switch back and forth between them all day long. If you came in one night and switched them around, I probably wouldn't notice the difference. How can that be?

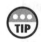

There's Speed, and Then There's Speed

CPU performance is only one of several factors that affects a computer's overall performance. A fast CPU is nice, but adequate memory size and hard drive performance are just as important. If your computer seems too slow, you might want to invest in a memory upgrade or a new hard drive before you spend the big bucks for a newer, faster system.

So how much CPU do you need? It depends on how patient you are. A computer's CPU determines how fast the computer can perform mathematical computations. Digital imaging software is very computation-intensive, but only for short bursts at a time. Virtually any PC with a Pentium II or Pentium III is fast enough. In the Mac universe, any system with a 604, G3, or G4 CPU should be just fine.

How Much Memory Do You Need?

As far as memory is concerned, the more the better. As we went to press, memory prices were at an all-time low. Most of the software you use to work with digital images needs lots of memory. If your computer has less than 128Mb of memory, you should seriously consider adding more memory.

Some operating systems benefit more than others from increased RAM memory. For Windows 98 and Windows Me systems, 128Mb is the "sweet spot." Adding memory beyond 128Mb doesn't have a huge effect on these operating systems. For Windows 2000 and Windows XP, 128Mb is the minimum; 256Mb is even better.

Macintosh systems running OS 9 need at least 128Mb. OS X requires 128Mb as a minimum, but you need at least 256Mb to make OS X fly.

Adding RAM to most computers isn't a big deal. Most recent computers use a "memory on a stick" circuit board called a Dual Inline Memory Module (DIMM). DIMMs are easy to install, but you should take your computer to a computer store or repair shop if you're squeamish about opening the computer's case and fiddling with the innards. If you have an Apple iMac, I strongly recommend letting someone else install the memory upgrade for you. iMacs are notoriously difficult to work on, especially if you've never taken a PC apart before.

Out with the Old...

When adding memory to your computer, keep in mind that you might have to discard the memory that's already installed before you can add more memory. Computers have a limited number of memory expansion slots—usually two or three.

So, for example, if your computer has two slots, each with a 32Mb memory DIMM installed, you need to toss those 32Mb DIMMs if you want to install two 128Mb DIMMs to bring your system up to 256Mb. The irony here is that you probably paid more for those 32Mb DIMMS than you did for the new 128Mb DIMMS. Now you understand why computer manufacturers can't make any money!

How Much Disk Space Do You Need?

Same answer as the memory question: Lots. The more the better. The files produced by digital cameras aren't all that large—they're typically from 1Mb to 3Mb each—but after you've had your camera for a few months, you're likely to discover that your hard drive is getting full. Later in this chapter we talk about moving those files off to CD-ROMs for permanent storage; but many people like to have all of their pictures—or at least, all of the good ones—in one place. That means keeping them on the hard drive.

Most PCs have room inside the case for a second hard drive. This enables you to add more storage with minimal hassle. Your existing programs and data stay where they are (usually on drive C:), and the second drive appears as drive D:. After you've installed the second drive, you can copy all your existing image files over to the new drive, freeing up some working space on the C: drive.

Another alternative is to upgrade your C: drive to a newer, faster, larger drive. Most replacement hard drives come with software that makes it easy to copy your existing files from the old drive onto the new one. Typically, aftermarket drives include detailed instructions that tell you how to install the drive and how to copy your old files onto the new drive.

As with the memory upgrades, you can have this done at most any computer store or repair shop if you're not comfortable with the DIY approach.

Faster Is Better

Thanks to technology improvements, newer hard drives transfer data much faster than older ones. If you're shopping for an additional or replacement hard drive, make sure you get one that spins at 7200 RPM or faster. Older drives typically ran at 5400 RPM.

The faster rotational speed translates directly into higher performance, and is well worth the small premium you'll pay for the faster drive.

Some Macs have room for a second drive, others don't. The iMac and Cube computers only have room for a single drive. If you want to upgrade an iMac or Cube, you need to purchase a larger drive and copy your old data onto the new one. Most G3 and G4 models have room for a second drive, so they're easy to upgrade.

Thinking Outside the Box

If you want to add more storage but don't have room for a second drive—or if you don't want to mess with a perfectly good, working computer—you might want to consider an external hard drive.

External drives come in USB and FireWire models, so you can choose the one that works with your PC. FireWire drives are much faster than USB drives, but they're also more expensive. See Chapter 4, "Storage and Connection Options," for more information on USB and FireWire.

One of the nice things about external drives is that they're portable, so you can use them with more than one computer, and you can use them on computers (such as laptops and compact desktop machines) that don't have room for an additional drive inside the box.

Keep It Clean, Folks

One final word on hard drives: Defragment. Over time, the files on your hard drive become scattered all over the drive. This happens because Windows and the Mac OS reclaim the space freed up when you delete a file. As you create, delete, and add new files, your files might be broken into one or more sections—called *fragments*—as they are stored on the disk. Fragmented files take longer to read and write because the disk drive has to locate several pieces of the file and glue them together.

All versions of Windows include a simple disk defragmenter tool that locates fragmented files and puts them back into one piece. Unfortunately, the freebie defrag program is very slow, so slow that many people don't bother with it.

Third-party defragmenters are available from several sources, usually as part of a larger package of utilities. Two of my favorites for Windows are Executive Software's Diskeeper and Symantec's Speed Disk, part of the company's Systemworks Utilities package.

Macs don't include a defragmenter tool as part of the standard operating system, but Symantec also makes a version of Systemworks for Macs.

ALL ABOUT CD-R DRIVES

Sooner or later, all hard drives fail. When they go, they often take your data with them. It might not be a big deal to lose all your letters and e-mail from the past year or two, but your image files are the digital equivalent of negatives for your digital pictures. When they're gone, they're gone forever.

Your best defense against a dead hard drive is to have a backup of your data. All sorts of backup solutions have been developed for PCs and Macs over the years, including tape drives, large floppy disks such as Zip and LS-120 disks, and removable hard drives like Iomega's Jaz.

As hard drives have grown larger—requiring larger and larger backup storage—removable storage technologies haven't kept up. A Zip disk, for example, costs $10 and only holds 250Mb of data. A 2Gb Jaz cartridge costs $100. I'd need 30 of them ($3,000 worth) to backup the data on my hard drive right now.

Enter the CD-R. The R stands for *recordable*. Virtually all new PCs and Macs come with CD-R drives as standard equipment. CD-R disks cost about $.30 to $.50 and hold 700Mb of data. The big attraction of CD-R for most people is that you can use them to make your own music CDs. But the side benefit is that they provide excellent, inexpensive, and easy-to-use backup storage, too.

Like hard drives, CD-R drives come in internal and external models. Some PCs have room for two CD drives, others don't. Installing a CD-R is much simpler than replacing a hard drive. It is very easy to replace an existing CD-ROM drive with a CD-R drive, but many users want to keep their existing CD drive so that they can copy CDs.

CD-R drives are rated by speeds, such as 16X. The "X" refers to the speed of the original, 1980s CD drives, or 150Kb/sec. The drive in Figure 17.1 is a 16X10X40 drive. This means that the drive can write regular CD-R disks at 16X and rewritable CD-RW disks at 10X speed. The last number indicates the read speed, rated at 40X for this drive. Faster is better, especially when you have lots of disks to make.

You Want That Drive to Go?

If you have room for only one CD drive, you might want to consider an external drive. As with hard drives, you can get an external CD-R drive with either USB or FireWire interfaces.

Besides being easy to install, external drives can be used with more than one computer. This is a nice feature if you have more than one computer because you can use the same drive to make CDs and backup files on all your computers.

Figure 17.1

External CD-R drives like this one are easy to install and can be used with more than one computer.

COLOR CALIBRATION

This might seem obvious, but you can't accurately edit a photo with a monitor that's all out of whack. There are many monitor settings and technical details that determine how a picture appears on a computer monitor. The brightness and contrast levels must be set perfectly, the monitor's white balance must be adjusted to a specific point, and the monitor's overall color balance must be set so that the colors on the screen match the colors seen by the camera.

After you've set all these parameters just so, they change. Even the best, most expensive monitors change over time as their picture tubes and other electronic components age.

The solution is to use a color calibration tool. There are two types of calibration tools: hardware-based and software-based. The software-based calibration tools rely on the user's ability to judge colors accurately. Hardware-based calibrators use software plus an optical sensor that electronically measures the image produced by your monitor. Both systems create a *monitor profile*, which is an electronic description of the way your monitor handles color.

When you start your computer after running a color calibrator, a profile loader program tells your computer's display card how to modify the signal sent to the monitor to make it display colors accurately.

Adobe includes a copy of their Adobe Gamma program with most versions of their popular Photoshop program. Figure 17.2 shows the Adobe Gamma program being used to calibrate a monitor.

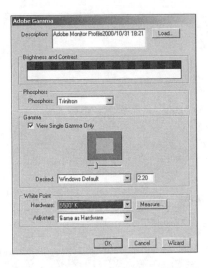

Figure 17.2

Adobe's Adobe Gamma color calibration tool is included with most versions of Photoshop.

Adobe Gamma is very simple to use and produces excellent results. If you have a good eye for color, you can achieve very accurate color balance with Adobe Gamma.

What's Gray, Anyway?

During the calibration process, Adobe Gamma asks you to choose the most neutral of a series of gray squares. Some of the squares appear reddish, others bluish. It can be hard to tell which one is perfectly neutral.

An 18% gray card (available from any camera store) can be a big help. The 18% gray card is pure, 100%, unadulterated gray. Hold it next to the monitor while you set up your color calibration, and you'll instantly know what's gray and what isn't.

For more critical applications, you might want to consider a hardware-based color calibration tool. There are several models on the market from a variety of vendors, but one of the most popular—and least expensive—is the Monitor Spyder (about $200, including software) from Colorvision USA (see Figure 17.3).

The Color Spyder comes with Colorvision's PhotoCal monitor calibration software. You plug the Spyder into a USB port, run the Photocal software, and attach the Sypder to the monitor's screen with suction cups. The Photocal software performs a series of calibration tests on your monitor and creates a color profile automatically.

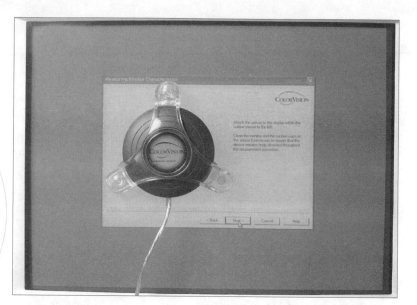

Figure 17.3

Colorvision's Monitor Spyder attaches to your monitor's screen with suction cups and creates an accurate color profile in a few minutes.

SUMI'S SNAPSHOT

Should I upgrade my old PC or buy a new one?

This is a tough question that we all face at one point or another. PC technology advances so fast that it's hard to justify upgrading a PC much more than 2 years old. If you need to spend more than a few hundred dollars to upgrade your PC, you're probably better off keeping it as a second machine and buying a new one.

Are there color calibration products for printers?

Yes, but you might not need one. Windows and the Mac OS both contain built-in color matching software that automatically adjusts your printed output to match a pre-defined profile. Most photo printers install their own profile, so the color-matching process is automatic.

IMAGING SOFTWARE—WHAT CAN IT DO?

Digital photography has a major advantage over conventional photography: It gives you complete creative control over your images. Digital image editing software enables you to edit, enhance, retouch, and manipulate images in seconds. To achieve the same results with conventional photographic methods, you need thousands of dollars in darkroom equipment, not to mention a lot of time.

In this chapter, we'll take a look at a sampler of common "digital darkroom" tasks:

- Straightening crooked images
- Cropping images
- Correcting underexposure
- Removing unwanted objects by retouching

MAC OR PC?

Back in the dark days before Microsoft Windows, there was a real advantage to using a Macintosh computer for digital imaging. The advantage was simple: Macs did graphics way better than DOS-based PCs. Over the years, the state of the art in graphics hardware and software has accelerated dramatically, but much of the new development has been aimed at the Windows market. As a result, the Mac and PC are now on level ground when it comes to graphics.

I own and use both systems. There's very little difference between a program—Adobe Photoshop, for example—running on a Windows PC compared to the same program running on a Mac. Windows users have a broader choice of software than Mac users, due to Windows' larger share of the overall market. Most digital cameras include entry-level image editing software, and that software is typically provided in the box for both Mac and Windows PCs.

Macs and FireWire

One area when Macs have an edge over PCs is in FireWire. All newer Macs include a FireWire port as standard equipment. Some PC vendors are beginning to include FireWire ports, too—but they're in the minority. Of course, this only matters if you have a camera or memory card reader with a FireWire port.

If you're planning to upgrade your system and have been thinking about switching, don't. Stick with the system you know best.

EDITING AND MANIPULATING IMAGES

Image editing programs provide a very complete set of tools that you can use to retouch, enhance, and manipulate images created with your camera. Most cameras include a simple image editor in the box; if you have a camera, you probably already have such a program.

At least a dozen image editor programs are available for both the Mac and the PC platforms. Some of the more popular ones are Adobe's Photoshop and Photoshop Elements, Corel's Corel Photo-Paint, JASC Software's Paint Shop Pro, and Microsoft's PictureIt! Different programs are aimed at users with different experience levels. Microsoft's PictureIt! is a very nice picture editor that is very easy to learn and use, but it's no match for Photoshop or Paint Shop.

Elemental Photoshop

Adobe's Photoshop 6.0 is considered by many to be the best and most powerful photo editor on the market. Photoshop 6.0 is widely used by professional illustrators, graphic artists, and photographers, but its $600 price tag is more than many amateur photographers want to spend.

Adobe offers a consumer version of Photoshop called Photoshop Elements. Elements retains 90% of the functionality of Photoshop but costs less than $100. Elements is also bundled with many digital cameras. There's also a trial version of Photoshop Elements on the CD-ROM that came with this book. You're welcome.

Photo editing software can enhance a good picture or salvage a not-so-good picture. To give you an idea what Photoshop Elements and similar programs can do, we've chosen a few pictures that were somewhat less than perfect, and we've used Photoshop Elements to make them as good as they can be.

This section shows only a small fraction of the things you can do with Photoshop or any other editor program. We use Photoshop Elements for the examples, but you can perform these same tasks with almost any image editor.

In particular, we'll show you four of the most common tools used to correct images. You learn how to correct exposure, how to retouch an image to remove unwanted elements, how to use cropping to strengthen the composition of an image, and how to use perspective correction to fix a badly distorted image.

Straightening and Cropping

Figure 18.1 shows a decent picture of New York's financial district, taken from a moving boat. As you can see, the exposure is good and the focus is sharp, but the moving, rocking boat made it difficult to frame the photo just the way I wanted. The image is slightly tilted, and there's a bit more water than necessary.

Figure 18.1

New York isn't really tilted like this.

It's not a bad picture, but with a little cropping and straightening, it can be a much better picture. The following paragraphs outline what I did to fix this image.

First, I opened the image with Photoshop Elements, and I turned on Photoshop's grid display, which lays a grid of horizontal and vertical lines over the image, as shown in Figure 18.2.

Figure 18.2

Photoshop's grid display shows a grid of horizontal and vertical lines.

It's important to understand that the grid only appears on your screen; it does not appear in the final picture. The grid makes it very obvious that this picture runs uphill from left to right. To fix the tilt, I selected Rotate, Canvas Custom from the Tools menu (see Figure 18.3).

Figure 18.3

Select Rotate, Canvas Custom to rotate the image to remove the tilt.

As you can see from the Tools menu, Photoshop Elements has an intriguing menu item called Straighten and Crop Image, which is what I did using the Rotate, Canvas Custom option. In fact, I tried that command on this image, but Photoshop still left some tilt in the image.

I took a wild guess that this image was tilted about 1° to the right, so I entered that information into the rotate command's dialog box. The resulting image was straight, but the edges were tilted, as you can see in Figure 18.4.

Figure 18.4

New York is level again, but the whole image is tilted!

The last step was to use Photoshop's Crop tool to select the part of the image I want to keep. The crop tool draws an adjustable rectangular box over the image (see Figure 18.5). Anything inside the box becomes part of the finished image; anything outside the box is cropped off and discarded.

As you can see, I've decided to crop out the dark building at the right edge of the picture. The finished picture is level, and has a more balanced composition with less water in the foreground, as you can see in Figure 18.6.

Figure 18.5

Use the Crop tool to lop off the parts you don't want to keep.

Figure 18.6

The edited picture has much better composition than the original.

Correcting Tilted or Skewed Images

New York might have been a little tilted, but this picture of the San Marco Cathedral in Venice is a mess. Unfortunately, this was the only chance I had to photograph the interior of the church, so I really wanted to save this picture if possible.

As you can see from Figure 18.7, the picture is badly tilted.

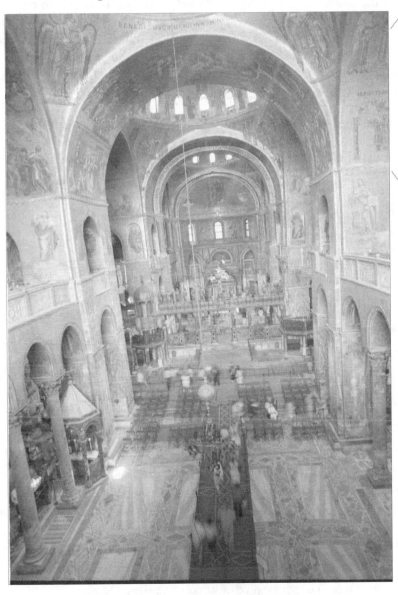

Figure 18.7

Venice's famous San Marco Cathedral is tilted worse than NYC!

Flash and tripods aren't allowed in the church, so I had to shoot this picture at a very slow shutter speed—about 1/4 second. I can't hold still that long, so I braced my elbows on the balcony railing to help hold the camera still. The resulting shot is in good focus and fairly sharp, but the balcony (and my elbows) were at a weird angle to the floor, so the picture is tilted.

To make matters worse, I shot this with a very wide angle lens, tilted down toward the floor. When you tilt a wide angle lens, the resulting picture is almost always distorted. This happens because a wide angle tends to make close objects appear much larger than distant objects. As a result, the archway in the middle of the picture appears to be keyhole shaped. Let's see if we can save this mess.

In Figure 18.8, the picture is opened in Photoshop Elements, with the grid display turned on.

Figure 18.8

Viewing the picture with the grid display reveals all the flaws.

The grid display makes it even more clear how messed up this picture is. The left side of the arch is tilted much more than the right side. The first step is to rotate the picture to get the horizon level. Fortunately, there's a light fixture hanging on a cable in the center of the picture. After a few trials and errors to determine the correct amount of rotation, I decide that four degrees is just right. Figure 18.9 shows the rotated picture.

The picture is level again, but the arch is still distorted. Photoshop's perspective tool makes it easy to fix this kind of perspective distortion (see Figure 18.10).

Figure 18.9

Four degrees of rotation return the picture to vertical.

Figure 18.10

Use the Perspective tool to straighten things out.

The Perspective tool is easy to use but hard to explain. When you select the Perspective tool, Photoshop draws a rectangular frame around the image. At each corner and at the midpoint of each side of the image, Photoshop draws a little box called a *handle*. When you click the handle with the mouse, you can move it in any direction. This causes the picture to shrink or stretch as you move the mouse. By moving the bottom corners of the image out to the side, I can correct most of the perspective distortion (see Figure 18.11).

Figure 18.11

Select new borders for the picture.

The final step—as shown in Figure 18.11—is to select new borders for the image. The finished picture is not too bad, as you can see from Figure 18.12.

Figure 18.12

The church is level, the arches are almost perfectly straight, and this picture is saved.

Fixing Exposure and Contrast

Digital camera autoexposure systems produce good results in a wide variety of lighting conditions. But even the most sophisticated light metering system can be fooled by tricky lighting conditions, which is what happened in Figure 18.13.

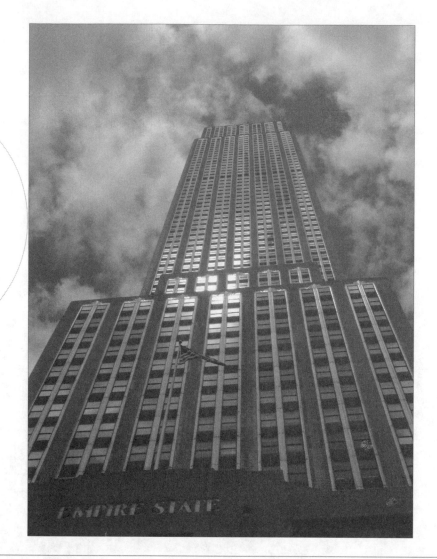

Figure 18.13

The sun's reflection off the windows caused the camera to underexpose this picture of the Empire State Building.

As you can see, the picture is framed and focused well, but it is way too dark. This picture was taken from the top of a moving tour bus, so there was no chance to go back and do it again. Fortunately, this picture—and most other underexposed pictures—is easily salvaged.

The first step is to open the picture with Photoshop Elements and select the Levels control from the Enhance-Brightness/Contrast menu. The levels control opens a small histogram display with three sliders, like the one in Figure 18.14.

At the bottom of the histogram display, three sliders control (from left to right) black level, contrast, and white level. The white level from the sun's reflection is the small spike at the

far right end of the histogram display. It is this intense white that fooled the camera's auto-exposure system, causing the rest of the picture to be too dark.

Figure 18.14

You can adjust brightness and contrast with the Levels command.

By moving the right slider to the left, you can increase the overall brightness of the image, as shown in Figure 18.15.

Figure 18.15

Adjust the white level to increase overall brightness.

Now the picture is bright enough, but there's too much contrast. All the detail in the bricks is lost, and you can barely see the "Empire State" sign on the front of the building. This can be fixed by adjusting the middle slider (see Figure 18.16).

Figure 18.16

Adjust the contrast to bring out details.

Reducing the contrast helps bring out the details in the building. Notice, though, that some of the detail in the clouds is now gone. This happens because some areas in the clouds were near the same brightness as the windows. When the white point was adjusted, those clouds became 100% white, or blown out. This is a sacrifice you sometimes have to make to save an underexposed picture. The resulting picture is much better than the original (see Figure 18.17) .

Figure 18.17

The finished picture. Some cloud detail is lost, but the building is now more visible.

Retouching

No matter how careful you are when composing and shooting your pictures, there are times when you just can't control the subject matter. This is especially true when you're shooting in a crowded urban area like New York City.

At a recent visit to the John Lennon memorial in Central Park, I waited about 10 minutes to get a clear shot of the "Imagine" mosaic. It was a rainy, windy day, and I was using a new camera that was on loan from the manufacturer, so I didn't want to get it wet. I waited for a clear shot, quickly turned the camera on, and got the picture in Figure 18.18.

Figure 18.18

Can you find the feet? There are three people's feet on the edges of the picture.

When I reviewed the pictures, I couldn't believe that despite my waiting for a clear shot, there were three shoes in my picture. Fortunately, removing small objects like shoes is no big deal. First, I opened the image with Photoshop Elements and zoomed in on the upper-left corner using the zoom tool.

Next, I selected the rubber stamp tool from the Photoshop toolbox. The rubber stamp tool copies image data from one area of the picture to another. This tool enables you to copy pixels from one area to another, usually to cover up something you don't want to see. Figure 18.19 shows the rubber stamp tool in action.

As you can see from Figure 18.19, one of the feet is already half gone. It only takes a few clicks to remove the two shoes. Next, I zoomed in on the upper-right corner, and again used the rubber stamp tool to remove the third shoe. Figures 18.20 and 18.21 show the upper-right corner before and after the rubber stamp tool was applied.

Figure 18.19

The rubber stamp tool copies data from the cross cursor to the round brush area.

Figures 18.20

See the shoe? Use the rubber stamp tool...

Figures 18.21

...to remove the shoe from the upper-right corner of the picture.

While I was editing, I also used the rubber stamp to remove a few leaves and to fix the crack at the bottom of the mosaic. The finished picture is shown in Figure 18.22.

Figure 18.22

The Imagine Mosaic, shoes removed, crack fixed, leaves blown off. Total editing time: less than five minutes.

SUMI'S SNAPSHOT

What happens to my original file when I edit the image?

Most photo editors save the edited version of the file in place of the original. If you want to keep your original file, you should do a Save As to save the image into a new file.

I've heard that a JPEG image loses some quality each time you open the file.

This just isn't true. You lose some quality each time you *save and reopen* a JPEG file, not when you open it. If you plan to make extensive changes to a JPEG image over several editing sessions, save the image in an uncompressed format between sessions.

PRINTING YOUR IMAGES

Printing can be the final, triumphant step that proves your mastery of your digital camera, or it can be a humbling, expensive exercise in frustration. For the beginning digital photographer, the process of transferring an image from the computer screen to the printed page seems simple enough. But getting perfect prints takes time and patience.

No matter how good your camera, computer, and printer are, it's possible—and in fact, very easy—to produce terrible prints. I know because I've done it myself. The good news is that the same camera, computer, and printer can also produce excellent prints. The difference between success and failure lies in some small details that are easy to overlook.

In Chapter 13, "How to Take Great Pictures," we showed you how to improve your photographic success rate by taking more good pictures and fewer bad ones. In this chapter, we show you how to improve your printing success rate. The result should be more good pictures on your wall and in your photo album, and fewer failures crumpled up in your trash can. In particular, we'll show you

- Why printing is harder than it looks
- Comparing camera pixels to printer dots
- Why color matching is important
- Software for printing

IT LOOKS SO EASY...

Printing is one of the most challenging aspects of any computer application. If you've ever created a long, complex document in a word processor, spreadsheet, or page layout program, you know how hard it can be to get that document to print on paper exactly as you saw it on the screen. Printing photos isn't any easier. In fact, printing high-quality digital images is far more complex.

It's fast and relatively inexpensive to reprint a spreadsheet or word processor document when things don't go as you planned. But high-quality photo paper and ink are expensive, and photos take much longer to print than text documents. When you make a bad print, you've wasted your time *and* money, so you really want to get it right the first time.

Digital photographers—including those who are experienced computer users—are presented with a host of strange and often cryptic terms and options when printing photographs. But those terms and options are a lot less threatening when you understand how the digital imaging process works. In this first section, we explain the two basic challenges you'll face when printing photographs: image size and color matching.

IMAGE SIZE AND THE PRINTED PAGE

Cameras are typically rated by the number of pixels they produce, and printers are classified by the number of dots they can print in a linear inch. This number is called *dots per inch*, or *DPI*.

JARGON

Dot Math

DPI is a confusing unit of measure because it doesn't really tell the whole story. Images are two dimensional, but DPI is a one-dimensional number. Doubling a printer's resolution—from 600 to 1200 DPI, for example—doesn't double the number of dots the printer lays down in a square inch, it quadruples it.

At 600 DPI, a printer has to make 360,000 dots to cover a square inch of paper; at 1200 DPI, that number jumps to 1,440,000!

Digital image files contain a setting called *pixels per inch*, or *PPI*, which defines how large the camera's image appears on a monitor or printer. Many users understandably confuse DPI with PPI. Although the two numbers are related, they aren't interchangeable. In fact, the camera DPI setting is so meaningless that most image editors ignore it anyway.

For example, the Canon D30 (and many other digital cameras) store images with a PPI setting of 180. At 180 DPI, the D30's 2160×1440 pixel images produce an image 12 inches wide and 8 inches tall. But if you open an image from a D30 in Adobe Photoshop and check the image size settings, you'll see that Photoshop assigns the image its own default setting of 72 DPI. At that DPI setting, the D30's images print at 30×20 inches, as shown in Figure 19.1.

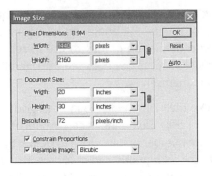

Figure 19.1

Photoshop defaults to 72 DPI when you open a document.

How did Photoshop arrive at such a large image size for this picture? The D30 produces images with 2160 horizontal pixels and 1440 vertical pixels. Divide 2160 and 1440 by 72 DPI, and you get 30 and 20 inches. Obviously, most people don't want to print pictures anywhere near this large. Most image editors set the PPI to 72 because 72 is the magic number that defines how many pixels a typical computer monitor can display in an inch.

For example, consider a typical PC or Mac with a 17" monitor and a display card operating at the common setting of 1028×768 pixels. The monitor can display 786,432 pixels total. At 72 PPI, that works out to an image 14.2" wide (1024 pixels/72 PPI) and 10.6" tall (768 pixels/72 PPI).

More Pixels = Smoother Image

Some systems use a screen display settings higher than 72 PPI, which produces a smoother onscreen image.

It's important to understand that any digital image file can be printed at a variety of sizes, regardless of the PPI setting specified in the file. The maximum print size you can make from a digital file depends on the number of pixels in the file, the quality of the original image, and the level of quality you expect from the final print.

Most photo editor programs ignore the DPI setting when you open an image. Instead of opening the image at the camera-specified size and DPI settings, programs typically open the image at a reduced size so that you can see the entire image on the screen. When you save the image, most photo editors maintain the 72 DPI setting, more as a matter of tradition than anything else.

Matching DPI and PPI

Many people think that it is necessary to resize an image before printing so that the new image has as many pixels as the printer has dots. But dots and pixels aren't the same thing. Inkjet printers produce millions of colors using only three or six colors of ink. Inkjet printers can't mix colors, so they do the next best thing by laying down adjacent drops

of different colored ink as the print head moves across the page. When your software sends an image to a color printer, the printer and the printer driver software analyze the image and decide what combination of inks to use to represent each pixel. The individual ink dots are too small to see, so our eyes see the overall color produced by the group of dots, and not the dots themselves.

Printer manufacturers like their DPI ratings to look as good as possible, so they count the number of individual color dots their printers can produce. But it takes a group of three or six dots (depending on the number of ink colors) to define the color contained in each individual pixel. A 1200 DPI six-color printer can really resolve only 200 pixels worth of detail. Fortunately, 200 DPI is more than enough detail to produce realistic photo-quality images.

Exact Size Only, Please

A few printers—most notably dye sublimation printers—require images that exactly match the printer's DPI setting to get the best results. If you print at the wrong DPI setting, the prints lose detail and have jagged diagonal lines.

If you're using such a printer, you should resize your images using the printer's DPI setting before you print.

Dot's Enough

When your imaging software prints an image, it must build a copy of the image you see on the screen. This copy is sent to the printer and becomes the image you eventually see on your paper. In most cases, the print image that your software sends to the printer is not the same size as the image displayed on the screen.

The size of the image sent to the printer depends on a number of factors, including the number of pixels in the image, the size of your desired print, the type of paper in use, and the desired quality of the final print. In most cases, the software must either discard pixels to make an image smaller, or it must create new pixels to make it larger. In either case, the software uses a complex mathematical formula called a resizing algorithm.

Some resizing algorithms produce images that are nearly indistinguishable from the original; others produce blocky, pixilated images with much less detail than the original image. Generally, the better algorithms take longer to operate and the simpler, faster algorithms produce poor results. A few programs like Qimage Pro (described later in this chapter) give you the option to decide between speed and quality.

How Big Is Too Big?

Even the best resizing algorithm can't produce a good print if there's not enough data to work with. Back in Chapter 3, "How Many Pixels Are Enough?," we offered some guidelines for the maximum print sizes for each class of camera. We didn't explain how we arrived at those numbers back in Chapter 3, but this is a good place to do it now.

You need around 200 DPI of detail to produce a photo-quality image. You can get by with less—down to as little as 120 DPI—but 200 DPI is a nice, round number that produces nice, sharp images. Table 19.1 shows how 200 DPI works out into actual print sizes for different camera pixel counts.

TABLE 19.1—The Largest Print You Can Make at 200 DPI

Pixel Count	Inches @ 200 DPI	Closest Standard Print Size
1.2 mp (1280×960)	1280/200=6.4''	4''×6''
2.0 mp (1600×1200)	1600/200=8''	5''×7''
3.1 mp (2048×1536)	2048/200=10.2''	8''×10''
4.9 mp (2560×1920)	2560/200=12.8''	11''×14''

This chart is a guide, and not an absolute rule. If you decrease the resolution down a bit—say to 150 DPI—you can bump your pictures up to the next standard print size with little or no loss in quality.

Don't Look Too Closely

Hand some photographers a digital print, and they'll hold it up to their noses to see if they can detect the individual pixels. Up close, almost all digital prints look digital.

But most of us don't hold our pictures up to our noses to view them. Judge your prints at a normal viewing distance, not under a magnifying glass. This is especially true for large (8''×10'' and larger) prints that will be displayed on a wall and viewed from several feet away.

ANOTHER PROBLEM: COLOR MATCHING

The second major obstacle to good prints is color. Digital image files describe an array of pixels that in turn make up the image itself. Each pixel has an RGB (red, green, blue) value that determines the color and brightness of the three colors that make up each pixel. A pixel with an RGB value of 255,255,255 is white, and one with a value of 0,0,0 is black. RGB images are convenient for use with computers, because computer monitors use RGB-based displays.

As we've already seen, most printers use cyan, magenta, and yellow (CMY) inks. Some printers also use black ink; these are called CMYK printers. When you print an image, your imaging software and printer driver work together to convert the image from the camera's RGB color system into the printer's CMYK color system. All color printers contain software—either in the printer itself or in the printer's driver software—that converts images from RGB to CMYK.

Running the Gamut

All cameras, monitors, scanners, and printers have a range of possible colors they can record or display. This range of colors is called a gamut. Unfortunately, cameras, monitors, scanners, and printers have different color gamuts. The challenge is to get the color

gamuts of all the devices you use to match one another as closely as possible. This is done through the use of a common color vocabulary called a *color space*.

Over the years, computer, scanner, camera, and software makers have created a large number of different—and largely incompatible—color spaces for their products. In 1993, a group of companies led by Apple Computer got together to create a standard for color management on personal computers, monitors, printers, and other color devices. Apple's color management systems is called ColorSync, and Microsoft's is called Image Color Management, or ICM. We focus on ICM for the rest of this chapter, but much of what we cover applies equally to ColorSync. ICM is supported in all versions of Windows since Windows 98, and ColorSync is supported in all versions of the Mac OS from 8.1 onward.

Windows 95 and Color

Windows 95 contained an early version (1.0) of ICM, but very few hardware and software companies paid it much attention. ICM 2.0 was introduced with the release of Windows 98 and is supported by virtually all image editor programs.

ColorSync and ICM provide a standardized way for color devices to describe themselves to the system. This is done through the use of small files called ICC color profiles. If a device comes with its own color profile, it is up to the device to install the color profile along with the device's other driver software.

Many devices don't include a special color profile, but instead conform to a standard color space called sRGB. Most digital cameras, printers, and imaging software on the market today can operate within the sRGB color space.

sRGB, We Hardly Knew Ye

The sRGB color space was originally designed to provide color matching on monitors, so its color gamut is somewhat limited.

A new color model called scRGB is under development by Microsoft and HP, and should begin to make its way into new products in 2002. scRGB provides a wider (16-bit compared to 8-bit for sRGB) and more precise range of colors.

ICM 2.0 is completely automatic and requires little or no action on the part of the user. By default, ICM 2.0 assumes that all the hardware and software in your system supports the sRGB color space. Any input or output device—including scanners, cameras, monitors, and printers—might have an ICC profile associated with it. If a device (a printer, for example) installed its own color profile, then ICM uses the device-specific color profile instead of the generic sRGB color profile. Figure 19.2 shows how to tell whether your printer's device profile is installed.

Figure 19.2

The Epson printer (left) uses a device-specific ICC profile, and the HP printer (right) uses the generic sRGB profile.

ICM and ColorSync take much of the pain out of color matching. In most cases, you can simply turn on ICM or ColorSync when you print, and leave it at that. If your printer came with an ICC profile, make sure the profile is installed, and you're finished.

Some printers provide their own color matching software embedded in the printer driver. These drivers often enable you to fine-tune the printer's color output to your liking, something you can't do with a standard profile. Figure 19.3 shows the color settings control for an Epson printer.

Figure 19.3

Epson's advanced settings printer control enables you to tweak the printer's color settings to your liking.

As you can see from the right side of Figure 19.3, the Epson printer driver offers users several types of color management. When you select Color Controls (as shown in the example), a set of adjustment sliders appear in the lower right corner of the printer's advanced settings dialog. You can use these sliders to adjust the color, brightness, contrast, and saturation (overall color level) to suit your personal taste. If you don't want to adjust the color settings manually, you can select ICM or sRGB and the adjustment sliders disappear.

PUTTING THE RIGHT INK ON THE RIGHT PAPER

Have you ever tried to write on plastic with a ballpoint pen? Or done the Sunday crossword with a fountain pen? If so, you know that not all inks work well with all types of paper.

The same is true—only more so—for computer printers. Each manufacturer's inks and papers are designed specifically to work together. Some people think this is an urban myth, or a clever scheme to get you to buy expensive paper and inks from a single source. It's not either one.

Discount Ink and Paper

There are some very good and compatible third-party ink and paper products on the market. For example, Kodak makes an excellent line of paper that works well in HP printers.

But before you save a ton of money by buying a 500-sheet bulk pack of photo paper, buy a small package and make sure that the paper works with your printer at its highest resolution setting. Not all papers work well in every printer.

Several third-party companies sell refilled ink cartridges and do-it-yourself refill kits for popular printers. We've heard mixed reports on these products. Some users claim they're as good as the originals, and others have complained of inaccurate colors and other problems. As with the paper, if you want to try these alternative inks, buy one and try it before you buy a large quantity of something you don't like or can't use. Also, be aware that many printer manufacturers do not honor warranty repair claims if they find evidence of damage caused by third-party inks.

Virtually all printers can print on plain paper—but only in text or low-resolution graphics modes. Modern inkjet printers use very tiny drops of ink—as small as 3 or 4 picoliters. (A picoliter is a trillionth, or a millionth of a millionth of a liter!) The tiny ink drop size enables printers to place lots of dots very close together on the page.

Ordinary paper can't handle the tiny ink drops. The fibers in plain paper are relatively coarse, so the paper acts like a sponge. When the ink hits the paper, it spreads into the fibers, creating a dull, smeared dot instead of a sharp, crisp dot. High quality photo paper has a coated surface that keeps the ink from soaking into the paper. The coating and ink are designed so that the ink dries quickly, which prevents the image from smearing. The bottom line is that you can't print high-quality (600 DPI or higher) photo-quality prints on plain paper.

Time Is Money. Ink Is Money.

Printing at a high DPI rating takes more time and uses more ink than a lower setting does. You don't always have to use your printer's highest DPI setting to get good prints. Depending on the print size and the original image, you might see little or no difference between a print made at the highest resolution setting and another print made at half the DPI rating—using half the ink.

With a little experimentation and experience, you'll be able to choose the DPI rating that's most appropriate for your needs.

One of the key elements to getting good prints is to use the appropriate print quality setting for the paper you're printing on. Most printer manufacturers make specific recommendations for each paper type they sell. For the best possible prints, you should choose photo quality paper.

SOFTWARE: CHOOSING THE RIGHT TOOL

Digital photographers can choose from an incredibly wide variety of image editing and printing software. We don't have room to cover them all in this book, so we've chosen one representative from each of three different classes of image editing and printing software as examples. The three programs are Adobe Photoshop Elements, Digital Domain's Qimage Pro, and Microsoft's PictureIt! Photo (the ! is part of the product name, not a typo). Trial versions of Photoshop Elements and Qimage Pro are available on the companion CD.

As we saw in Chapter 18, "Imaging Software—What Can It Do?" Photoshop Elements is a full-featured image editor program. Like all image editors, it includes features for making high-quality prints—but it can only print one picture at a time.

Qimage Pro is a great tool to use when you want to print more than one picture at a time, or when you want to make multiple prints from a single picture. It uses a simple drag-and-drop interface that enables you to print multiple small prints on a larger sheet of paper.

PictureIt! is a very complete program that provides image editing and retouching tools along with a library of pre-designed projects that enable you to make everything from calendars to greeting cards in a few simple steps. Like Qimage, PictureIt! includes features to print multiple pictures on a page and multiple copies of a single picture. PictureIt! can also build Web pages, and it can automatically upload your pictures to Kodak's Ofoto or Fuji's Fujifilm.net for printing.

Understanding Print Settings

Every photo printer includes a piece of software called *driver software*, which handles the interaction between the computer and the printer. All printer drivers contain user-adjustable settings for print quality, page size and orientation, port connections, and other printer-related settings.

The correct driver settings are critical to getting the best possible images from your printer. All printer drivers enable you to choose the correct paper size and orientation, and most also provide tools to adjust the print quality and color management system. We can't show you every option for every printer driver on the planet, so we've chosen the driver for Epson's high-end Stylus Photo 1280 as an example. The settings in the 1280's driver are similar to those used in other Epson models, and most photo-quality printers (like those from Canon, Lexmark, and HP) include similar settings. The example screens shown in this section are for Windows, but the same concepts apply to Mac systems, too.

The first step to making a print from any program is to select the Print choice from the program's file menu. In most applications, this opens a print setup dialog where you can choose the print quality and the number of prints to make. Figure 19.4 shows the Print dialog from Adobe Photoshop.

Figure 19.4

Adobe Photoshop's Print dialog shows some basic printing options, but the good stuff is hidden behind that button marked Setup.

Before you click Print, there are a few settings you should check. Click the Setup button to see the printer-specific settings page (see Figure 19.5).

As you can see from Figure 19.5, a large number of options can be set on the Epson printer. Two of the most important are the Media Type and the Printer Mode. The Media Type tells the printer what type of paper you're using. In this example, Premium Glossy Photo Paper is selected, which is Epson's best grade of photo paper. Custom Settings is also selected from the Mode menu. The Custom Settings option enables you to make some further fine-tuning adjustments by clicking the Advanced button, as shown in Figure 19.6.

Figure 19.5

This is the main page of the Epson printer driver, where you can set the paper type and print quality.

Figure 19.6

The Epson advanced settings screen is where you fine-tune the printer.

Epson's advanced settings screen gives you complete control over a large number of printer settings. In this example, 1440 DPI is selected from the Print Quality menu, and the box marked High Speed is turned off. The Epson high-speed option is called bi-directional printing in other manufacturer's print drivers. This setting speeds up printing by printing on both passes as the print head moves back and forth over the paper, but it also reduces print quality. If you're not in a hurry, and you want the extra print quality, leave it turned it off. Note that ICM under Color Management is also selected; this tells the printer to let Windows handle color management.

The Save Settings button at the bottom of the screen enables you to save commonly used settings so that you don't have to revisit this dialog box every time you print; you can simply select the saved settings from the main Printer Properties screen.

Default Printer Settings in Windows

Each time you make a print, the printer settings revert back to the default settings. This can be annoying when the default settings aren't the ones you use the most often. You can change the default print settings in Windows by opening the printer from the Windows Start Menu or the Windows Control panel. Select Properties, and then click Printing Preferences near the bottom of the Properties display. The printer settings dialog appears. Any changes you make to the printer settings become the new default settings.

Printing from Photoshop Elements

For many beginning digital photographers, the photo editor program is the only tool they have for printing photos. Most photo editors are designed to work with a single picture at a time. To print a picture, you must open the picture with the editor; make any changes, such as color and brightness correction; and then print the picture.

By hand-tweaking the color, brightness, and contrast of each picture, you obtain the best possible prints from your images. The only problem with this approach is that it can be very time consuming.

Changes Are Forever

If you make major changes to a digital image, you might want to save the changed version of the image in its own file. After you've changed and saved the original file, you can't go back and undo the changes.

When you're working with JPEG images, keep in mind that each time you save the file, the file is recompressed. JPEG compression isn't lossless, so you lose a little bit of picture quality each time you open and re-save a file. If you plan to do extensive editing to a JPEG image over several editing sessions, save the file in the editor's native file format or as an uncompressed TIFF file.

Photoshop Elements—like many other image editors—includes a print preview feature that enables you to see how your image fits on the page before you actually print it. This is a great feature because it keeps you from printing mistakes and wasting paper and ink. Figure 19.7 shows the Print Preview screen with an image that's way too large for the page.

As you've probably guessed from Figure 19.7, I don't really want to make a 20"×30" print of my dog's nose. (There's Photoshop's 72 DPI default setting at work again!) What I really want to do is print the largest image—of the whole dog—that will fit on a standard 8 1/2"×11" page. Clicking the Scale to Fit Media button fixes this problem in an instant (see Figure 19.8).

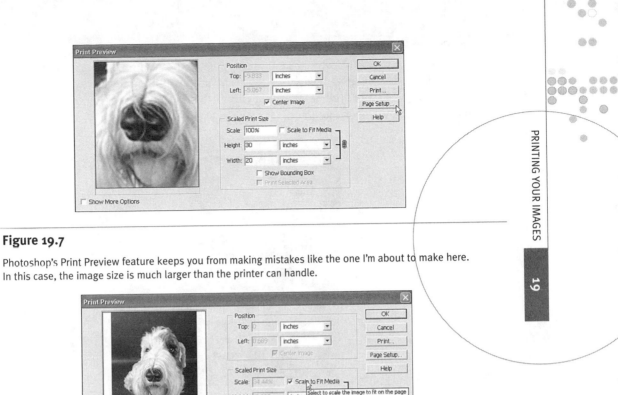

Figure 19.7

Photoshop's Print Preview feature keeps you from making mistakes like the one I'm about to make here. In this case, the image size is much larger than the printer can handle.

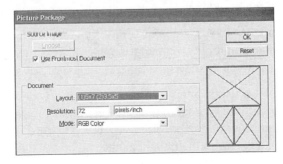

Figure 19.8

Photoshop can automatically scale your image to fit your paper size.

Sometimes you want to make several prints of the same picture. Photoshop Elements contains a neat feature called Picture Package that builds a picture with multiple copies of your image at a variety of different sizes (see Figure 19.9).

Figure 19.9

Photoshop's Picture Package feature prints multiple copies of your image on a single page, just like those prints the kids bring home from the school photographer.

The Picture Package feature builds a single image that contains multiple copies of the original image, resized and rotated as necessary to fit them all on a single page. You can choose from dozens of layouts and sizes, including everything from wallet-size photos all the way up to 11"×14" prints. After you choose a size and layout, Photoshop takes over and builds a new image like the one shown in Figure 19.10.

Figure 19.10

This is a sample Picture Package image with one 5"×7" and two 3 1/2"×5" prints on a single 8 1/2"×11" page.

Photoshop puts the Picture Package image into a new image, so you can print the file on the printer or save it for future use.

Printing with Qimage Pro

Unless you've been into digital photography for a while, the chances are good that you've never heard of a program called Qimage Pro. It's one of those programs that is so useful, you'll wonder how you ever did without it. There's a trial version of Qimage Pro on the CD-ROM in the back of the book; the full, registered version costs only $35.

Qimage Pro does a lot of things, but what it does best is print images on paper. Qimage Pro uses a simple drag-and-drop user interface that enables you to print one or a hundred pictures at a time. Figure 19.11 shows the main Qimage Pro screen.

Qimage Pro can print a wide variety of image sizes on a wide variety of paper. It's the best tool I know of for making lots of prints at one time. To use Qimage Pro, you open the program, select a print and paper size using the QuickSize button, and then drag as many pictures as you like from the thumbnail display on the left to the page preview on the right.

Figure 19.11

Qimage Pro's drag-and-drop user interface couldn't be much simpler.

As you drag new images onto the page preview, Qimage automatically rotates the images, if necessary, to fit as many pictures onto the page as possible. I use it because it lets me put three 4"×6" prints on a single 8 1/2"×11" page—something that few other programs can do.

Another of my favorite Qimage features is the image filter. This feature enables you to make changes like color correction, sharpening, and brightness adjustments without changing the original image file (see Figure 19.12).

The nice thing about Qimage Pro's filter feature is that it doesn't change the original files. You can create a filter for each individual image, or you can create a single filter (called a Global Filter) to be applied to each image you print.

Qimage uses a very sophisticated resizing algorithm to produce the sharpest possible prints. It also includes a laundry list of features for file management, image processing, and image viewing.

No Scissors, Please!

All of the programs we cover in this chapter can print multiple images on a page. You can cut the prints apart with a pair of scissors, but you need a keen eye and a steady hand to cut the pictures perfectly straight. Besides, cutting more than a few pictures with scissors quickly becomes a chore.

Several manufacturers make inexpensive paper trimmers designed specifically for photo paper. These trimmers use a round blade that runs on a track, so your cuts are always straight and clean...and they're a lot more fun to use than scissors!

Figure 19.12

Qimage Pro's filter feature lets you fix common problems like underexposure and color balance on a group of pictures at once.

Printing with Microsoft PictureIt! Photo

Microsoft's PictureIt! Photo does so many things that it's hard to categorize. PictureIt! combines a full-featured, easy-to-use image editor with a library of canned projects that you can use to create collages, greeting cards, calendars, Web pages, flyers, posters, and just about anything else you can print on paper.

PictureIt! Photo features a simple user interface that is designed for beginners (see Figure 19.13). The program can guide you through each step of each task, or you can work on projects on your own. PictureIt! Photo includes excellent retouching tools for removing red-eye, adding text, and applying special effects to photos. Despite the simple interface and low $39.95 price tag, PictureIt! Photo includes some features that even jaded, experienced digital photographers (and I'm not naming names here) will find too good to pass up.

I'll confess that I use Photoshop 6.0 for most of my editing tasks, and I use Qimage Pro for 90% of my printing needs. But when I need to create a collage of photos, a quick greeting card, or a poster, I turn to PictureIt! Photo.

One of the reasons that PictureIt! Photo is so popular with beginners is that it puts everything you need in one place. The main menu screen resembles a Web page, with icons that you click to perform specific tasks. You can open existing files, import new files from your camera, or scan new images right from the main screen. A Gallery feature enables you to organize your photos, and the Web page builder enables you to build Web pages with your photos without your knowing a single line of HTML code.

Figure 19.13

PictureIt! Photo does it all, as you can see from the main menu screen.

My favorite PictureIt! Photo feature enables you to make a photo collage using pre-made templates (see Figure 19.14).

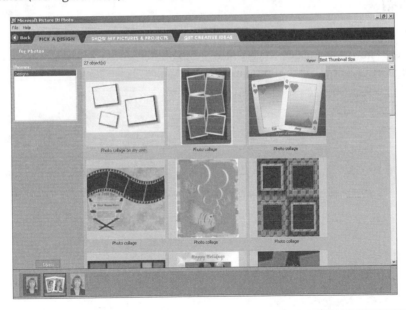

Figure 19.14

PictureIt! Photo provides tons of templates for photo projects, like the photo collages shown here.

To make a photo collage, you select a template from the collage display, and then drag and drop one or more photos into the collage. PictureIt! Photo automatically positions, sizes, and even rotates your pictures to fit into the picture cutouts in the collage, as you can see in Figure 19.15.

Figure 19.15

This photo collage took about two minutes to make.

PictureIt! Photo also includes a very nice photo printer feature that is similar to Photoshop's Picture Package, but much more flexible.

SUMI'S SNAPSHOT

What's the difference between Photoshop Elements and Photoshop 6.0?

About $500. Photoshop 6.0 is aimed at professional photographers, illustrators, and graphic artists who need many of the specialized features found in the full version of Photoshop. Elements contains 90% of those tools at one-fifth the price. The nice thing about Photoshop Elements is that the user interface is very similar to Photoshop 6.0, so you can take your accumulated Photoshop knowledge with you if you move up to 6.0.

What's the big deal about putting several 4"x6" prints on a single page? Why not just print on 4"x6" paper?

Although most photo printers can accept 4"×6" paper, very few can print borderless prints, so you end up with a white border around the print. When you print 4"×6" prints on an 8 1/2"×11" sheet, you get 4"×6" prints without borders. Even if your printer can do borderless 4"×6" prints, a single sheet of 8 1/2"×11" is usually much cheaper than three sheets of 4"×6" paper.

CHAPTER 20

OUTSOURCING YOUR PRINTING

Sometimes it just doesn't pay to do things yourself. Businesses started the outsourcing trend several years ago when many companies discovered that it was cheaper and more effective to farm out—or *outsource*, in the new business vocabulary—those things that a company can't do efficiently or properly by itself. Many companies outsource their payroll, information technology management, and even their mailroom operations to companies that specialize in those areas.

In this chapter, we examine your options for outsourced printing and tell you the pros and cons of outsourcing. Here are a few of the topics in this chapter:

- Why outsource?
- Your local photofinisher
- Online printing services

WHY OUTSOURCE?

If printing your own digital pictures seems too expensive or time consuming, you might want to consider sending your images out for printing. Sending your digital images out for printing frees you from the sometimes tedious task of printing your own images on your PC. In most cases, outsourced prints cost about the same as prints you make on your own printer—or even a bit less.

The quality of outsourced printing varies widely, just as the quality of 35mm film processing varies from one photofinisher to another. Several factors affect print quality, including the equipment and materials used and the skill level of the person making the prints. Before you order a large number of prints from any one source, ask for a few samples to make sure you're pleased with the results.

There are two major sources for outsourced printing. First, many retail photofinishers and camera stores can produce prints from digital files. Digital image printing is in its infancy, but many national camera store and photofinishing chains are rushing to put digital printing facilities in place. Second, several online photofinishing companies specialize in producing prints from digital images. Each has its pros and cons, which are discussed later in this chapter.

There are several reasons why you might want to forego the immediacy and control of printing at home to let someone else do your printing for you:

- You need a large number of prints from a single image (for holiday cards, graduation announcements, and so on).
- You need a print larger than your printer can handle.
- You took way too many pictures on your vacation and you don't have time to print them all.

YOUR LOCAL PHOTOFINISHER

A growing number of camera stores and other retail photofinishing outlets provide digital printing services. Typically, you drop off your digital media, order your prints, and pick them up in an hour or two—much like you would with film processing.

Photofinishers have a variety of ways to produce images from digital files, so price and quality varies widely depending on the type of equipment in use.

Photographic Prints

Many retail photofinishers that offer digital prints use a conventional film processing mini-lab—such as Fuji's popular Frontier system—that can accept digital input. These systems can print photos from digital images on flash memory cards, CD-ROMs, floppy disks, and even direct uploads from customers' cameras. The digital image is projected onto photosensitive paper, which is processed using the same equipment and chemicals used for regular color negative printing. The Fuji Frontier and similar systems produce excellent prints on normal photographic paper, so the finished prints look and feel like prints from film.

Because the photofinisher can use the same equipment and supplies for digital images, the cost of prints from digital images is about the same as a standard 35mm print. And because the prints are produced on standard silver-based photographic paper, they last as long as prints from film cameras.

This service is in its infancy, but the equipment makers and retail photofinishers are gearing up to make digital printing a major part of their businesses.

Digital Prints

Many photofinishers have older film minilabs that can't be adapted for digital input, so they do their digital prints on a dedicated digital photo printer. The price and quality of the finished product depends largely on the equipment in use and the amount of manual labor required to produce the prints.

Kodak and several other manufacturers make high-quality dye sublimation printers that are popular with small photofinishers, but these printers are expensive to operate. Check pricing before you drop off that CD with 100 images to be printed—I've seen prices as high as $1.00 for a standard 4"×6" print!

Many photo labs aren't ready to take on the digital world just yet, but they don't like to see customers walk out the door, either. Kodak's Picture Maker lets retailers offer a variety of digital printing services in a small, self-contained unit. The Picture Maker is a self-service scanner/printer/image editing system that accepts input from negatives, slides, flash memory, CD-ROMs, and prints using the unit's built-in flatbed scanner. The output quality is excellent, thanks to the Picture Maker's dye-sub printer. It's a great tool if you just need a few prints, but the system is often expensive to use.

ONLINE PHOTOFINISHING

Before the Internet implosion of 2000-2001, online photofinishing was hailed as one of those "next big things" that were going to change the world. After the dust settled, many online photofinishers were long gone. Not surprisingly, the ones that remain are the ones with the deepest pockets.

Online photofinishers work just like your local retail photofinisher. They take your film (via mail) or digital camera images (via an Internet upload), and print them on standard photographic paper. The cost is about the same as your local photofinisher—around $.50 for a 4"×6" print.

The main difference between online and retail photofinishers is a matter of convenience. If you live in an area without a digital-capable photofinisher, an online service provides you with similar services at a similar cost. Even if you have a local photofinisher, it might be more convenient to upload your pictures to an online service, rather than making a trip to a retail store.

Whatever your reasons for using an online service, keep in mind that you need to upload your images to the service. If you have a slow dial-up Internet connection, it can take several minutes to upload each picture. Even if you have a broadband Internet connection such as cable or DSL, it can still take a long time to upload a few dozen pictures to an online service.

Bandwidth Blues

Cable modem and DSL Internet services can be amazingly fast for viewing Web pages and downloading files. But most cable and DSL services are asymmetrical, meaning that they're faster in one direction than in the other.

Typical cable and DSL upload speeds top out at around 128 kilobits per second. This means that file uploads—like sending image files to an online printing service—take a lot longer than file downloads.

Some cable and DSL providers offer faster upload speeds for a small increase in the monthly service charge. If you plan to upload lots of pictures to a print service or Web site, the few dollars will be well worth the time you save.

A TOUR OF OFOTO

Ofoto is Kodak's online photofinishing service. Like other online photofinishers, Ofoto offers a complete range of online printing services, including prints as small as wallet size and as large as 20"×30". Ofoto also offers frames, photo greeting cards, albums, and other specialty items. Here's a quick tour of Ofoto to give you an idea of how it works.

Step 1: Create an Album

Before you can upload any pictures to Ofoto, you create an album to hold the pictures. Ofoto allows you to have as many albums as you like, so you can organize your pictures by date, topic, or any other way. For this example, we created an album called "New Mexico," as you can see in Figure 20.1.

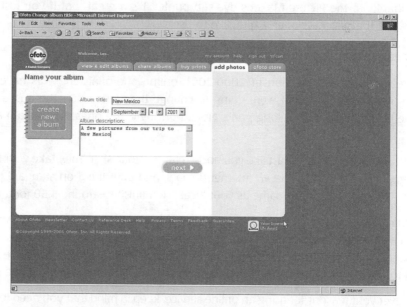

Figure 20.1

Ofoto's album creation page enables you to create online albums to hold your photos.

Step 2: Add Pictures

After you've created an album, you can add pictures to it. Figure 20.2 shows the photo selection screen, where you select pictures to upload from your computer to Ofoto.

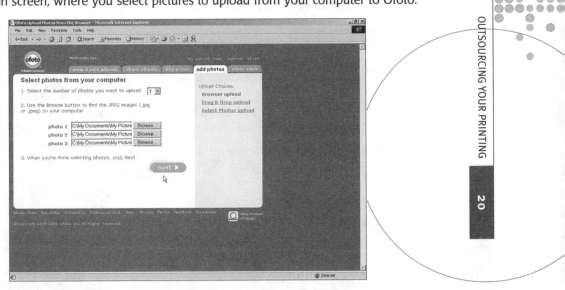

Figure 20.2

Ofoto's add photos screen enables you select the pictures you want to upload.

As mentioned earlier, uploading can take some time, especially if you are uploading high resolution images over a dial-up link. When your upload is complete, small thumbnail images of each picture you uploaded appear onscreen (see Figure 20.3).

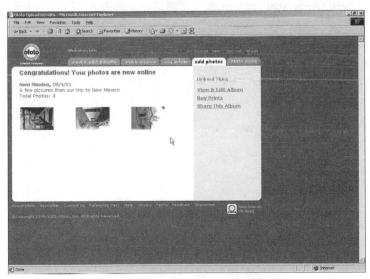

Figure 20.3

After your upload is complete, you see a small image of each picture.

Step 3: Select Pictures to Print

After you've uploaded your pictures, you can select the pictures you want to print. You can choose the number of prints to make and the size of each print, as shown in Figure 20.4.

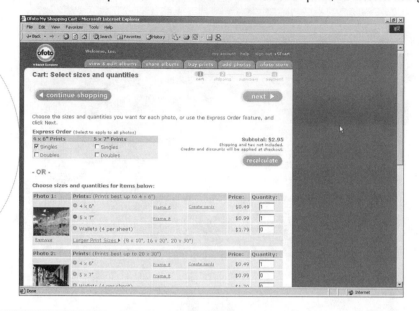

Figure 20.4

Ofoto offers a variety of print sizes.

After you've selected the prints and entered the size information, you proceed to the checkout screen where you enter your payment and shipping information.

Step 4: Share Your Album

If you like, you can share the photos in your album with friends and family. You must send an invitation by e-mail to each person you'd like to view the album (see Figure 20.5).

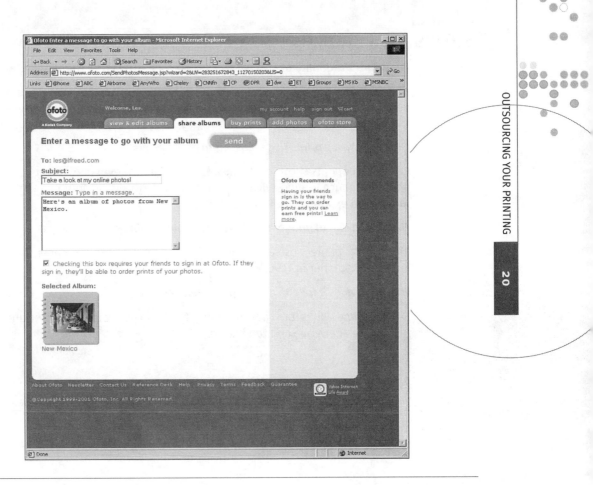

Figure 20.5

The share album feature allows other people to see your album.

SUMI'S SNAPSHOT

How does the quality of silver-based prints compare to high-quality inkjet prints?

Appearance-wise, they're about the same. Keep in mind that when you print your own pictures, you can make adjustments for color, brightness, and contrast. When you send your prints out, you lose control over these variables.

Do silver-based prints last longer than inkjet prints?

Older inkjet prints showed significant fading after a few years. Silver-based prints last much longer—15 years or more—with no significant fading. All prints fade when exposed to ultraviolet light.

How is the digital image transferred to photographic paper?

Most digital printers use a laser to project the image onto the paper, very much like a film scanner in reverse.

How long does it take to get my prints back?

Delivery time varies, but most photofinishers process your prints the same day or the day after you send the files in.

PART V

SHARING YOUR IMAGES

CHAPTER **21**

ORGANIZING AND PROTECTING YOUR DIGITAL IMAGES

Digital cameras invite users to take more pictures. After all, there's no film or processing to buy, so there's no cost involved.

As you take more and more pictures, you might find yourself overwhelmed by the number of images on your computer. Without good organization, you might find it difficult to locate the images you want, when you want them. Even worse, a catastrophic computer failure could wipe out the only copy of your digital images.

This chapter examines some simple ways to keep your images organized and protected from loss. In particular, you learn

- How to organize your images
- Image management features in Windows XP
- Managing and cataloging images with ThumbsPlus
- Archiving your images to a CD-R drive

ORGANIZING YOUR IMAGES

Most casual photographers have a shoebox (or several dozen) full of old negatives or slides. If you lose or damage a favorite print, it's reassuring to know that you can always go back to the original slide or negative and have another print made—if you can find the original.

The good news about digital photography is that you don't have to worry about storing negatives or slides anymore. The bad news is that you do need to worry about storing and organizing your digital images. Your image files are the digital equivalent of your slides and negatives.

Most people take more pictures with their digital cameras than they ever took with their film cameras. As you take more and more pictures, you might find that it becomes more and more difficult to locate a specific image or group of images. The filenames assigned by most digital cameras aren't much help, either.

All cameras assign each image file a unique filename, usually a mix of letters and numbers like DSCN5043.JPG. The "5043" tells you that this was the 5,043rd image taken with your camera, and the file date and time stamp tell when the picture was taken. But with 5,043 images in a single directory on your hard drive, you're likely to have a tough time finding anything!

Image Numbering

Many cameras include an option to reset the frame number (used as part of the image filename) each time you erase or format the memory card. With this option on, the camera starts counting over from 1 instead of counting up from the last frame number. This option is usually turned on by default.

If your camera has such an option, turn it off so that each individual picture has a unique number. If you let the camera reset the frame number, you'll almost certainly run into a problem with duplicate filenames, in which two different pictures have the exact same filename. This makes it impossible to organize your pictures by subject, because you can't have two files with the same name in the same folder.

The easiest way to avoid problems organizing your image collection is to develop a filing plan and stick to it. The file system used on Windows and Macintosh computers enables you to create any number of folders. Folders can contain files, or they can contain other folders.

You can organize your pictures any number of ways, depending on your needs and personal preferences. For example, I keep all of my image files in a folder called My Pictures, which in turn is in the My Documents folder on my PC. In the My Pictures folder, I have a large number of sub-folders that are arranged by general topic. I have separate folders for family pictures, trips, friends, and so on. Figure 21.1 shows how the pictures in my Trips folder are organized.

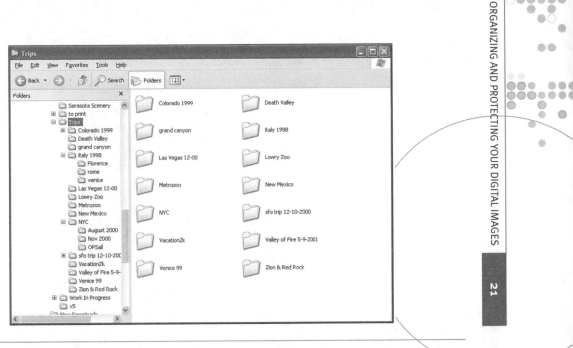

Figure 21.1

My Trips folder is separated into separate folders for each family vacation. Some of the longer trips are even split into several sub-folders, so that I can locate pictures from specific parts of the trip.

Looking at all this organization, you might get the impression that I'm a compulsive organizer. I'm not. But I have (at last count) over 10,000 images on my hard drive. The few minutes I spend organizing my images saves hours of searching when my wife asks me for a print of "that picture of the three of us by that lake in Yellowstone"—I know just where that picture is.

Keep the Keepers, Toss the Losers

There's no reason to keep every image you shoot. If an image is out of focus, poorly framed, or badly exposed, delete it. It won't get any better with age.

Managing Image Files with Windows XP

Windows XP includes several features designed to make it easy to work with images from digital cameras. The Scanner and Camera Wizard is the main tool you use to move images from your camera onto your PC. You can start the Wizard from the Start button, and it automatically starts when you connect most digital cameras or when you insert a memory card containing image files into a card reader attached to your PC. Figure 21.2 shows the Scanner and Camera Wizard dialog that pops up when you connect your camera.

When you connect a camera or insert a memory card, the Scanner and Camera Wizard offers you several choices. You can copy the images to your computer, view a slideshow of the images, print some or all of the pictures, or open a Windows Explorer window to work with the files manually.

Figure 21.2

The Windows Scanner and Camera Wizard asks you what to do with the picture on your camera or memory card.

Is It a Camera or a Disk Drive?

If there are no pictures on your camera's memory card when you connect it to the PC, Windows XP does not start the Scanner and Camera Wizard. Instead, it opens a Window showing the contents of the card as an external disk drive.

In the example in Figure 21.2, we've chosen to copy the pictures to the computer's hard drive. The next step is to choose the pictures we want to copy (see Figure 21.3).

After you choose the files to copy, you must tell Windows where you want to put the pictures. Use a descriptive name for the file folder; this makes it easy to identify the pictures at a later time. Windows automatically creates a folder using your description as part of the folder name (see Figure 21.4).

You don't have to create a new folder for every batch of pictures you copy. If you want to copy the pictures to an existing folder on the hard drive, you can use the Browse button to select an existing folder to receive the pictures.

Where's That Priceless Picture?

You might have noticed a check box marked Delete Pictures From my Device After Copying Them under the folder name box in Figure 21.4. You might also have noticed that Les didn't mention it. It's not a good idea to delete your original images until you're certain that they have been successfully copied to the hard drive.

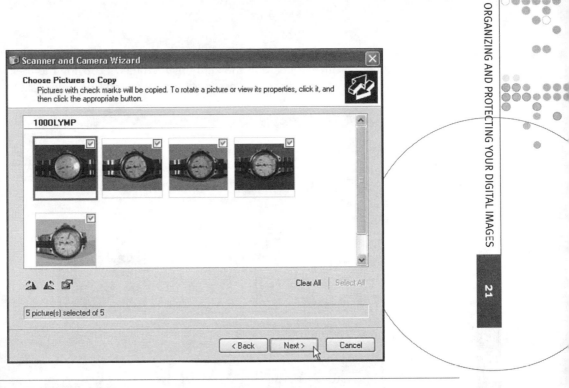

Figure 21.3

From this screen in the Camera and Scanner Wizard, you choose the files you want to copy.

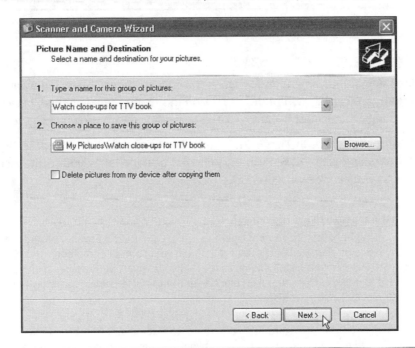

Figure 21.4

Windows makes a folder using your description as part of the name.

After you enter or select the folder name and click Next, Windows copies the files from your camera or memory card to the hard drive. While it's copying the files, Windows displays a progress box to keep you occupied and reassured (see Figure 21.5).

Figure 21.5

Windows keeps you posted while it copies your files.

The final step in the Camera and Scanner Wizard is to choose what you want to do after the pictures are copied. Two of the choices on this menu are a little odd, because they're not the things you're most likely to do. The three choices are shown in Figure 21.6.

The third menu choice in Figure 21.6 is a little misleading. If you choose Nothing. I'm Finished Working with These Pictures, Windows actually takes you to the Picture Tasks window, as you can see in Figure 21.7.

What Happened to My Filenames?

As you might have noticed from Figure 21.7, the Camera and Scanner Wizard automatically renames your files as it copies them from your camera or memory card. Each picture is renamed to the same name as the folder you used, with a three digit number added to make each picture a unique name. You can also choose to simply rename each picture "Picture" plus the serial number.

If you'd rather keep the original filenames, choose Open Folder to View Files when the Camera and Scanner Wizard first starts (refer to Figure 21.2). You have to manually copy the files where you want them to go, but you can keep the original filenames intact.

Figure 21.6

After your pictures are copied, you can publish the pictures on the Web or print them at Kodak or FujiFilm's online printing services.

Figure 21.7

The Picture Tasks window includes tools to view, print, e-mail, and publish your pictures.

Windows XP Picture Tasks

The Picture Tasks window is new in Windows XP, and it includes a nice suite of tools for managing your image files. The Picture Tasks screen shows small thumbnail images of each file in a window at the bottom of the screen, with a preview of the currently selected image in a larger window at the top.

Several menus on the left side of the screen enable you to work with your images. Here's a quick rundown on what each feature does:

- **Slide Show**—This feature displays a slide show using the pictures in the folder.
- **Order Prints Online**—This feature starts the Online Print Order Wizard, which sends your pictures to Kodak or FujiFilm's online printing services.
- **Print Pictures**—This feature starts the Photo Printing Wizard. This tool enables you to print pictures on your photo printer and includes features to print multiple pictures on a page.
- **Set as Desktop Background**—This feature uses the selected picture as your Windows Desktop picture.
- **Rename, Move, Copy, Delete**—These are the basic file management tools.
- **Publish on the Web**—This feature enables you to Publish the file(s) to an MSN online community or an Xdrive Web file sharing account (both are free). It includes tools to create MSN or Xdrive accounts, if you don't already have one.
- **E-Mail this file**—This feature starts your e-mail program and sends the selected files as attachments. This feature can optionally resize large images to make them smaller for mailing.

There's one very nice feature of the Picture Tasks screen that isn't on the menus. When you right-click an image in the preview window, a menu of useful tasks pops up (see Figure 21.8).

The pop-up menu shown in Figure 21.8 duplicates many of the menu items at the left side of the screen, but it also includes an option to edit the picture using any of the image editors installed on your system. This is a great feature for people who often work with more than one image editor program.

Managing Image Files with ThumbsPlus

There are at least a dozen image management programs on the market for the PC and Macintosh. I've tried most of them, but I keep coming back to ThumbsPlus. A trial version of ThumbsPlus is located on this book's CD-ROM. The trial version does everything the full version does, but it's only good for 30 days. The registered version costs $74.95 and is money well spent.

If your image collection grows to more than a few hundred images, an image organizer like ThumbsPlus is essential. In my daily work with digital images, ThumbsPlus is always my starting point. It's a sort of Swiss Army knife of image tools, and includes the major features listed in Table 21.1.



PART 5 · SHARING YOUR IMAGES

Figure 21.8

Right-clicking an image in the preview window brings up this list of common tasks.

TABLE 21.1—ThumbsPlus Features

Feature	Purpose
Thumbnail Catalog	This Windows Explorer-like display provides a visual catalog of your image files.
Image Organizer	You can drag and drop images within ThumbsPlus and between ThumbsPlus and other programs. ThumbsPlus includes tools to move, delete, copy, rename, and e-mail image files.
Slide Show	Displays a slide show of the selected images.
Image Printer	Prints one or several images on a page, very useful for creating a printed catalog of your image files.
File Viewer	Displays one or more image files on your screen.
Image Editor	Provides basic image editing functions, including color and brightness adjustments, cropping and resizing, rotation, sharpening, and red-eye removal.
Program Launcher	ThumbsPlus can launch the image editor of your choice.

Despite the long list of features, ThumbsPlus is very simple to use. Figure 21.9 shows the main ThumbsPlus screen.

Many other image catalog programs require that you keep your image files in a specific directory on your hard drive so that the program knows where to find them. ThumbsPlus can work with your images wherever they are, even if the images are on another computer connected over a network, on a CD-ROM, or on a removable disk like a floppy or ZIP drive.

Figure 21.9

ThumbsPlus displays a tree-structured list of directories on the left; the graphics files in the selected directory are shown in the large window on the right.

ThumbsPlus maintains a database of your images. When you add a new image to your library of images, ThumbsPlus adds the new picture's thumbnail image and file information to its database. This process takes a second or two per image, but only has to be done once per image.

The database approach has several advantages. First and most importantly, because the thumbnail images are stored in the database, ThumbsPlus doesn't need to open each image file and build a new thumbnail each time you start the program. This lets ThumbsPlus operate much faster than many other catalog programs. Second, the ThumbsPlus database can contain thumbnails of images stored on CD-ROMs or other removable disks. You can review the thumbnail catalog of those images even if the disk isn't currently in the computer. Finally, each image in the database can have one or more search keywords associated with it. When you add images to the database, you can assign one or several keywords to each image. This is a great feature that enables you to search your image library to find specific images in just a few seconds.

ThumbsPlus has so many features that I could easily fill this entire chapter and several more describing them all. Because we don't have that much room, here are a few of my favorite features.

The Image Viewer

When you double-click an image in the main ThumbsPlus display, ThumbsPlus displays that image on your screen. You can press the spacebar to move on to the next image in the database, or backspace to go to the previous image.

A menu at the top of the picture display window provides access to common image editing tools. Although the image editor isn't as sophisticated as Photoshop Elements or PictureIt!, it is very simple to use and is well-suited for simple tasks like rotating images, adjusting color and brightness, and resizing images to fit a particular paper size. Figure 21.10 shows the main editing menu.

Figure 21.10

ThumbsPlus features a simple but effective image editor that is all you need for most simple editing tasks.

One of my favorite ThumbsPlus features is the Trim to Size feature that enables you to quickly resize an image to fit a particular frame or picture size (see Figure 21.11). This is very handy when you're preparing to print 8"×10" prints that require a considerable amount of cropping.

Figure 21.11

The Trim to Size feature shows how your picture fits into different-sized paper and frames.

As you can see from Figure 21.11, the Trim to Size feature uses a moving window that is the same proportions as the paper or frame you selected. The part of the picture that won't fit into the paper is shown in gray. You can move the window around the screen until you get the exact fit you want on your prints.

Catalogs and Contact Sheets

ThumbsPlus includes several features to create catalogs and contact sheets from your images. A catalog is basically a printed version of the ThumbsPlus thumbnail display. Each

image can be printed with additional information like filename, date, and time, image dimensions, and catalog keywords. A typical catalog printout contains 25 images on an 8½"×11" page, but you can make the individual images larger or smaller.

A contact sheet is similar to a catalog, but a contact sheet is a new image file that contains thumbnail images of other files (see Figure 21.12).

Figure 21.12

A ThumbsPlus contact sheet combines many thumbnail images into a single image file.

Image Printing

I know, I raved about Qimage Pro in Chapter 19, "Printing Your Images." But ThumbsPlus includes its own set of image printing tools that are especially useful for creating printed catalogs that are larger than the ones produced by the Image Catalog feature. Figure 21.13 shows how ThumbsPlus prints multiple image files in a variety of sizes.

As you can see from Figure 21.13, ThumbsPlus automatically rotates horizontal images for printing so that all images print at the same size. The Text and Options tab enables you to print information like filename, size, date, and time next to each picture.

Figure 21.13

ThumbsPlus can print one or several images on a page, in a large variety of sizes.

SAVING YOUR IMAGES ON CD-ROMS

Virtually every new Mac and PC now comes with a CD-recordable (CD-R) drive as standard equipment. Just a few years ago, CD-R drives were an expensive luxury item, with drives selling for $600 and more. Today, CD-R drives cost less than $100. Modern CD-R drives are faster and more reliable than ever.

Most people think of CD-R drives as tool to make music discs, but they're also an excellent back-up tool for digital photographers. A single CD-R disc can hold from 650–800Mb of data. The low cost of blank CD-R discs also makes them a popular medium for sharing digital images. A CD-R can hold hundreds of high-quality images, and can be mailed in an ordinary envelope.

Several excellent CD-R authoring programs are available on the market, including CD Creator from Roxio Software and Nero 5 from Ahead Software. Both programs include Wizards that guide you through the process of making a CD-R disc.

Windows XP includes features that enable you to make CD-R discs with no additional software. In this section, we show you how to copy image files to a CD-R disc with Windows XP.

Step 1: Locate the Files to Copy

The first step in making a CD-R is to choose the files you want to copy to the CD. In this example, I assume that your pictures are in the My Documents folder.

The fastest way to do this is to click the Start button, then select My Documents from the start menu. When the My Documents screen appears, navigate to the folder that contains your images. In this example, the pictures I want to copy are several folders deep, in the My Documents\Projects\TTVGTDC\Photos folder.

Step 2: Select the Files to Copy

When you locate your files, the Picture Tasks screen is displayed. Select the images or folders you want to copy, and click Copy All Items to CD from the Picture Tasks menu on the left side of the screen (see Figure 21.14).

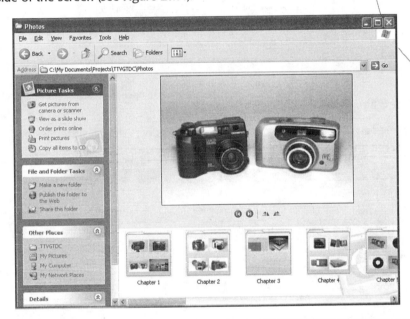

Figure 21.14

The Picture Tasks screen includes a menu option to copy files or folders to your CD-R drive.

Add as many files or folders as you like, but be careful not to exceed the capacity of your blank disc.

Step 3: Review the Files to Copy

When you've finished adding items to the CD, insert a blank disc into the CD-R drive. Windows asks what you want to do with the blank disc (see Figure 21.15).

Figure 21.15

When you insert a blank CD-R disc into the drive, Windows offers to open the folder that contains the files waiting to be written to the CD.

Click the Open Writable CD folder option, and Windows displays the files and folders you chose in the previous steps. The display should look something like the one in Figure 21.16.

Figure 21.16

These are the folders I'm preparing to write to the disc.

Step 4: Write the Disc

You're almost finished. Windows asks you to name the new disc. Enter a name, and click the Next button. Windows writes the files to the CD. When the CD is complete, Windows asks if you want to make another disc using the same files.

SUMI'S SNAPSHOT

My PC came with a CD drive, but no CD-R drive. Can I replace the CD drive with a CD-R drive?

In most cases, yes. Virtually all PCs use a standard interface to connect CD-ROM drives to the system board, and CD-R drives use the same interface. If you have an empty drive bay, you might want to keep your existing CD drive and add the CD-R as a second CD drive. Having two drives makes it easier to copy existing CDs.

When shopping for a CD-R drive and blank discs, I see lots of references to 12X, 16X, and so on. What do these numbers mean?

The original CD-ROM drives (from about 1986 or so) operated at a data transfer rate of 150 kilobytes per second (KBps). When manufacturers came up with faster drives, they needed a way to let consumers know how fast the new drives were. A 10X drive operates at ten times the speed of a 1X drive, or 1500KBps.

Okay, why is my new drive rated 20/10/40X, and what does that mean?

A few years ago, the CD-RW (rewritable) CD appeared on the scene. Unlike a conventional CD-R disc (which can only be written once), CD-RW discs can be erased and re-used. But CD-RWs are slower than conventional CD-R discs. The three numbers refer to the CD-R write speed, the CD-RW write speed, and the CD read speed of your drive.

I've seen black CD-R discs that are more expensive than conventional discs. Are they worth the money?

Black CD-R discs are supposed to be more scratch-resistant and longer-lasting than conventional CD-R discs. They're worth the money if you're concerned about the archival life of your discs. But be aware that many laptop CD-ROM drives use an optical sensor to tell when a disc is inserted. Some of these drives can't detect a black CD because it doesn't reflect enough light back to the disc insertion sensor!

SHARING YOUR PICTURES ON THE WEB

Digital Photos and the Internet seem made for each other. Not surprisingly, the explosion in digital camera sales has sparked an explosion in the number of photo sharing sites on the Web.

In this chapter, we show you how to

- Create your own photo Web page
- Publish your pictures on your own Web site
- Publish your pictures using a photo sharing service

SHARING YOUR PICTURES ON THE WEB

The Web was made for sharing words and images. If you have a digital camera, a computer, and an Internet connection, you have everything you need to share your pictures with the world. Just a few years ago, photographers wishing to share their pictures on the Web had to learn HTML, the standard page definition language of the Web. Today, hundreds of Web sites provide online photo sharing, many of them for little or no cost.

In this section, we show you how to share your pictures on the Web. There are two basic approaches to Web photo sharing. You can create your own page and publish it on your own site, or you can upload your pictures to one of the online photo sharing sites like Club Photo or PhotoPoint.

Creating Your Own Photo Web Site

Most Internet Service Providers offer Web server space as part of their standard dial-up account package. For example, I have an account with Earthlink that I use for dial-up Internet access when I'm traveling. My Earthlink account includes 100Mb of Web server space, enough to hold a few hundred pictures. I could—and will a little later in this chapter—create my own photo page, upload it to the Earthlink server, and publish it on the Web for all to see.

If I was a true propeller head, I could crank up my favorite HTML editor, design my own page, and spend hours tweaking and adjusting the page until everything is just right. But I hung up my programmer hat about 10 years ago, and I don't care to learn another programming language right now.

Why build your own site when there are dozens of photo sharing sites? The big photo sites like Club Photo and PhotoPoint don't allow for much customization. When you use one of those sites, your pictures are displayed using their standard layout. Some sites allow you to change colors or adjust the size of the images, but if you want to do a really creative site, you have to do it yourself.

Several tools are available that help lazy guys (and girls) like me create a pretty good photo Web page without writing a single line of HTML code. In fact, we've already seen two of them in this book. Microsoft PictureIt! and ThumbsPlus both contain tools to build photo Web pages.

Here's a quick tour showing how to build a photo Web page with PictureIt!

Step 1: Start PictureIt! and Select the Pick A Design Tab

The Pick A Design screen displays a list of all the projects you can create with PictureIt!, as shown in Figure 22.1.

Figure 22.1

To create a Web page, select Web/E-Mail Projects from the PictureIt! Design screen.

Step 2: Choose a Design Template

The Web/E-Mail Projects screen contains several Web page templates that you can use as a starting point for your page. You can create three types of photo Web pages with PictureIt!. An Album page displays a cover page with thumbnails of all the photos in the album; when a user clicks on a thumbnail image, the site displays a large version of the picture. A single page site puts all your pictures on one page, and a Slide Show site steps through the pictures one at a time.

For this example, I create an Album site using the design in the middle of the screen, as you can see in Figure 22.2.

Step 3: Choose Your Pictures

The next step is to choose the pictures you want to include on the Web page. PictureIt! uses a drag-and-drop file chooser. You navigate through your pictures using the directory tree on the left, and then you click the pictures you want to use and drag them to the black area at the bottom of the screen (see Figure 22.3).

Figure 22.2

This screen shows the design templates for photo albums.

Figure 22.3

Drag the pictures you want to include down to the tray area at the bottom of the screen.

Step 4: Add Captions to Your Pictures

Believe it or not, we're almost finished creating our example Web page. The next step is to click and enter a caption for each picture, as shown in Figure 22.4.

Figure 22.4

Each picture in your album can have its own caption.

Step 5: Save or Publish Your Site

After you enter captions for each picture, you can change a few other options, such as the size of the pictures and the color of the text. You can also add music to play in the background while people look at your pictures. As you can see in the example in Figure 22.5, I've changed the title of the page to "Les' Sample Web Site."

Step 6: Upload the Files to Your Web Server

PictureIt! can automatically upload your files to your Web server. This is a tremendous time-saver, because it spares you from learning the technical details of how to upload content to a Web server. All you need to know is the name of your Web server and your login ID and password. PictureIt! does the rest (see Figure 22.6).

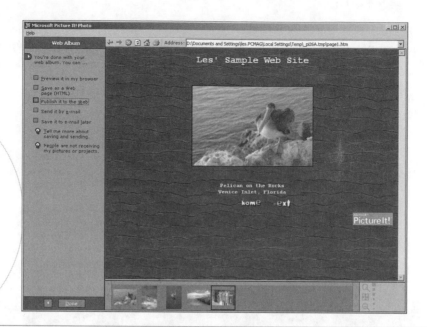

Figure 22.5

We're almost finished. This screen enables you to preview your site before you ship it off to your Web server.

Figure 22.6

PictureIt! knows how to upload files to Web servers, so you don't have to.

Step 7: Sit Back and Watch

PictureIt! automatically uploads your content and displays a progress bar to keep you occupied while your files upload (see Figure 22.7). The upload time varies depending on the number and size of the pictures in your album and your Internet connection speed.

Figure 22.7

While you're waiting for your files to upload, PictureIt! keeps you posted on its progress.

Step 8: You're Done!

After PictureIt! uploads your files, it offers to launch your browser so that you can check out your new Web site. Figure 22.8 shows how the sample site looks displayed in the browser.

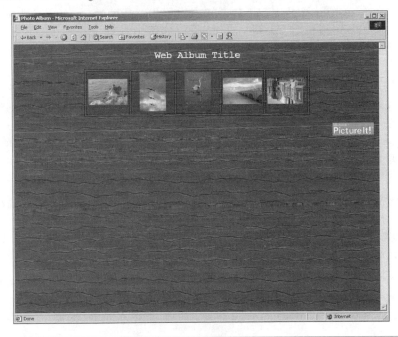

Figure 22.8

This is how our sample site looks on the Internet. Clicking a small picture...

Figure 22.9

...takes you to a larger version of the same image.

I can almost hear the sophisticated Webheads in the audience groaning about how lame it is to use a canned page like this when you could code your own, much cooler, page in HTML. My answer is, "Sure, but this took all of ten minutes."

Sharing Pictures on a Commercial Photo Site

At last count, over a dozen companies offered photo sharing sites on the Web. Some sites are completely free, others are fee-based. Others offer limited free services, but charge extra for increased storage or additional features. In addition to the traditional photo-sharing sites, many Web portal sites like MSN, Yahoo!, and Excite offer limited free photo-sharing services.

Just before we went to press, one of the largest photo sharing sites went out of business, and a formerly free site began charging an annual fee for its service. Rather than present you with a list of sites that will probably be outdated before the ink dries, let's take a close look at one site in particular.

Club Photo was one of the first photo sharing sites on the Web. Accounts on Club Photo are free, but the pictures in free accounts expire after 90 days. Annual memberships start at $25, which includes storage of up to 15 albums with up to 60 pictures in each album.

Club Photo offers an impressive array of online printing services. They have the usual photographic prints and frames, but Club Photo can also print your images on t-shirts, mousepads, notepads, and even on cookies and cakes, using special edible inks.

This example shows how to create a new account on Club Photo:

1. Starting from the main Club Photo Web page (www.clubphoto.com), click Join Now; the Membership Sign-up screen is displayed (see Figure 22.10).

Figure 22.10

Signing up for a new Club Photo account is free and very simple.

2. Enter is you name, your e-mail address, and a password. Read and agree to the terms of service, and click the I Agree button. You move to the next screen, on which you can purchase a full membership (see Figure 22.11).

3. For now, let's just use the free account. To do so, click Create an Album. The My Albums screen appears (see Figure 22.12).

Figure 22.11

If you like, you can purchase a full membership from this screen. If you don't purchase a membership, your pictures will expire after 90 days.

Figure 22.12

This mostly empty screen is the launching point for your online photo albums—after you've created some albums to share.

4. To create a new photo album, click the Create an Album link on the left side of the screen. The Create an Album screen appears (see Figure 22.13).

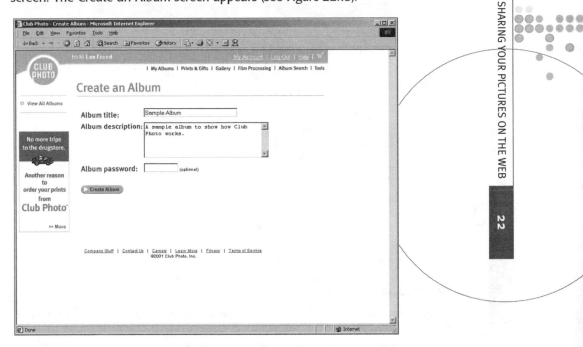

Figure 22.13

On the Create an Album screen, you can enter a name and brief description of your album.

5. As you can see from Figure 22.13, you can add a password to your album. If you choose to add a password to the album, then visitors to your Club Photo page must know the password to view the album. Without the password, the album doesn't even show in your list of albums. This is a nice feature, because it enables you to have a mix of public and private albums. The private albums are completely hidden from public view.

 To make this a public album, leave the password blank and click the Create Album button. The Add Pictures screen appears, as shown in Figure 22.14.

6. You can add pictures to an album in three ways. If you have Club Photo's Living Album software (available as a free download), you can upload the entire album at once. If you just want to add a single picture, you can use the Browse button to locate a single image file on your PC. If you want to upload several pictures, you can drag and drop the files onto the PhotoDrop button on the right side of the screen.

7. Using ThumbsPlus, select the pictures you want to upload (see Figure 22.15).

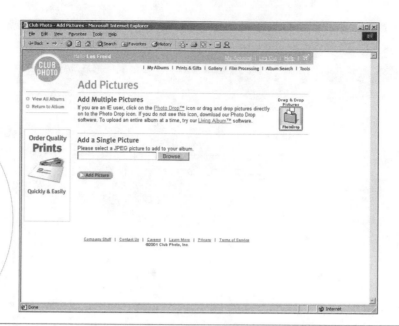

Figure 22.14

The Add Pictures screen enables you to upload several pictures at once by dragging the files onto the PhotoDrop button.

Figure 22.15

Four pictures are uploaded for this example. Selected them in ThumbsPlus by clicking each thumbnail while holding down the Ctrl key on the keyboard.

8. Now, all you have to do is drag the pictures from the ThumbsPlus window onto the PhotoDrop button on the Club Photo page. This requires careful positioning of the browser and ThumbsPlus windows so that you can see the PhotoDrop button while you're working in ThumbsPlus. When you drag the image files onto the PhotoDrop button, a new window opens, as shown in Figure 22.16.

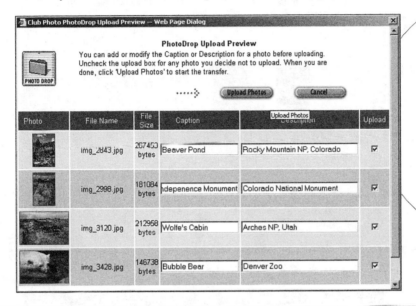

Figure 22.16

The Upload Preview window pops up when you drag and drop new files onto the PhotoDrop button.

9. The new window contains a thumbnail image of the pictures you want to upload, and it includes text boxes where you can enter captions and descriptions for the photos before you upload them to Club Photo. You've done that in the example, so click the Upload Photos button to begin the upload.

10. After the upload is complete, your new photo album is displayed onscreen (see Figure 22.17).

At this point you can leave the album as-is, or you can click the Edit Album button to customize your new album. The Edit Album screen enables you to change fonts, colors, and the album's background color. You can also turn off the Order Print button to prevent people from ordering prints from your pictures.

When you have your album arranged just the way you want, you can use the Share This Album to send e-mail invitations to your friends and relatives (see Figure 22.18).

Figure 22.17

The new album is complete and ready for the world to see.

Figure 22.18

This screen enables you invite others to view your new album.

The Share This Album feature sends a short e-mail containing the exact URL of your Club Photo page. Your recipients can click the URL link in the e-mail message to see your Club Photo page.

With these URL links, recipients can access the album without being asked for the password, even if the album is password protected.

SUMI'S SNAPSHOT

I like the idea of doing my own site, but I want something more personal than the canned sites in PictureIt!

There are dozens of excellent Web authoring tools, including Adobe's GoLive, Macromedia's Dreamweaver, and Microsoft's FrontPage. These are very powerful and flexible tools, but they have a much steeper learning curve than PictureIt!, and price tags to match.

I'd like to publish some of my pictures on the Web, but I've heard that some people steal images from the Web and use them on other Web pages or even sell prints of other people's pictures.

Yes, it happens all the time. You can add a digital watermark to your images (see `www.digimarc.com` for details), but if you're truly concerned, publish your images in a private, invitation-only album.

PART **VI**

ONLINE RESOURCES

DIGITAL IMAGING RESOURCES ON THE WEB

The Web is a wild, wonderful place. Searching for the good stuff can take hours. To help you learn more about photography without all the dead-ends and side-trips you often encounter on the Web, we've compiled this list of useful photo-related links.

CAMERA REVIEWS

- **TechTV** (www.techtv.com)—Check TechTV online for reviews and product news on the latest digital cameras. The Web site includes links to text reviews and streaming video highlights from recent TechTV shows.

- **PC Magazine** (www.pcmag.com)—*PC Magazine*'s First Looks section is updated daily and covers all aspects of computing and digital imaging, including PCs, cameras, printers, and software.

- **Extreme Tech** (www.extremetech.com)—A relative newcomer, ExtremeTech focuses on the technology behind the products we use every day—including computers, digital cameras, and printers. The site contains detailed explanations of how technology works, written in clear, concise, plain English.

- **Digital Photography Review** (www.dpreview.com)—One of the most respected camera review sites on the Web, London-based DPReview specializes in deep, detailed reviews of digital cameras. DPReview also has one of the most active discussion forums on the Web, where users can exchange tips and help each other with problems.

- **Imaging Resource** (www.imaging-resource.com)—Imaging Resource offers an extensive library of digital camera reviews and product information. True to its name, Imaging Resource also includes reviews of film scanners and photo-quality printers.

- **Photography Review** (http://www.photographyreview.com/)—Photography Review provides an online forum where users can trade opinions and ratings on photographic equipment, including digital cameras. Some of the reviews are very informative, but others appear to have been written by people who don't actually own the equipment being reviewed. Read the reviews, but take the numeric rating system (computed by tallying votes from readers) with a grain of salt.

- **Steve's Digicams** (www.steves-digicams.com)—Like DPReview and Imaging Resource, Steve's Digicams has a huge library of digital camera reviews. Steve's also features links to other reviews of the same equipment, so potential buyers can see several different opinions before they buy.

DISCUSSION FORUMS

- **Digital Photography Review** (www.dpreview.com)—I know DPReview was already mentioned, but its discussion forum is one of the best and most active on the Web. Frequent visitors include a mix of amateur and professional photographers from all over the world. It's a great place to get info before you buy and to compare notes with other camera owners after you buy.

- **Photo.Net** (www.photo.net)—Your first visit to photo.net is a bit like walking into the Library of Congress—you're overwhelmed by the amount of information. On the Web since 1994, photo.net is the granddaddy of all Web photo sites. Primarily aimed at film photographers, it contains lots of good basic photography tips and examples that are equally applicable to digital photography. There's an extensive discussion forum, and users are invited to upload photos for critique by other photo.net members.

- **Rob Galbraith Online** (www.robgalbraith.com)—Rob Galbraith is a well-known photojournalist and was one of the first PJs to switch to digital cameras. Rob's site is aimed primarily at professional photojournalists, but the discussion forums on Rob's site are interesting reading for all digital photographers, especially for users of Canon, Fuji, and Nikon digital SLRs.

- **Photo Critique Forum** (www.photocritique.net)—This unique site enables you to post your images for other users to critique. If you don't want to hear how good (or bad!) your images are, it's an interesting site to browse, if only to see what others are doing with their cameras.

PHOTOGRAPHY BASICS

- **Photo Imaging Council** (www.takegreatpictures.com)—Sponsored by two photo industry trade groups, this site is designed to help users take better pictures. To that end, it contains tutorials and examples that explain the basics of photography. A masters gallery section includes works from some of the country's best photographers, and an events calendar keeps track of photo-related events around the USA.

- **Photography Tips** (www.photographytips.com)—Designed for the beginning photographer, Photography Tips contains useful information on technique, lighting, and composition. It's not as deep as many of the other sites, but it might be a refreshing change if you're intimidated by some of the more technical sites.

- **Kodak's Taking Great Pictures** (www.kodak.com/US/en/nav/takingPics.shtml)—Kodak knows a thing or two about how to take photos, and they're glad to share that information with you. Although the site is not specifically for digital photographers, it provides lots of good information, including excellent tutorials on composition and lighting.

- **Outdoor Photographer** (www.outdoorphotographer.com)—The online counterpart to the popular print magazine has lots of useful information on travel and scenic photography. OP was one of the first photo magazines to fully embrace digital photography, so there's plenty of info of interest to digital camera users, including a calendar of upcoming photo workshops and an excellent travel planner.

CAMERA MANUFACTURERS/IMPORTERS

- **Canon USA**—www.powershot.com
- **Fujifilm USA**—www.fujifilm.com
- **Kodak**—www.kodak.com
- **Minolta**—www.minoltausa.com
- **Nikon USA**—www.nikonusa.com
- **Olympus America**—www.olympus.com
- **Polaroid Digital Cameras**—www.polaroiddigital.com

APPENDIX A

A TOUR OF TECHTV

Boasting the cable market's most interactive audience, TechTV is the only cable television channel covering technology information, news, and entertainment from a consumer, industry, and market perspective 24 hours a day. Offering everything from industry news to product reviews, updates on tech stocks to tech support, TechTV's original programming keeps the wired world informed and entertained. TechTV is one of the fastest growing cable networks, available around the country and worldwide.

Offering more than a cable television channel, TechTV delivers a fully integrated, interactive Web site. Techtv.com is a community destination that encourages viewer interaction through e-mail, live chat, and video mail.

TechTV, formerly ZDTV, is owned by Vulcan, Inc.

AUDIENCE

TechTV appeals to anyone with an active interest in following and understanding technology trends and how they impact their lives in today's world—from the tech investor and industry insider, to the Internet surfer, cell phone owner, and Palm Pilot organizer.

WEB SITE

Techtv.com allows viewers to participate in programming, provide feedback, interact with hosts, send video e-mails, and further explore the latest tech content featured on the television cable network. In addition, `techtv.com` has one of the Web's most extensive technology-specific video-on-demand features (VOD), offering users immediate access to more than 5,000 videos as well as expanded tech content of more than 2,000 in-depth articles.

INTERNATIONAL

TechTV is the world's largest producer and distributor of television programming about technology. In Asia, TechTV delivers a 24-hour international version via satellite. TechTV Canada is a "must-carry" digital channel that will launch in September 2001. A Pan-European version of TechTV is planned for 2002.

TECH LIVE QUICK FACTS

Tech Live is TechTV's unique concept in live technology news programming. Tech Live provides extensive coverage, in-depth analysis, and original features on breaking technology developments as they relate to news, market trends, entertainment, and consumer products. Tech Live is presented from market, industry, and consumer perspectives.

Mission

Tech Live is the leading on-air resource and ultimate destination for consumers and industry insiders to find the most comprehensive coverage of technology and how it affects and relates to their lives, from market, industry, and consumer perspectives.

Format

Tech Live offers nine hours of live programming a day.

Tech Live is built around hourly blocks of news programming arranged into content zones: technology news, finance, product reviews, help, and consumer advice.

Tech Live news bureaus in New York City, Washington D.C., Silicon Valley, and Seattle are currently breaking technology-related news stories on the financial markets, the political arena, and major industry players.

The TechTV "Superticker" positioned along the side of the screen gives viewers up-to-the-minute status on the leading tech stocks, as well as additional data and interactive content.

Tech Live runs Monday through Friday, 9:00 a.m.–6:00 p.m. EST.

NETWORK PROGRAM GUIDE

The following is a list of the programs that currently air on TechTV. We are constantly striving to improve our on-air offerings, so please visit www.techtv.com for a constantly updated list, as well as specific air times.

AudioFile

In this weekly half-hour show, Liam Mayclem and Kris Kosach host the premiere music program of its kind that dares to explore music in the digital age. From interviews with artists and producers, to insight into the online tools to help create your own music, *AudioFile* discovers how the Internet is changing the music industry.

Big Thinkers

This weekly half-hour talk show takes viewers into the future of technological innovation through insightful and down-to-earth interviews with the industry's most influential thinkers and innovators of our time.

Call for Help

This daily, hour-long, fully interactive call-in show hosted by Becky Worley and Chris Pirillo takes the stress out of computing and the Internet for both beginners and pros. Each day, *Call for Help* tackles viewers' technical difficulties, offers tips and tricks, provides product advice, and offers viewers suggestions for getting the most out of their computers.

CyberCrime

This weekly half-hour news magazine provides a fast-paced inside look at the dangers facing technology users in the digital age. Hosts Alex Wellen and Jennifer London take a hard look at fraud, hacking, viruses, and invasions of privacy to keep Web surfers aware and secure on the Web.

Extended Play

In this weekly half-hour show, video game expert hosts Kate Botello and Adam Sessler provide comprehensive reviews of the hottest new games on the market, previews of games in development, and tips on how to score the biggest thrills and avoid the worst spills in gaming. This show is a must-see for game lovers, whether they're seasoned pros or gaming novices.

Fresh Gear

A gadget-lover's utopia, host Sumi Das supplies viewers with the scoop on the best and brightest technology available on the market. In this weekly half-hour show, detailed product reviews reveal what's new, what works, what's hot, and what's not and offers advice on which products to buy—and which to bypass.

Silicon Spin

Noted technology columnist John C. Dvorak anchors this live, daily, half-hour in-depth look at the stories behind today's tech headlines. CEOs, experts, and entrepreneurs cast a critical eye at industry hype and separate the facts from the spin.

The Screen Savers

Whether you are cracking code, are struggling with Windows, or just want to stay up to speed on what's happening in the world of computers, *The Screen Savers* is here to help. Leo Laporte and Patrick Norton unleash the power of technology with wit and flair in this live, daily, hour-long interactive show geared toward the tech enthusiast.

Titans of Tech

Titans of Tech is a weekly hour-long series of biographies profiling high tech's most important movers and shakers—the CEOs, entrepreneurs, and visionaries driving today's tech economy. Through insightful interviews and in-depth profiles, these specials offer viewers a rare look at where the new economy is headed.

INDEX

INKJET PRINTERS

INDEX

WHITE BALANCE MODE

INDEX